IMAGES

of America

HERKIMER VILLAGE

Palatine Village, Destroyed by Canadian French and Indians, November 12, 1757

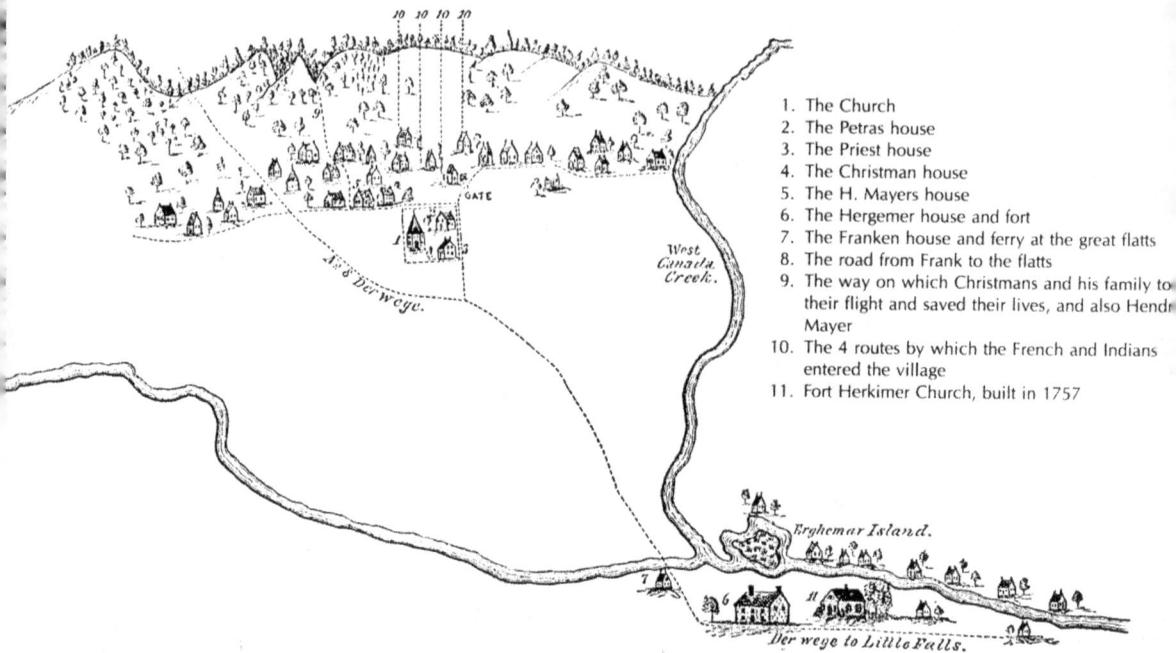

1. The Church
2. The Petras house
3. The Priest house
4. The Christman house
5. The H. Mayers house
6. The Hergemer house and fort
7. The Franken house and ferry at the great flatts
8. The road from Frank to the flatts
9. The way on which Christmans and his family to their flight and saved their lives, and also Hendr Mayer
10. The 4 routes by which the French and Indians entered the village
11. Fort Herkimer Church, built in 1757

PALATINE VILLAGE, 1757. Palatine Village, a part of the Burnetsfield settlement, was located on the north side of the Mohawk River on the west bank at the junction of the Mohawk River and the West Canada Creek. Burnetsfield was established in 1725 when a group of 92 Palatine Germans received a land grant from royal governor William Burnet (Burnetsfield Patent) in the extreme western frontier of the province of New York. This map was based on a survey made as early as 1750 by John Lawyer Jr., a practical surveyor. The village numbered 30 dwellings with a Reformed church. It was destroyed by French Canadians on November 12, 1757.

On the cover: **HERKIMER SESQUICENTENNIAL PARADE.** Pictured is a parade float carrying the sesquicentennial queen, Joan Hunt, in 1957. As queen, she won a weekend trip to New York City and a stay at the Waldorf Astoria hotel. Joan Hunt was a featured local celebrity in the village's bicentennial parade in 2006. (Courtesy of the Herkimer County Historical Society.)

IMAGES
of America

HERKIMER VILLAGE

Susan R. Perkins and Caryl A. Hopson

ARCADIA
PUBLISHING

Published by Arcadia Publishing
Charleston, South Carolina

Library of Congress Catalog Card Number: 2008926391

For all general information contact Arcadia Publishing at:
Telephone 843-853-2070
Fax 843-853-0044
E-mail sales@arcadiapublishing.com
For customer service and orders:
Toll-Free 1-888-313-2665

Visit us on the Internet at www.arcadiapublishing.com

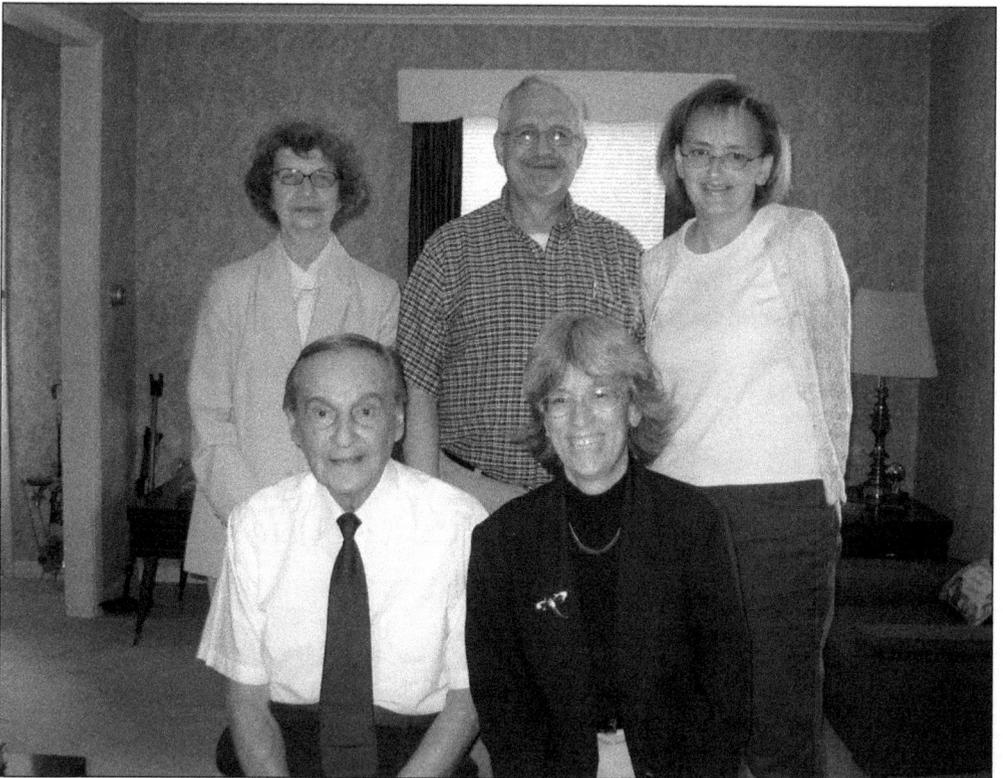

We would like to dedicate this book to our volunteers who helped make it possible: Alta DeLong, Steve Knight, Marion Morse, and our very own "Mr. Herkimer," Tod Waterbury. Pictured from left to right are (first row) Waterbury and Susan R. Perkins; (second row) Morse, Knight, and Caryl A. Hopson. DeLong is absent from the photograph.

CONTENTS

ACKNOWLEDGMENTS

This would not be a book about Herkimer without the support from people who have made Herkimer their home. Their pictures and memories have helped paint a picture of the village's history, which will be preserved for future generations. Thank you to the following who donated pictures: Joseph Basloe, Jane and Don Bellinger, Arthur Brown, Florence and Laura Caliguire, Margaret (Meta) Pierce Campbell, Joe Faga, Mary Falk, Henry Gaffey, Lil Gaherty, Jack Greiner, Jim Greiner, Herkimer County Community College, Herkimer fire chief John Spanfelner and the Herkimer Fire Department, Herkimer Baptist Church, Herkimer Christ Episcopal Church, Herkimer Methodist Church, Herkimer Reformed Church, Herkimer Trinity Lutheran Church, William Homyk, David Hunt, Margaret Kaminski, Arthur Kineke, Bob and Julie Lasowski, Mary and Vito Losito, Deborah Luppino, Donna Merryman, Pat Meszler, Thelma Miles, Marion Morse, Bob Murphy, Katie Nichols, Tom O'Connell, John Piseck, Joe Putnam, Richard Ruller, Edith Evans Seveny, Snell family, SS. Peter and Paul Church, Phyllis Shelton, Charlotte Szarejko, Temple Beth Joseph, Chick Vennera, Tod Waterbury, Minnie Wezalis, Bob Wilson, and Genie Zoller. Unless otherwise indicated, all images came from the Herkimer County Historical Society's photograph collection.

Thank you to our dedicated volunteers who helped research and write captions for the pictures: Alta DeLong, whose writing ability helped refine our captions; Steve Knight, our roving researcher who was a regular at the *Evening Telegram* office and Herkimer library for us; Marion Morse, who, if she did not know the answer, found someone that did; Tod Waterbury, who we consider "Mr. Herkimer," with stories to share that one cannot get from history books; and Bob Petrie, who was always ready to help.

Thank you to James Greiner, our enthusiastic and always-helpful village, town, and county historian, for writing our introduction; to Jeff Steele, for helping proofread; and to Todd Harter from the New York State Department of Transportation for helping us find Route 5.

INTRODUCTION

By the mid-1700s, the first settlers began to trickle into the vast wilderness area of Upstate New York commonly referred to as the Mohawk Valley. The first immigrants were farmers, mostly from the Palatine region of Germany. During the American Revolution, they sought refuge and protection at Fort Dayton. When the war was over, the cluster of homes near the fort was renamed for a fallen hero of that war, Gen. Nicholas Herkimer.

Dirt paths and trails eventually gave way to the Erie Canal, as more and more people came to Herkimer. By the 1840s, the railroad brought countless immigrants to the village. In the decades that followed, knitting mills and factories located near the tracks. Ironically, the railroad that provided passage to the village also divided it for generations. Even today, those who cannot recall that a railroad once divided the village (it was rerouted in 1943) still refer to one section as predominantly Italian: the south side. In fact, the entire section was made up of many nationalities. One street, Eureka Avenue, boasted 46 families in 1925. They hailed from Russia, Poland, Germany, Ireland, and Italy.

The village expanded as more people came to the village. Streets were laid out in orderly fashion. Former mayors and judges as well as a prize fighter had streets named in their honor. One of the first settlers of Herkimer, the Bellinger family, garnered the most street names. Not only is there a Bellinger Street, but there is also a Bellinger Avenue. Henry, Margaret, Caroline, Marion, Graham, and Frederick Streets are named for Bellinger children.

A unique feature of the village was the construction of the Hydraulic Canal. Completed in the 1830s with the use of Irish contract labor, the canal rerouted the nearby West Canada Creek into the village for the purpose of providing water and eventually electric power. Ten years later, an ice jam on the lower section of the West Canada Creek forced so much water into the canal that it overflowed onto the village streets. It left most of the village underwater for several days. The Herkimer flood remains one of the single-most photographed events in the history of the village.

This book is really about the people, where they worked, how they raised their families, and where they went to church. The village of Herkimer managed to survive floods, fires, and economic hardships, largely due to those people, who are ancestors. They came from some other part of the world and called Herkimer their home.

—James Greiner, village of Herkimer and Herkimer County Historian

One

NOTABLE PEOPLE

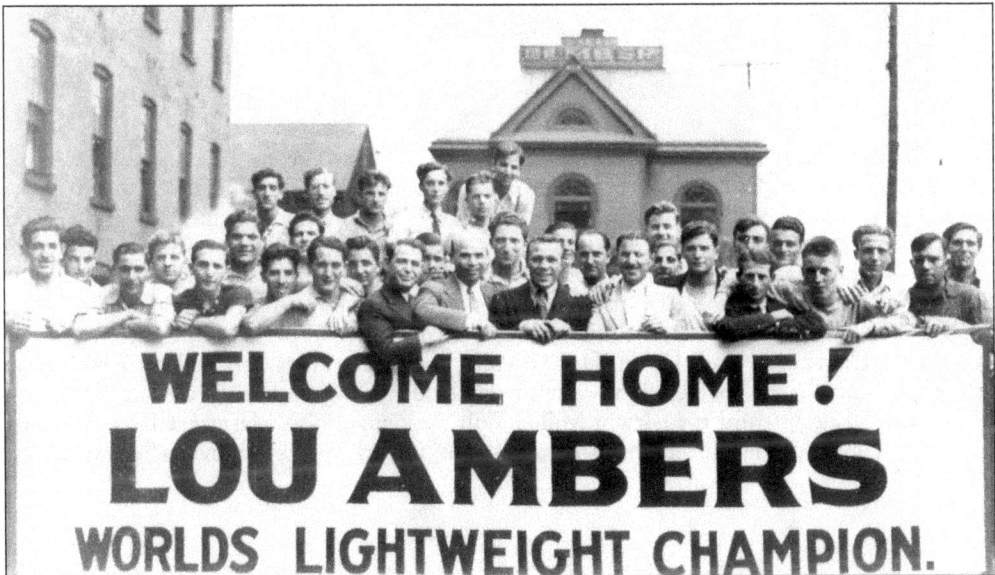

WELCOMING LOU AMBERS HOME. Lou Ambers always received a big fanfare of a welcome when he returned home to Herkimer after winning his boxing championships. He was the only lightweight in boxing history to recapture the title from the man to whom he lost it, defeating Henry Armstrong in 1939 after losing the title to him the year before. Ambers is seen here in the center of a Herkimer crowd in front of Snell Lumber Company. (Courtesy of Deborah Luppino.)

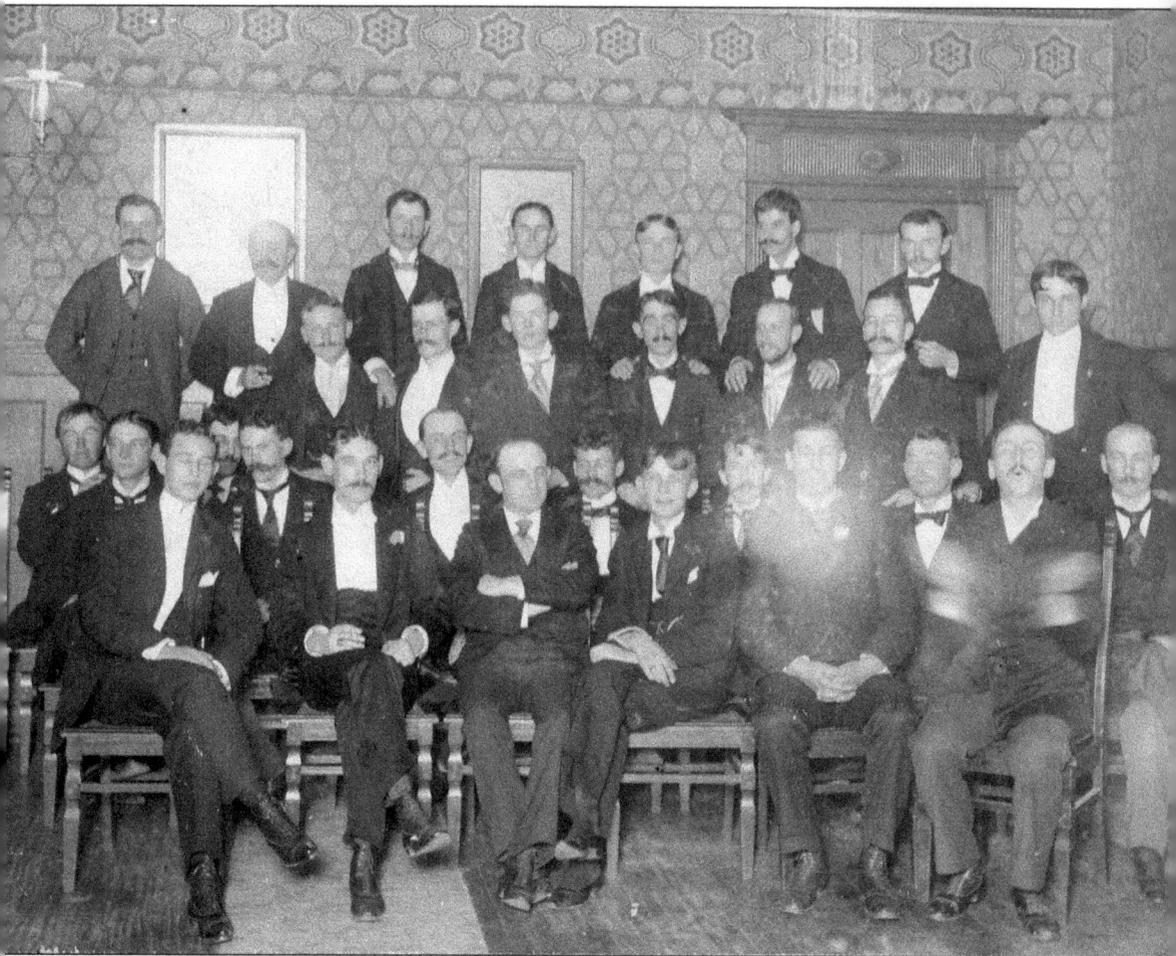

ANTENUPTIAL BANQUET. Alvin Evans gave an antenuptial banquet to fellow members of the Kappa Gamma Chi Society, a business-professional organization, at the Palmer House on October 7, 1895, to celebrate his upcoming nuptials to Margaret Munson. In the picture are some well-known Herkimer names. From left to right are (first row) Lewis B. Jones, LaMott Devendorf (best man), George Evans, Fred Lewis, Rinaldo Wood, Alvin (groom), Will Taber, Charles Stewart, Arnold Nelson (usher), Archibald Munson (usher), John Schrott, Marcus Hagerdorn, Clarence Dwyer, Dr. H. H. Longstaff, and Frank Addy; (second row) Jake Rice, Frank Christman, Charles Reardon, Clinton Batchelder, Dr. Fred Smith, George Rich, and Max Miller (usher); (third row) Irwin Miller, Will A. Pierce, John Metzger, Clarence Avery, Charles T. Gloo, Eugene Harter, and Albert Williams. (Courtesy of Edith Evans Seveny.)

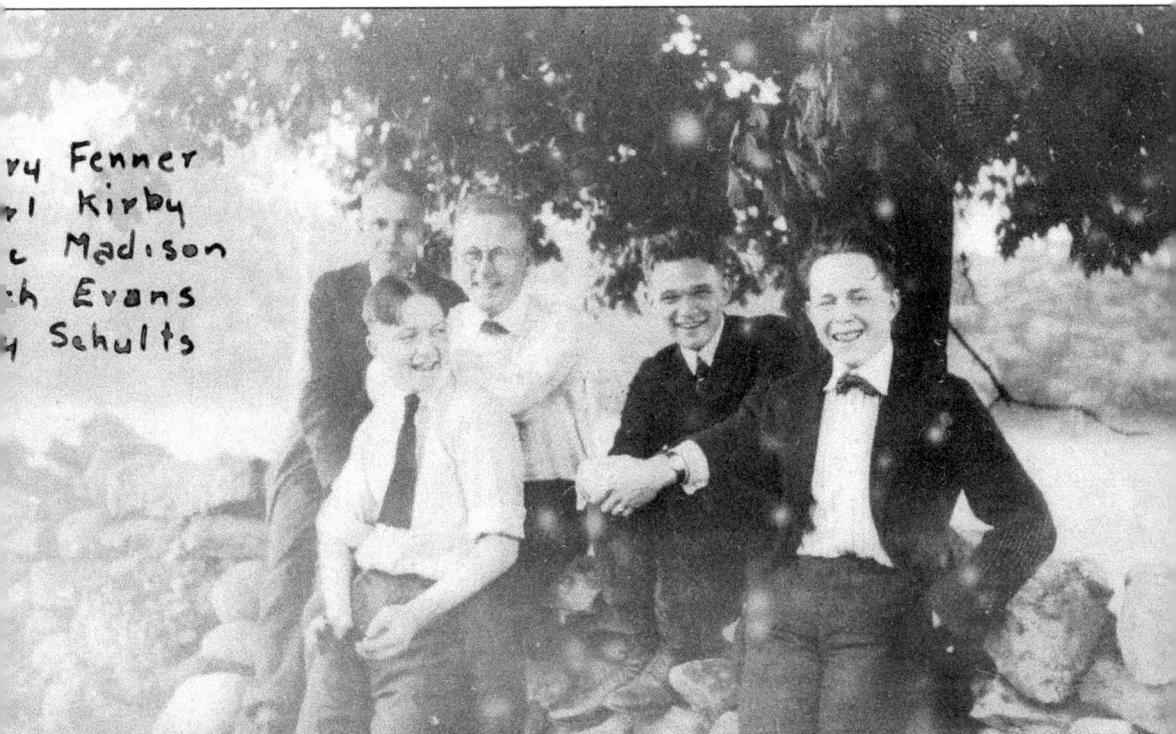

ry Fenner
rl Kirby
c Madison
h Evans
y Schults

SUMMER OF 1919. In this 1919 photograph, these five young Herkimer men look like they are enjoying the summer at the aftermath of World War I and the beginning of the Roaring Twenties. From left to right are Gerald (Jerry) Fenner, Carl Kirby, Duane "Doc" Madison, Archibald (Arch) Evans, and Sylvester (Sly) Shults. Fenner was the son of John and Jennie Fenner and became a land and claims adjuster for the New York State Department of Transportation. Kirby, the son of George and Mary Kirby, is well known as the founder of the Kirby Office Equipment Company. He was instrumental in the building of Herkimer Memorial Hospital and was the first president of the Herkimer Kiwanis Club in 1946. Madison, the son of Henry and Hattie Madison, was a longtime dentist in Herkimer, practicing for 43 years in his office at the corner of Park Avenue and North Main Street. Evans, the son of Alvin and Margaret Evans, was a civil engineer working for the New York Central Railroad, the U.S. Department of Agriculture, and the state highway department. Shults, the son of Burton and Daisy Shults, moved from Herkimer with his family to California where he operated a dry goods store. (Courtesy of Edith Evans Seveny.)

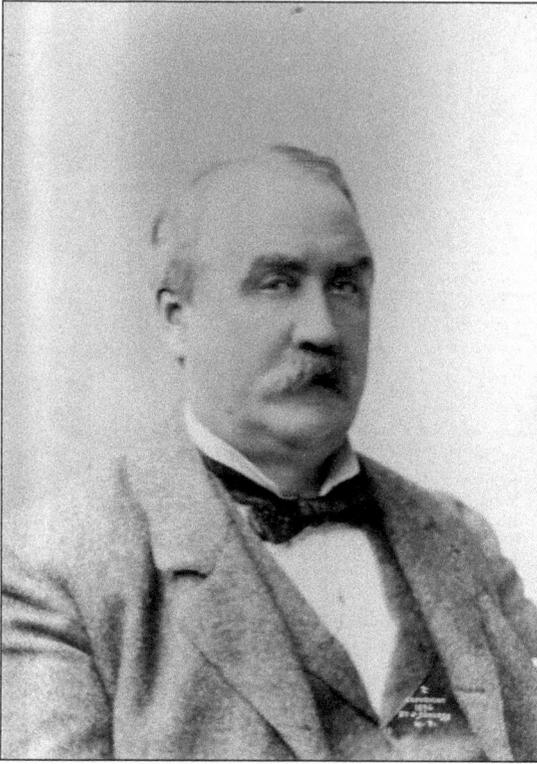

SEN. WARNER MILLER. Warner Miller (1838–1918) was one of Herkimer's most prominent citizens. A native of Oswego County, he developed an improved method of making paper from wood pulp and owned the Herkimer Paper Mill after purchasing it from Addison and Laflin in 1865. Active in political life, Miller served in the state assembly, the U.S. House of Representatives, and was the only person from Herkimer County to serve in the U.S. Senate. (Courtesy of Genie Zoller.)

HENRY MARCUS QUACKENBUSH. Henry Marcus Quackenbush (1847–1933) was the founder of the H. M. Quackenbush Company. As an inventor, he held patents for extension ladders and air guns. Although best known nationally for producing nutcrackers, his factory on North Prospect Street also produced air rifles and bicycles. Henry married Emily Elizabeth Wood in 1871, and they had three children, Camilla, Paul, and Amy. After Emily's death, he remarried Flora Franks in 1897, and they had two sons, Franks and Henry Marcus Jr. His son Paul took over the company when Henry died at the age of 86 in 1933.

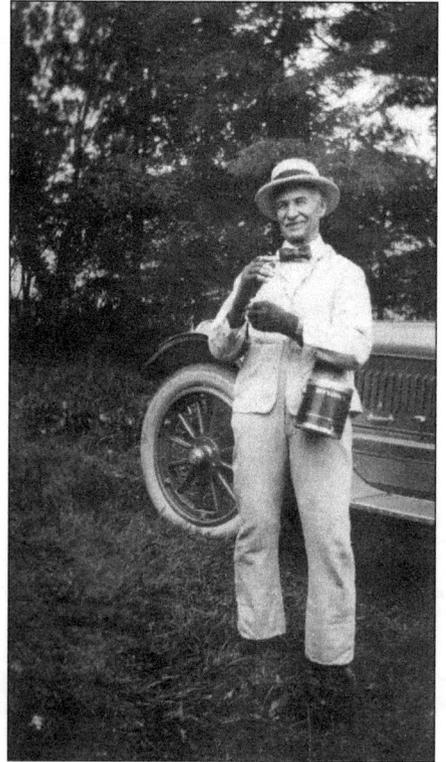

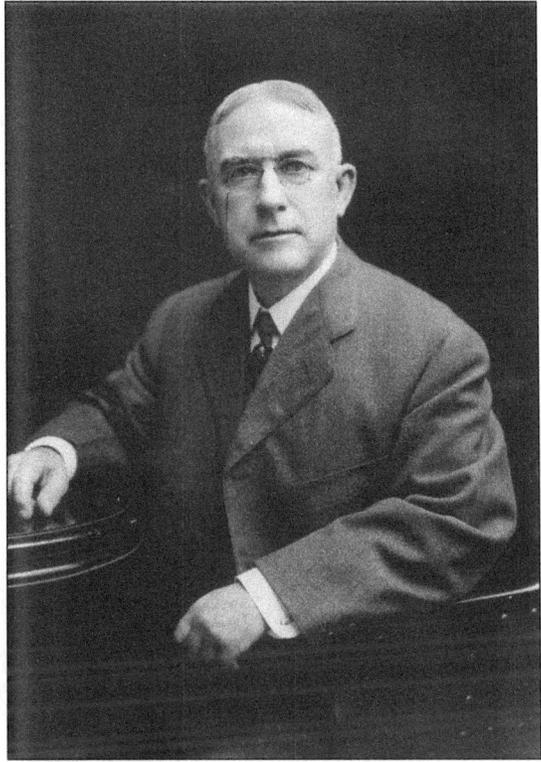

DR. AUGUSTUS WALTER SUITER. The presence of Dr. Augustus Walter Suiter (1850–1925) can be felt every day by the residents of Herkimer. His beautiful Queen Anne–style building on North Main Street was willed to the Herkimer County Historical Society as a memorial to his parents, Col. James A. and Catherine Suiter, and today houses the society's museum and collection. The doctor opened an office, waiting room, and library in the rear of the house and lived just a few doors down on North Washington Street. He was secretary of the Herkimer County Medical Society for over 50 years and is remembered as having formulated the defense of imbecility interposed in the behalf of Jean Gianni at his trial.

CHRISTOPHER COLUMBUS PIERCE. Christopher Columbus Pierce (1847–1931) enlisted in the 2nd New York Heavy Artillery at the age of 18 in 1864. At the time of his passing at age 84 in 1931, he was the last surviving Civil War veteran in the village. He treasured a letter from Theodore Roosevelt, thanking him for his assistance after Roosevelt stopped in Herkimer during his campaign for governor in 1898. There were no steps for him to mount a platform, and Pierce hurried home and brought back the steps from his own house. (Courtesy of Meta Pierce Campbell.)

JOSEPH BASLOE. Joseph Basloe (née Breslau), 1858–1928, an immigrant success story, was born in Austria and served in the Austrian army, fighting against Turkey. Through diligent saving, he was able to immigrate to the United States in 1891. He came immediately to Herkimer where he heard that workers were needed to build the New York Central Railroad. He went on to work for the Deimel and Snell lumberyard and then Standard Furniture Company, soon saving enough to bring his family over. (Courtesy of Joseph Basloe.)

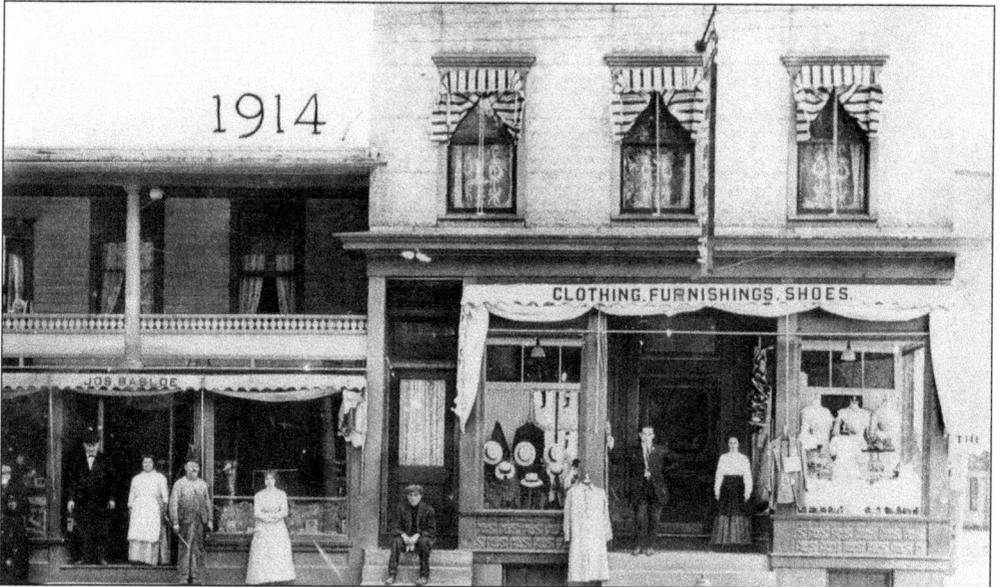

BASLOE STORE. Striving to be his own boss, Basloe opened a small candy store on South Washington Street. He was also credited with conceiving the idea of the lunch wagon. He converted old horsecars into lunch wagons after the trolley made them obsolete. He sold this business and expanded his store on South Washington Street. Pictured from left to right in front of the store are Bud Tower, Basloe, Hannah Basloe, Ted Daly, Syra Rosenkrantz, Frank Basloe, Henry Stern, and Nellie Powell. (Courtesy of Joseph Basloe.)

14

ELIZABETH SNELL FOLTS. Elizabeth Snell Folts (1843–1898), wife of George P. Folts, founded the Folts Missionary Institute in 1893 in connection with the Methodist Church to train young women for worldwide missionary work. The institute was located in Folts's beautiful home on North Washington Street. The school was discontinued in 1927. In 1943, it reopened as the Folts Home for the Aged. Today it offers a variety of services to the elderly, from independent-living facilities to full nursing home care.

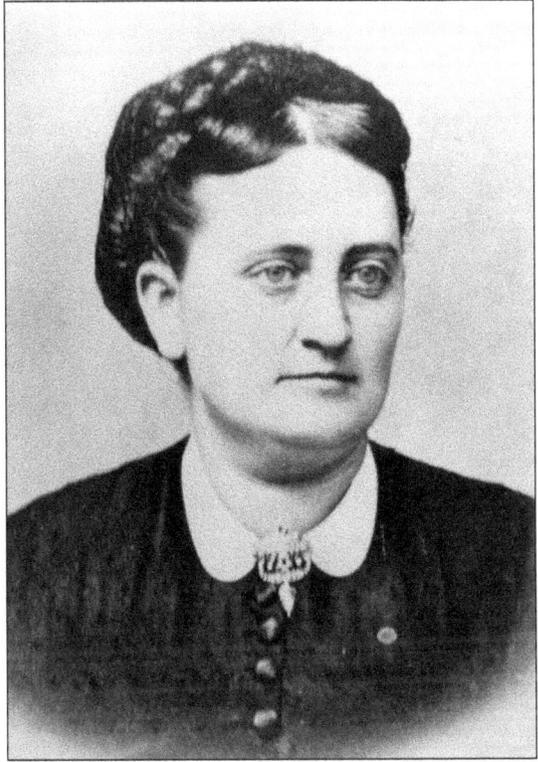

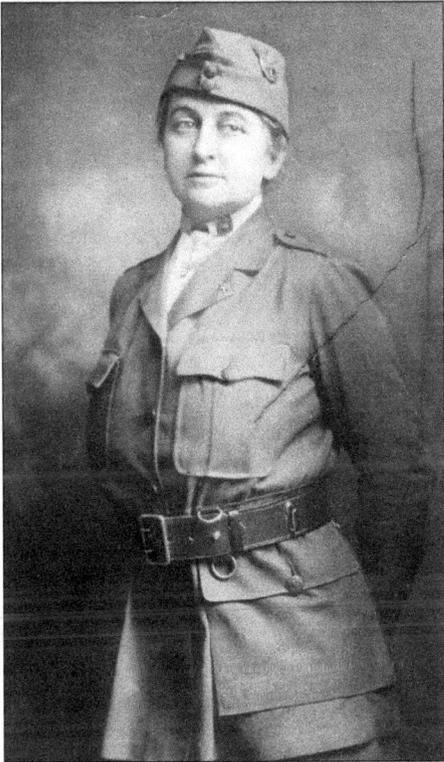

MARGUERITE THOMPSON. Marguerite Thompson (1872–1939) was well known for her social work. She came to Herkimer with her husband, Charles, from Boston in 1916. She served as a probation officer until the establishment of Children's Court and headed the social service department of the Herkimer Police Department for more than 30 years. At the time of her death in 1939, she was the only woman ever to have authority as a policewoman on the force. She also founded the Herkimer Boys Club.

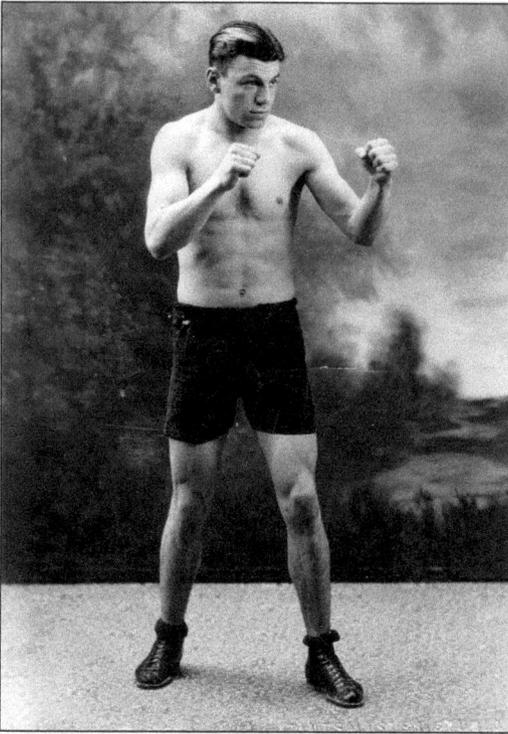

LOU "HERKIMER HURRICANE" AMBERS. Born Luigi D'Ambrosio on November 8, 1913, Lou Ambers, the "Herkimer Hurricane," was one of Antonio and Louisa D'Ambrosio's 10 children. He grew up in Herkimer, learning to box in St. Anthony's church basement. He went on to hold the title of Lightweight Champion of the World from September 1936 to July 1938 and August 1939 to May 1940. (Courtesy of Deborah Luppino.)

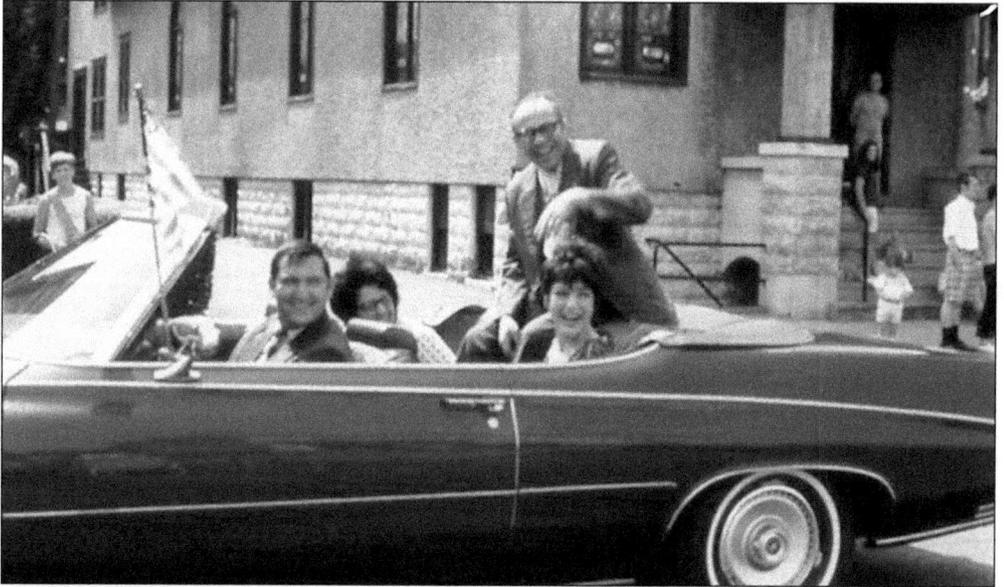

LOU AMBERS TRIBUTE WEEK. The week of August 2–8, 1971, was Lou Ambers Tribute Week in Herkimer. Ambers returned to Herkimer from his home in Phoenix, Arizona, for the event held in his honor. A parade, banquet, and boxing exhibition were staged, and a road and athletic field were named in his honor. Pictured is a parade shot with Ambers riding in a convertible driven by Arthur Richer, who headed up the tribute committee, and Amber's wife, Margaret, and daughter Regina. He died at the age of 81 on April 24, 1995, in Phoenix, Arizona. (Courtesy of Joe Faga.)

MARGARET TUGER. Margaret Tuger (1864–1939), seen here with (from left to right) Ruth, Don, and Brad Fenner in 1934, is described as a Herkimer legend, serving as principal of the South Side School from 1891 to 1931. She is remembered for her generosity and the good manners she instilled in her students. Others remember "Old Faithful," a memorable wooden paddle that had a good effect on Herkimer's juvenile delinquency rate. In 1932, the school district honored her by placing her name on the school.

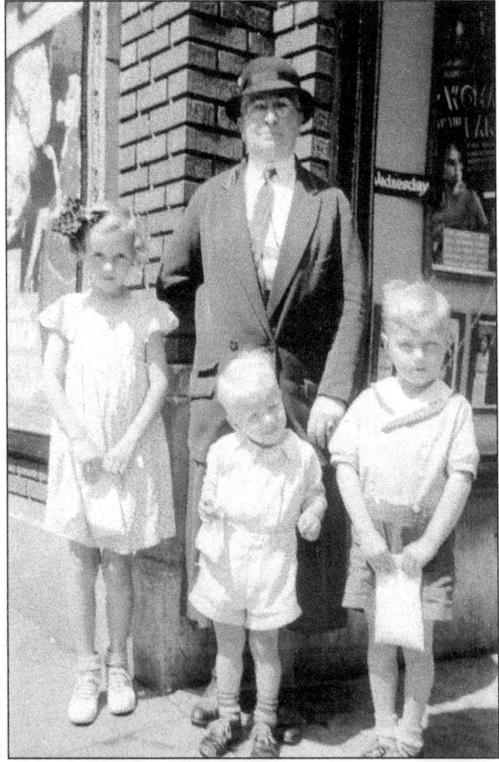

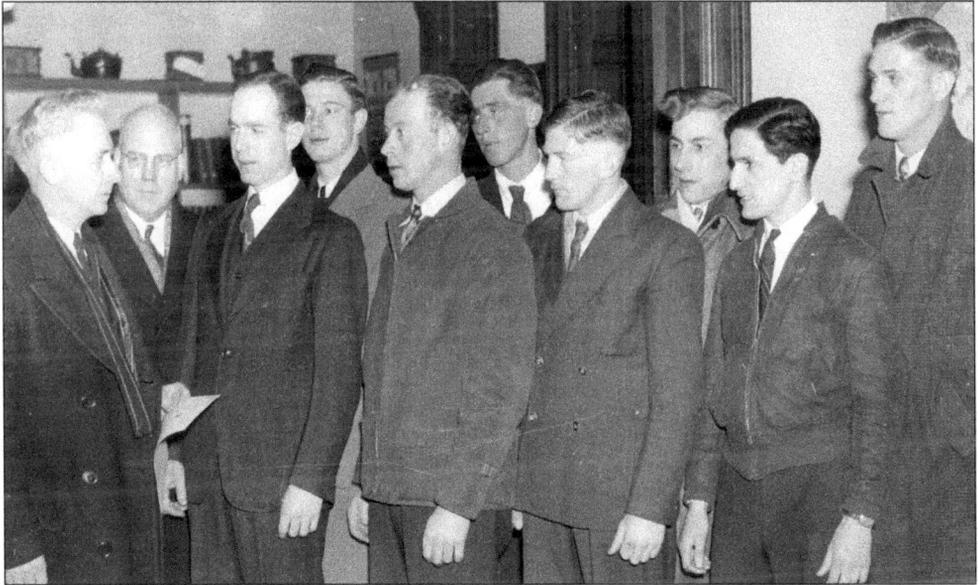

LORRAINE W. BILLS. Lorraine W. Bills (1880–1954) started his career teaching mathematics at Little Falls and was soon promoted to principal. After serving eight years in Waterford as superintendent, he came to Herkimer, where he remained as superintendent of Herkimer schools for 20 years. Active in civic and fraternal circles, he was chairman of the Herkimer Draft Board during World War II and can be seen here (far left) with a group of draftees in the Herkimer County Historical Society building in 1941.

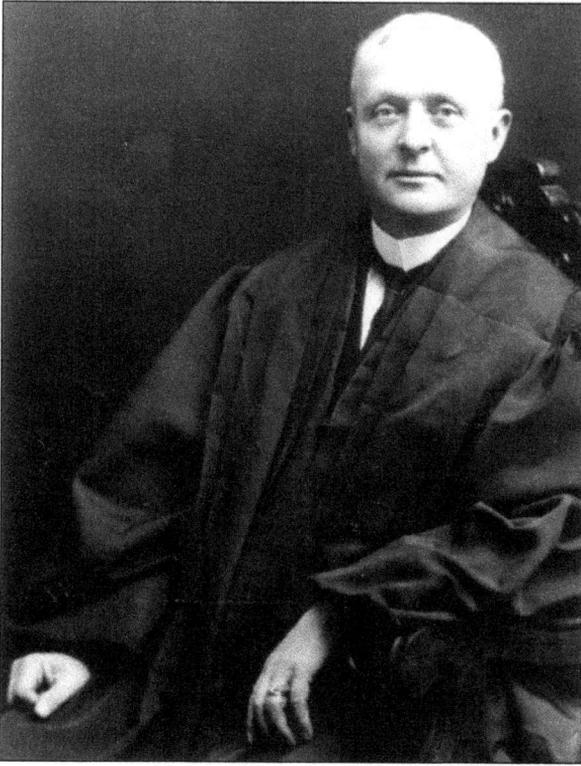

JUDGE IRVING R. DEVENDORF.
New York State Supreme Court
justice Irving R. Devendorf
(1856–1932) drew as his first murder
trial the case of Chester Gillette,
bringing him national publicity.
Devendorf was admitted to the
bar in 1880 and began his practice
in Herkimer. He spent 37 years
in public service, first as district
attorney and then as judge and
surrogate. He became a New York
State supreme justice for the fifth
judicial district in 1906 and served
until 1926, after which he served
as a referee of the New York State
Supreme Court.

JUDGE ABRAM ZOLLER. Abram Zoller
(1882–1962) devoted his life to public
service and the law, starting his career as
a lawyer. He was a Herkimer County judge
from 1929 to 1934 and then was elected
as New York State Supreme Court justice,
serving there until 1952 when he retired
at the age of 70. His wife, Muriel, was
active in the Herkimer County Humane
Society with her sister-in-law Zaida Zoller.
They lived at 426 North Main Street
and are seen here celebrating the judge's
64th birthday.

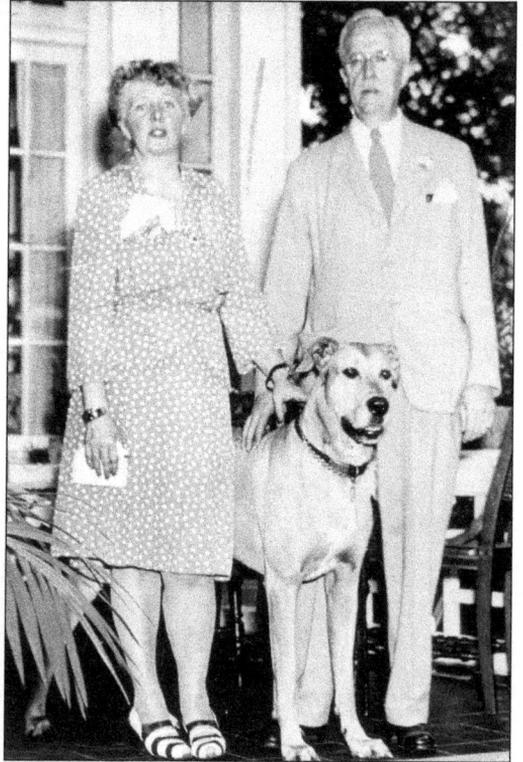

REV. VINCENT A. NOWAK. The statement, "He looked out for his parish first," typifies the high regard that parishioners had for Fr. Vincent A. Nowak (1910–2001) of St. Joseph's Church. He was pastor of the church from 1946 until his retirement on September 1, 1977. During that time, he oversaw many changes there, including retirement of the church's mortgage and the building of a new convent, school, rectory, and church hall. He died on December 12, 2001, and is buried in the priest plot of Calvary Cemetery. (Courtesy of Margaret Kaminski.)

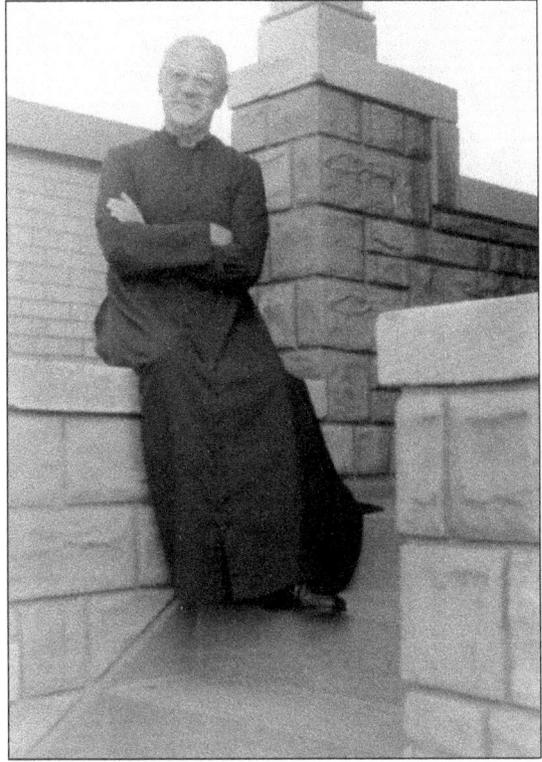

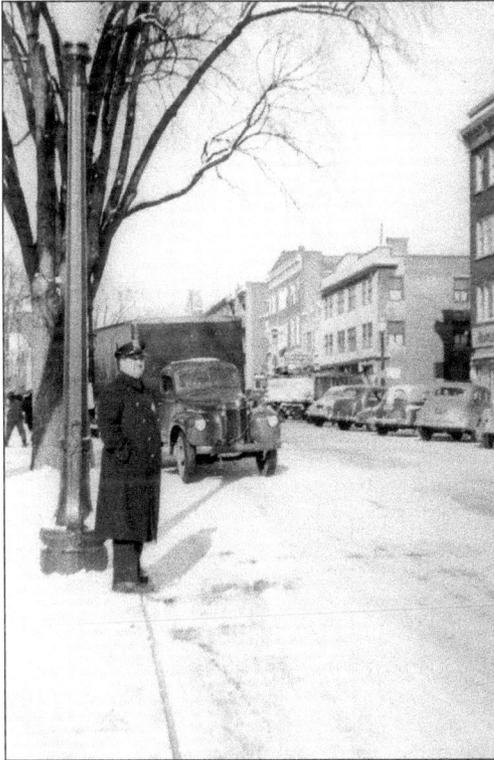

PATROLMAN HOWARD MARQUISSEE. Prior to the use of patrol cars, the local policemen walked a beat. Officer Howard (Howie) Marquissee (1915–1975) served in that capacity and was a well-liked policeman who patrolled Main Street and its side streets. Hired in 1937 as a part-time policeman while working at the Standard Furniture Company, he became a full-time member of the force in 1941. This 1946 picture shows him standing at the crosswalk near the National Diner and the library.

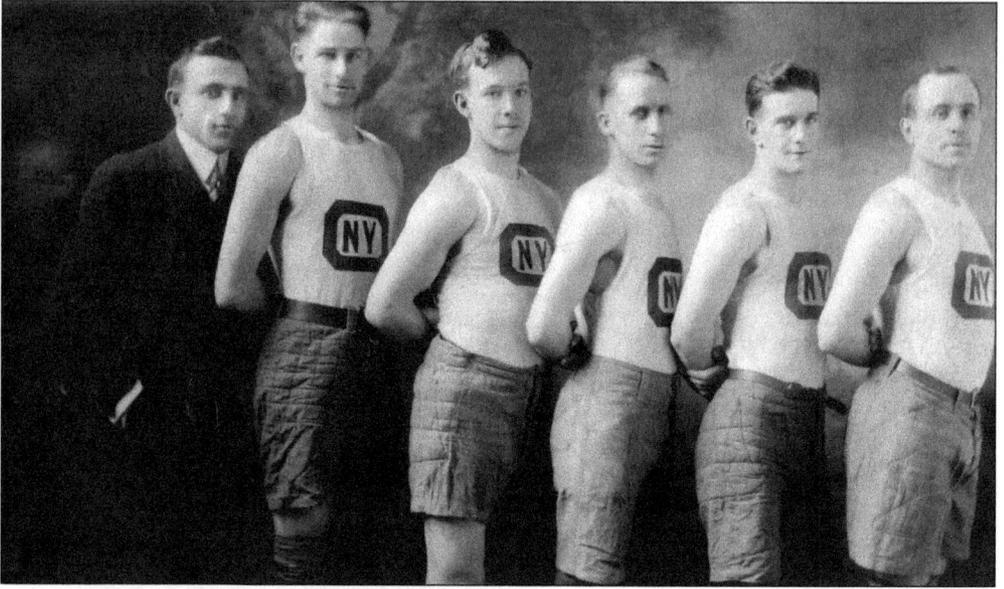

FRANK J. BASLOE. Frank J. Basloe (1887–1966) organized a basketball team named the Globe Trotters, who traveled all over the United States and won the world championship in 1914. He was commissioner of the New York State Basketball League from 1937 to 1947 and was a big advocate of sports facilities for youth of the area. Pictured is the Oswego team who defeated the Buffalo Germans for the 1914 championship. From left to right are Basloe, Minn Bradshaw, Wabby Hammond, Jim Murnane, Johnny Murphy, and Mike Roberts. (Courtesy of Joseph Basloe.)

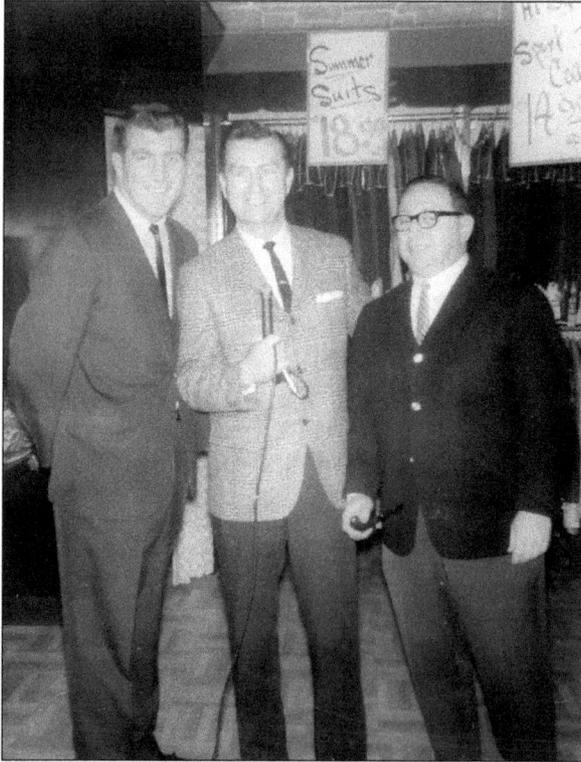

NEW YORK GIANT COMES TO HERKIMER. Saul Myers (1914–2001), proprietor of the Myers Clothing Store, invited Alex Webster, the No. 29 running back for the New York Giants football team, to speak at a banquet at the Temple Beth Joseph in Herkimer in 1963. Pictured are Webster, local radio personality Hank Brown, and Myers at the Myers Clothing Store.

H. PAUL DRAHEIM. H. Paul Draheim (1905–1993) was a longtime reporter who put his writing expertise to new use when he became county historian. During a noteworthy career of 45 years as a reporter, editor, and columnist, he wrote over 2,000 historical columns. One of his scoops was coverage of the Lake Shore Limited train wreck in Little Falls in 1940. One of the first on the scene, he sent out a report complete with photographs to the Associated Press 45 minutes after his arrival. His license plate read, "Herkimer."

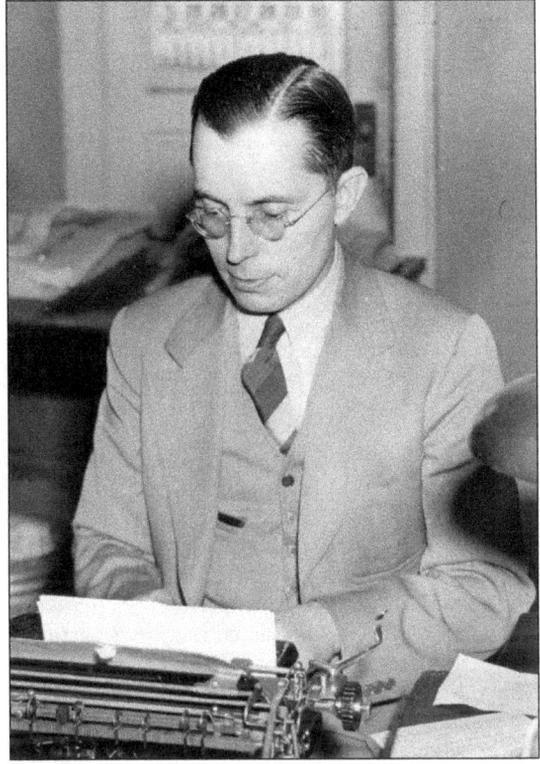

HAZEL CRILL PATRICK. The touch of Hazel Crill Patrick (1901–2000) can be seen everywhere one looks when visiting the Herkimer County Historical Society's library. She served as a board member and a valued staff member who contributed much genealogical material and authored histories on the Bellinger, Casler, Harter, Herkimer, Kast, Petrie, and Rasbach families. She graduated from Herkimer High School with the class of 1918 and was a lifelong resident of East Herkimer, where she lived with her husband, Andrew Patrick.

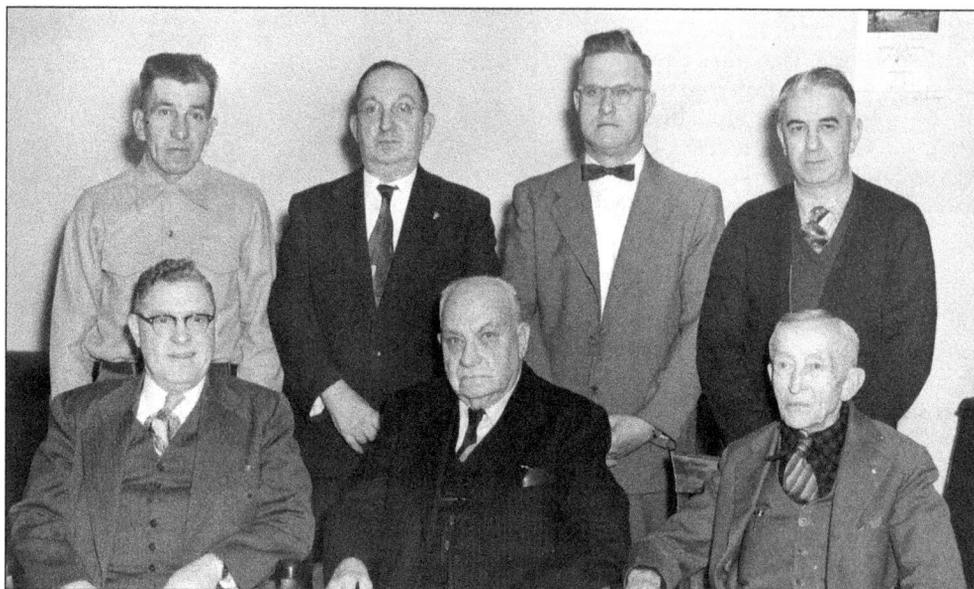

FIREMEN BENEVOLENT ASSOCIATION. Pictured are the Herkimer Fire Department Benevolent Association officers who served the fire department faithfully. From left to right are (first row) Lambert Anderson, William Greiner, and Wesley Bates; (second row) Peter Hubiak, F. Arthur Miller, Ken Brown, and Herbert Hartigan. Hubiak was honored in 2006 for 60 years of service. He volunteered at the age of 35, and when they said he was too old to be a fireman, he became an on-call fireman, a position he kept all his life. (Courtesy of the Herkimer Fire Department.)

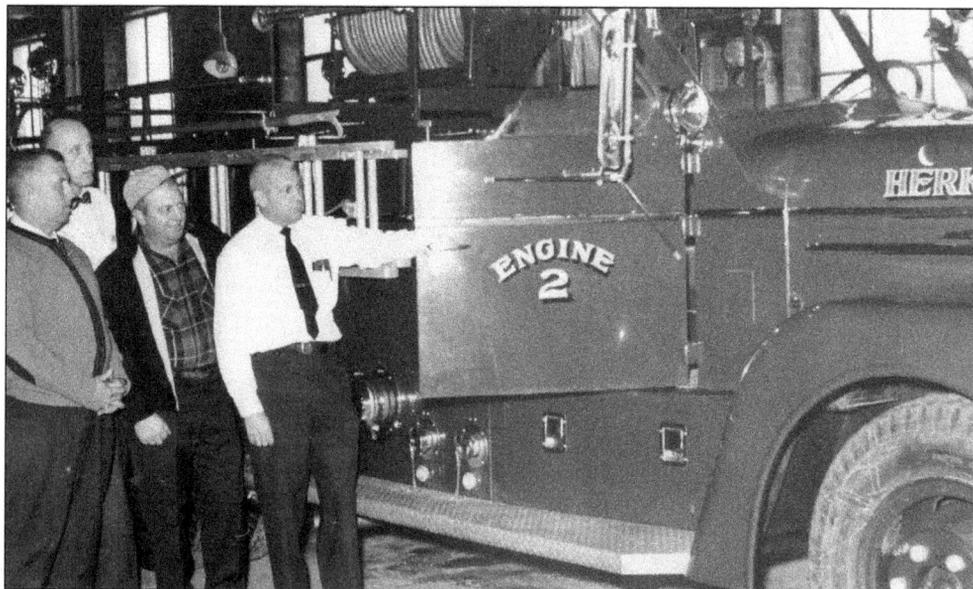

VILLAGE OFFICIALS WELCOME NEW ENGINE. The Herkimer Fire Department received a new fire engine around 1963. Pictured with the new engine from left to right are John Pryor, village mayor; Bill Fredlund, village administrator and engineer; Joe Nettie, village trustee; and John Graves, Herkimer fire chief. The fire department was housed in the old municipal hall at that time. It moved into its new quarters on North Washington Street on October 18, 1989. (Courtesy of the Herkimer Fire Department.)

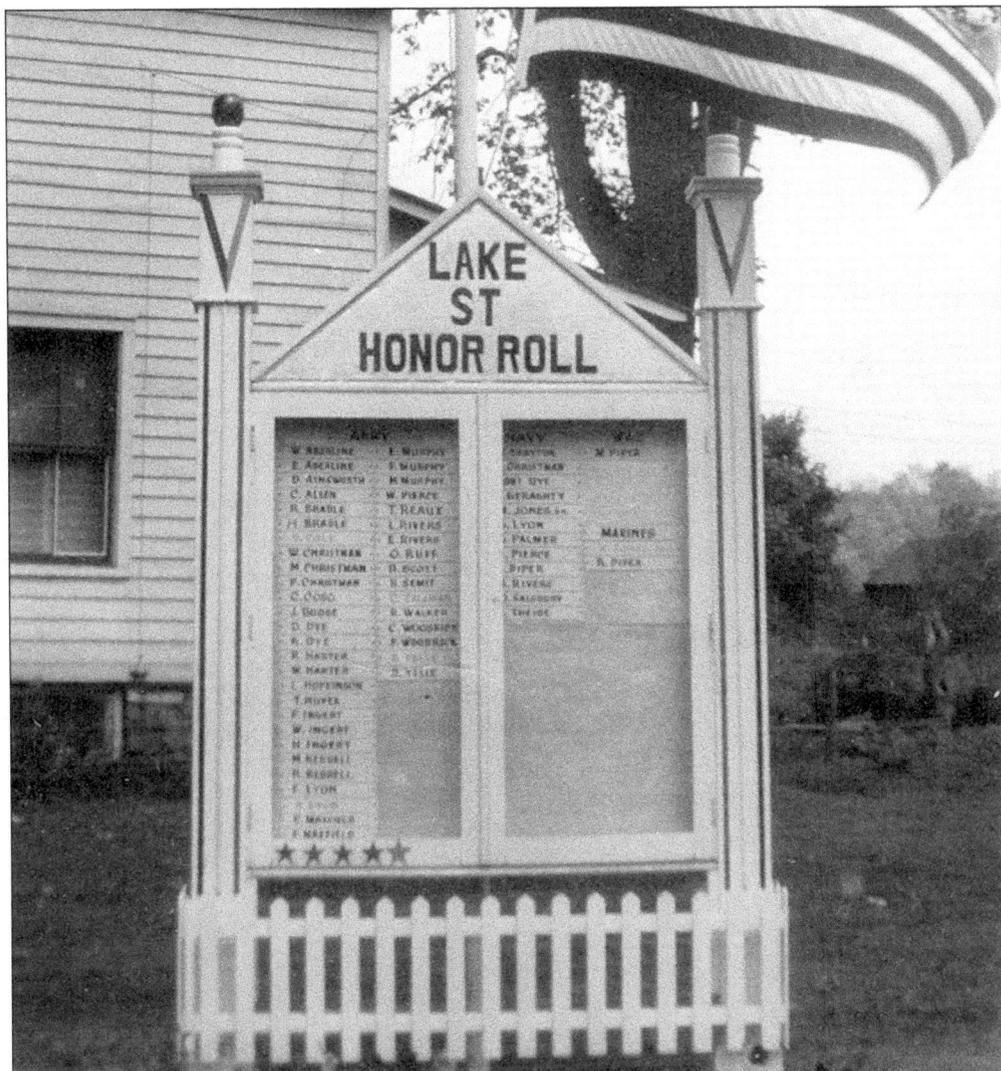

LAKE STREET WORLD WAR II HONOR ROLL. Herbert Spencer constructed a wooden monument in honor and memory of the young men and women in the Lake Street neighborhood who served in World War II. It stood on the corner of Lake Street near the Cole residence for many years until it deteriorated from the weather. Listed on the monument for the army are William Abeline, T. Abeline, Douglas Ainsworth, Cyrus Allen, Russell Bradle, Howard Bradle, Charles Cole, Willard Christman, Myron Christman, Paul Christman, Charles Coso, Joseph Dodge, D. Dye, Russell Dye, Robert Harter, William Harter, Linn Hopkinson, Thomas Heyer, Frederick Ingert, Herbert Ingert, Walter Ingert, Maurice Keddell, Robert Keddell, Floyd Lyon, Robert Lyon, Frank Maxfield, Clarence Maxfield, E. Murphy, F. Murphy, M. Murphy, William Pierce, Ted Reaux, Leo Rivers, Earle Rivers, George Ruff Jr., Ralph Scott, Herbert Semit, Clarke Tallman, Robert Walker, Charles Woodrick, Frederick Woodrick, Edward Yelle, and Benjamin Yelle; for the navy are Raymond Brayton, Fritz Christman, James Dye, John Geraghty, Maynard Jones Sr., George Lyon Jr., George Palmer, John Piper, Donald Rivers, Donald Salsbury, and Ralph Thiede; for the Women's Army Corps is Margaret Piper; for the marines are Maynard Jones Jr. and Robert Piper. Of all these servicemen and women, Charles Cole, Robert Lyon, Clarke Tallman, Edward Yelle, and Maynard Jones Jr. made the ultimate sacrifice. (Courtesy of Katie Nichols.)

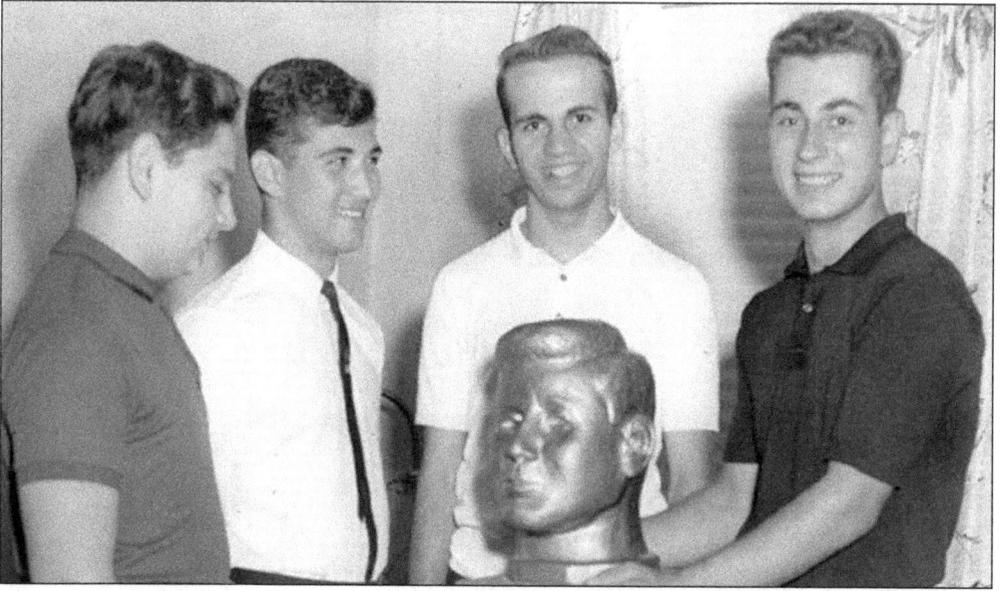

JOSEPH FAGA. Coming to the United States in 1956 from Italy, Joseph Faga attended Herkimer High School, where he excelled in his ceramics class, creating presidential busts of Theodore Roosevelt, Franklin Delano Roosevelt, and John F. Kennedy. It was an exciting moment for Faga (far right) and Herkimer when he traveled with his friends Dominick Scalise, Albert Celio, and Richard Macri to the White House to make a presentation of the bust to Kennedy's assistant Jack McNally in 1963. (Courtesy of Joe Faga.)

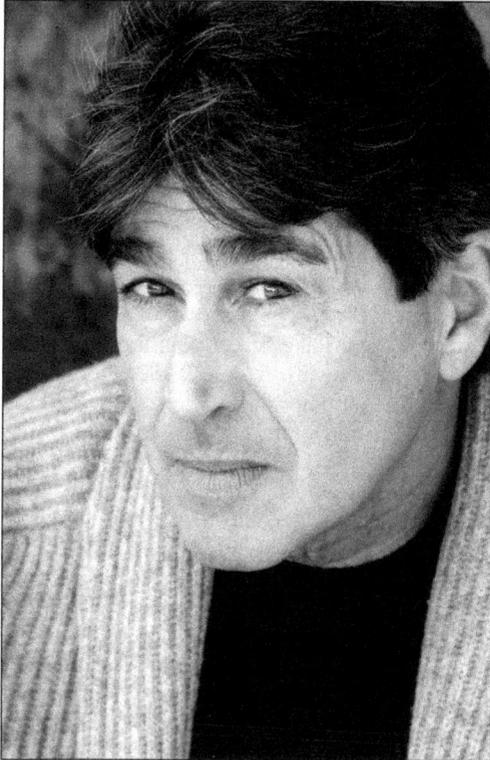

CHICK VENNERA. A native of Herkimer, Chick Vennera is an actor, singer, songwriter, dancer, writer, and director. He has appeared in many roles both on and off Broadway and has appeared in more than 50 films, including *The Milagro Beanfield War*, directed by Robert Redford, and worked with such well-known personalities as Vanessa Redgrave and Richard Gere. He has also written and directed for the stage, movies, and television. He now teaches at the esteemed Beverly Hills Playhouse. (Courtesy of Chick Vennera.)

Two

HISTORIC HOMES
AND BUILDINGS

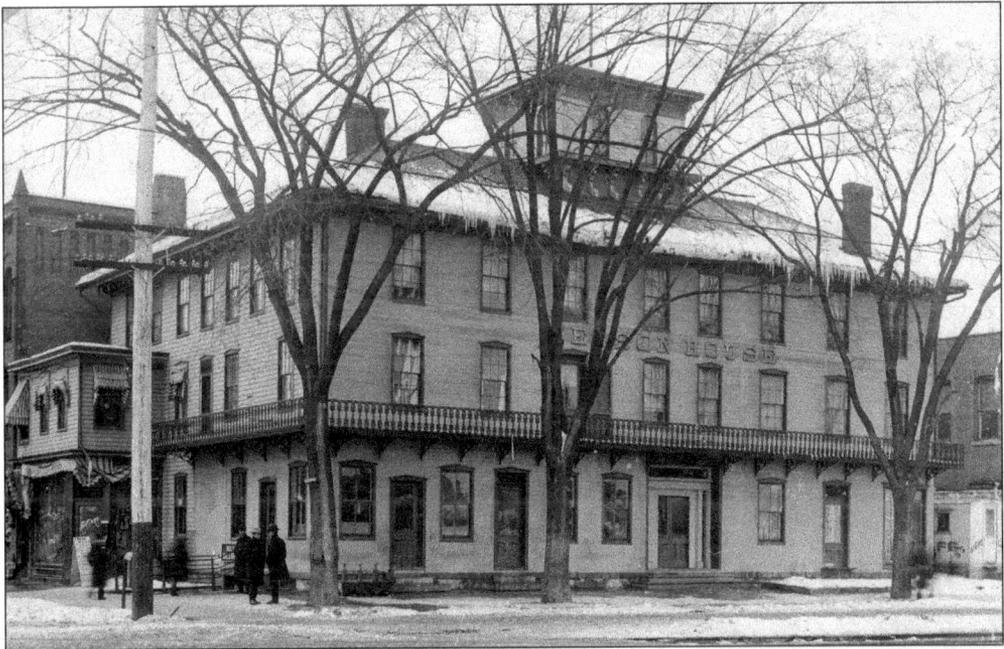

THE TOWER HOUSE. The Tower House, operated by Julius C. Tower in 1871, was located on the corner of East Albany and North Main Streets across from the New York Central Railroad depot. It was the site of a hotel for many years in Herkimer. In 1892, builder and contractor John H. Nelson bought the hotel and named it the Nelson House. He later remodeled the structure and used the wooden-framed hotel as the nucleus for the new Nelson House, later to be known as the Nelson Block.

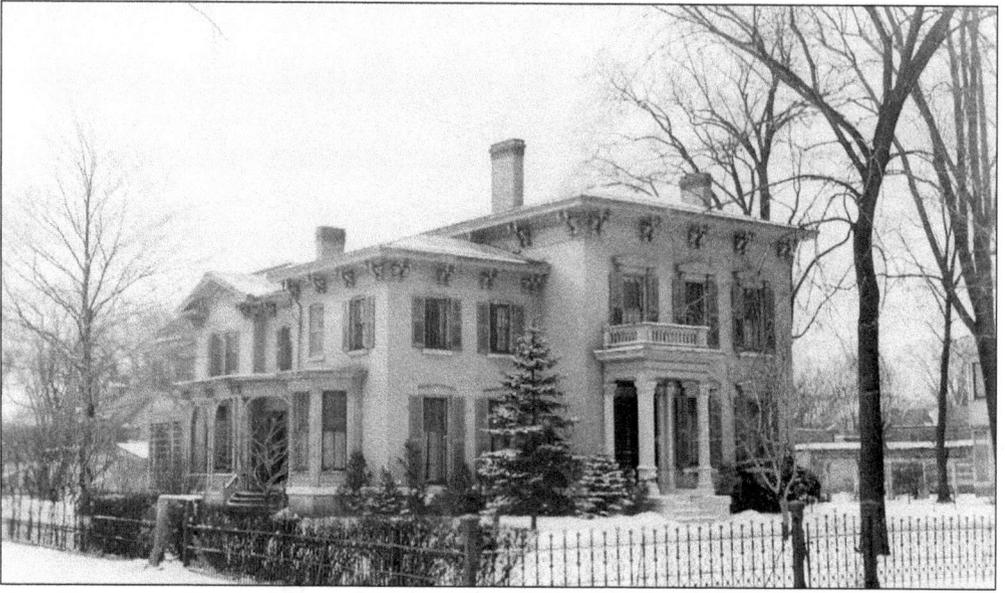

THE CORNELIUS REUBEN SNELL HOME. The Snell home, located at 245 North Main Street, was built in 1836 for Dr. Andrew Doolittle, a prominent Herkimer physician. The handsome brick house featured the Federal-style architecture popular for that time. In 1883, the estate was sold to Cornelius Reuben Snell, owner of the lumber company C. R. Snell and Sons. The Snell family lived there until 1956, when the home was sold and razed to become Acme Supermarket in 1959 and eventually the Frank J. Basloe Library.

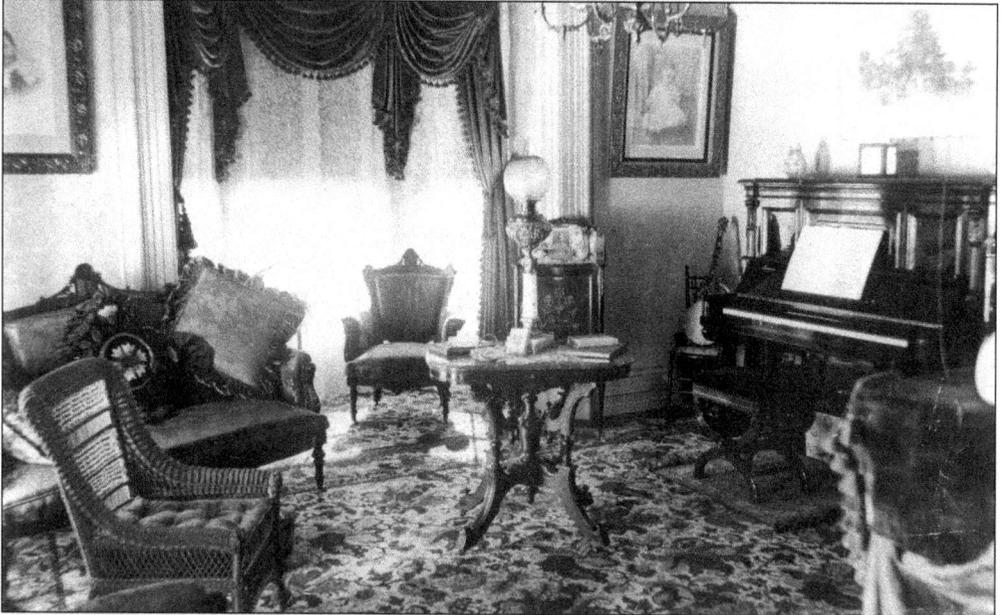

INTERIOR SHOT OF SNELL HOME. The Rose Room, pictured here in 1890, served as a library and dining room for the Snell family, with beautiful oak panels and an ornate ceiling. Snell's son Cornelius Harry married Katharine Kinne of Ovid in 1917 and raised a family of four daughters, Cornelia, Julia Griswold, Katharine Kinne, Mary Harriet, and two sons, Cornelius Harry Jr. and George Birge. (Courtesy of the Snell family.)

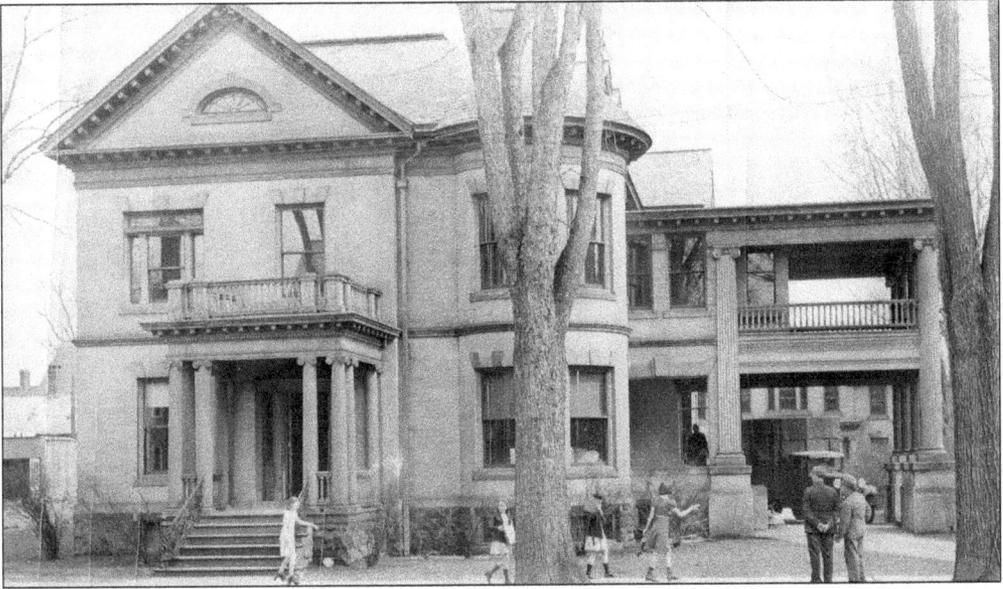

MICHAEL J. FOLEY HOME. Located at 112 Mary Street, this home belonged to one of Herkimer's self-made success stories. Michael J. Foley started his career as a carpenter, working with William Horrocks to make cabinets for typewriters under the firm name Horrocks and Foley. He became president of Standard Furniture Company; under his leadership, it became the largest desk manufactory in the world. The home was purchased in 1943 by the Herkimer Elks Lodge No. 1439 and replaced by the present Elks building.

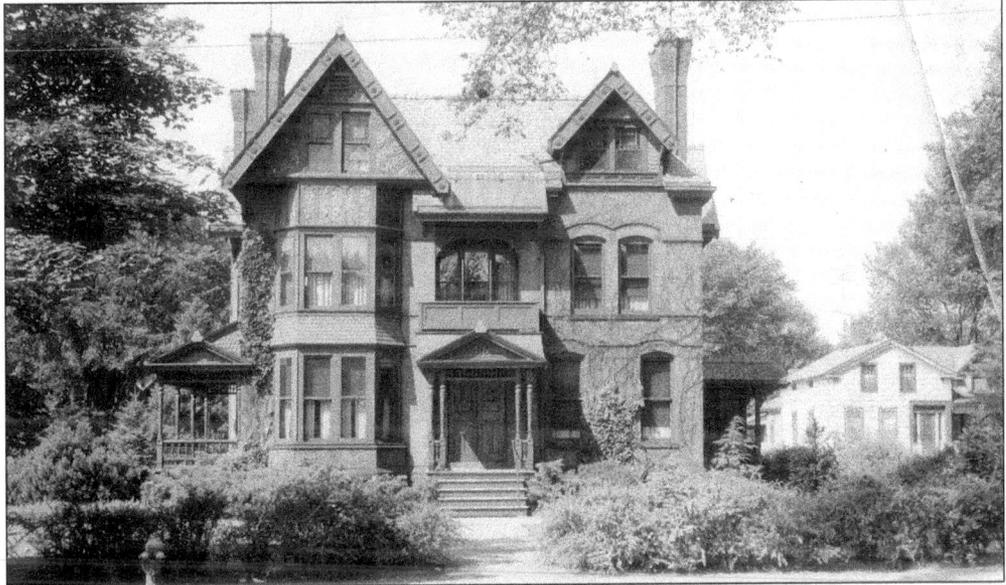

HENRY MARCUS QUACKENBUSH HOME. The home of one of Herkimer's best-known inventors, Henry Marcus Quackenbush, this large, redbrick Victorian mansion was built in 1886 at 219 North Prospect Street across the street from the H. M. Quackenbush Company factory, and Quackenbush only had to walk a few yards to his business. A spacious lawn surrounded the home, and when the home was razed to make way for the new building of the Savings Bank of Utica, a large magnolia tree from his yard still stood behind the bank.

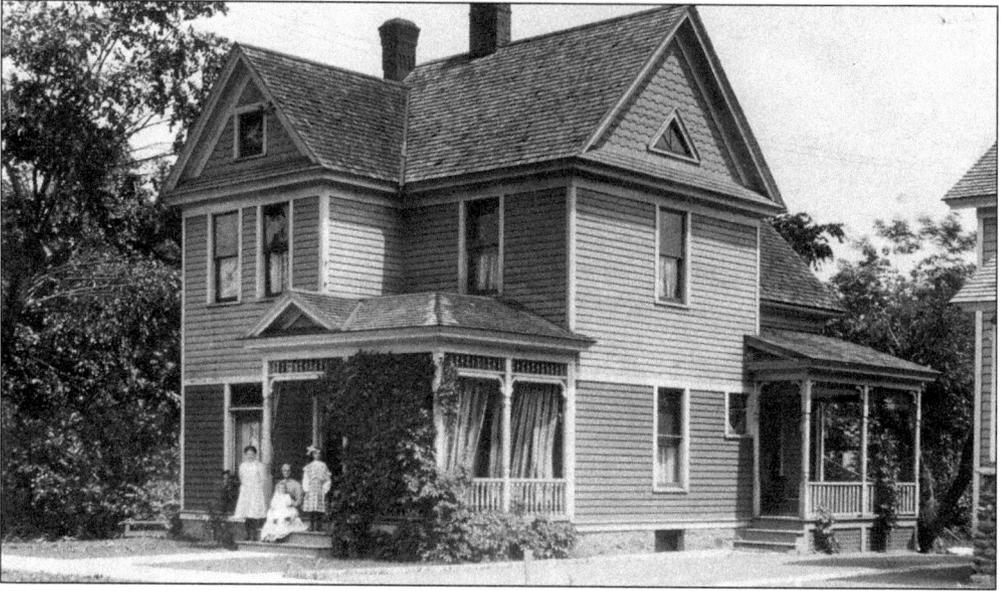

WILLIAM A. PIERCE HOME. Well known throughout the Mohawk Valley, William A. Pierce made his home at 210 Green Street. He conducted a prosperous newspaper, tobacco, and candy business in the Tower Block on North Main Street for many years and, at one time, owned and operated the Adirondack Hotel at Fourth Lake. In his later years, he served as the justice of the peace and police judge of Herkimer. Identified in the picture is William Pierce Jr. on his grandmother's lap. (Courtesy of Meta Pierce Campbell.)

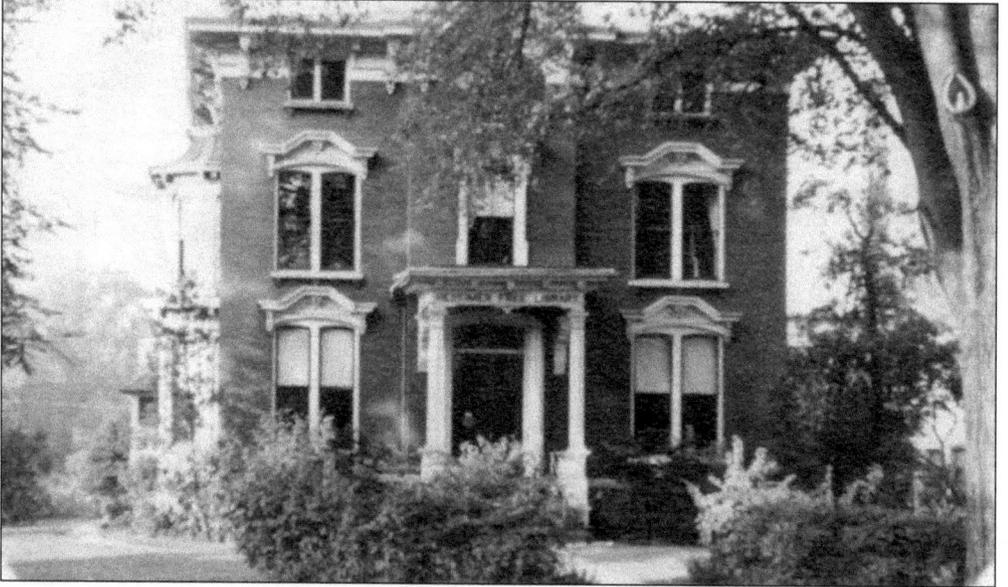

ROBERT EARL HOME. This Italianate-style building was constructed in 1874 as the home of Judge Robert and Juliette Earl on North Main Street. In 1895, the Earls gave the property to the village to serve as a library, with a donation of 2,000 books. The Herkimer Free Library (now the Frank J. Basloe Library) was located here from 1896 until 1975, when it moved to its present location. This building also housed the Herkimer County Historical Society from 1896 until 1938. It is now the Rotunda building.

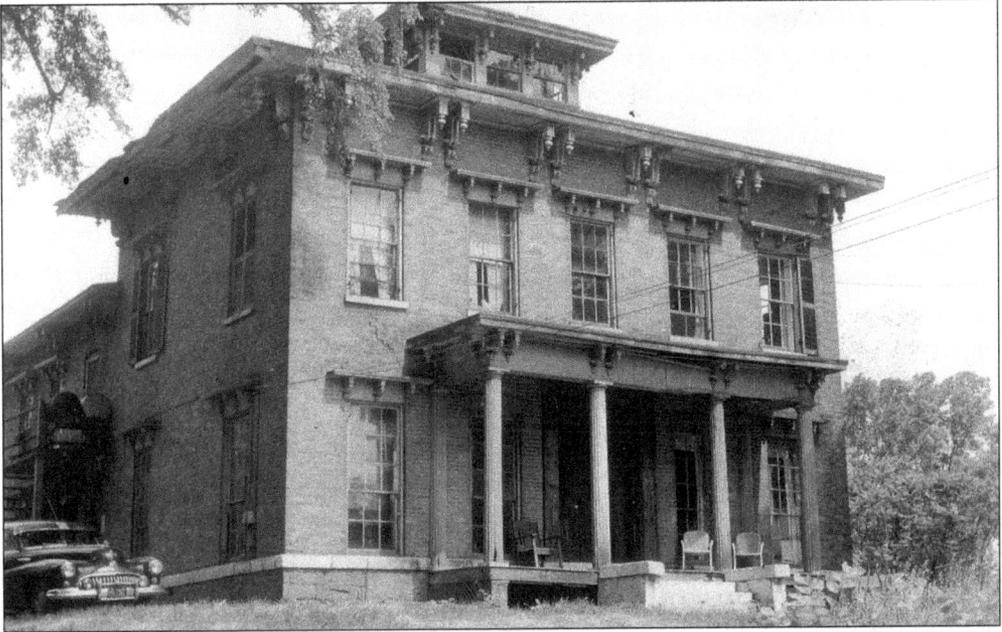

GEORGE W. PINE HOME. George W. Pine, a local author, shop merchant, and farmer, built this two-story brick home at 640 West German Street for his wife, Lucy, around 1859. After his death, the property became a real estate development known as Maple Grove Farm. Pine Street, named for Pine, was renamed Dewey Avenue after Adm. George Dewey's victory at Manila Bay during the Spanish-American War. Today the home, along with the old Hale Manufacturing building, is known as Brookwood Apartments.

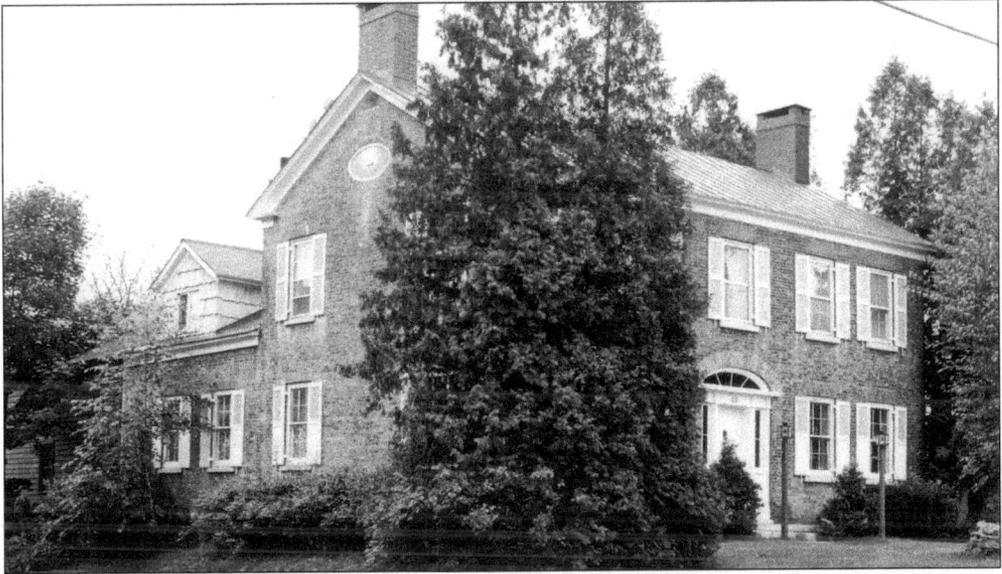

JOHN F. HELMER HOME. One of the oldest homes in Herkimer is this almost two-century-old brick dwelling at 619 West German Street, built by John Helmer around 1815. In 1837, the property changed hands to Christopher Bellinger. His wife, Anna Margaret Weber was the daughter of Jacob Weber, also known as "King" Weber of Colonial times, who established a profitable business trading with the Native Americans. It later was the home of Judge Irving Devendorf and Ralph Gorthy.

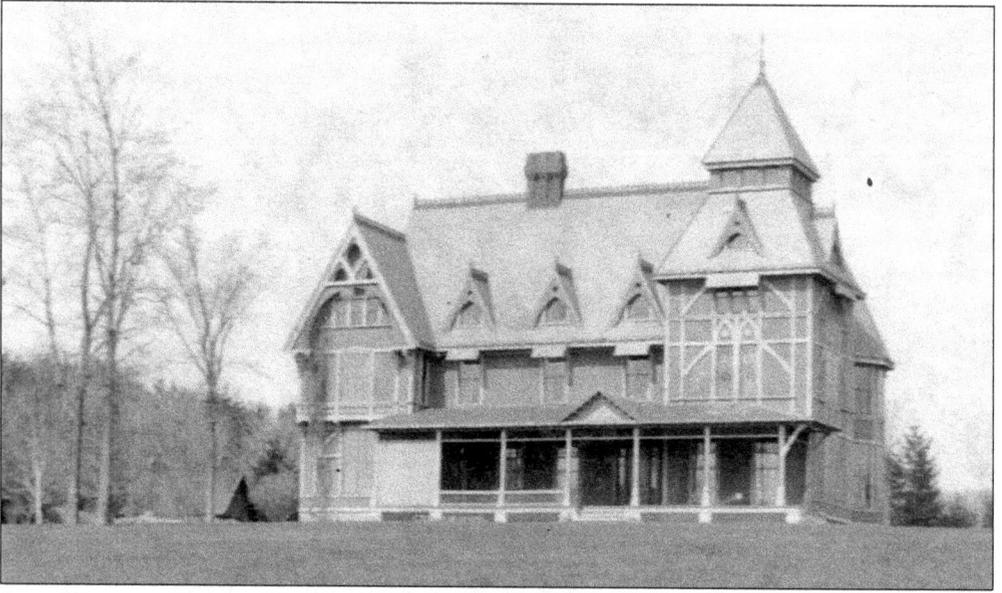

SEN. WARNER MILLER HOME. This magnificent mansion on Oak Hill, built in 1877, was the home of Warner Miller, a Herkimer businessman and United States senator. The home welcomed guests such as Susan B. Anthony and Gen. John Logan. After Miller's death, the building became a summer hostelry operated by Everett Dibble but was destroyed by fire in September 1930. Today Oak Ridge Free Methodist Church stands on the site. The carriage house of the home survived the fire and is used now as an apartment building.

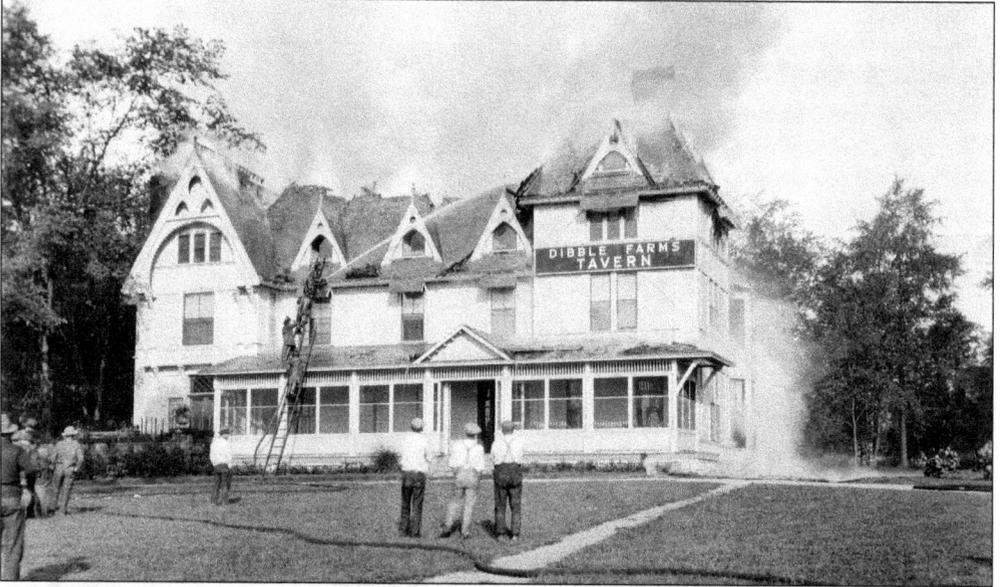

FAMOUS LANDMARK BURNED. The Miller home burned in 1930 while being operated as the Dibble Farms Tavern. While the fire burned in the upstairs part of the home, the senator's daughter Augusta Hildreth and her daughter Carolyn, assisted by volunteers, rescued some of the most valuable pieces of furniture. By the time the fire was put out, only the first floor remained. The Dibble Farms Tavern had come to be one of the chief meeting places in this part of the state for gatherings.

30

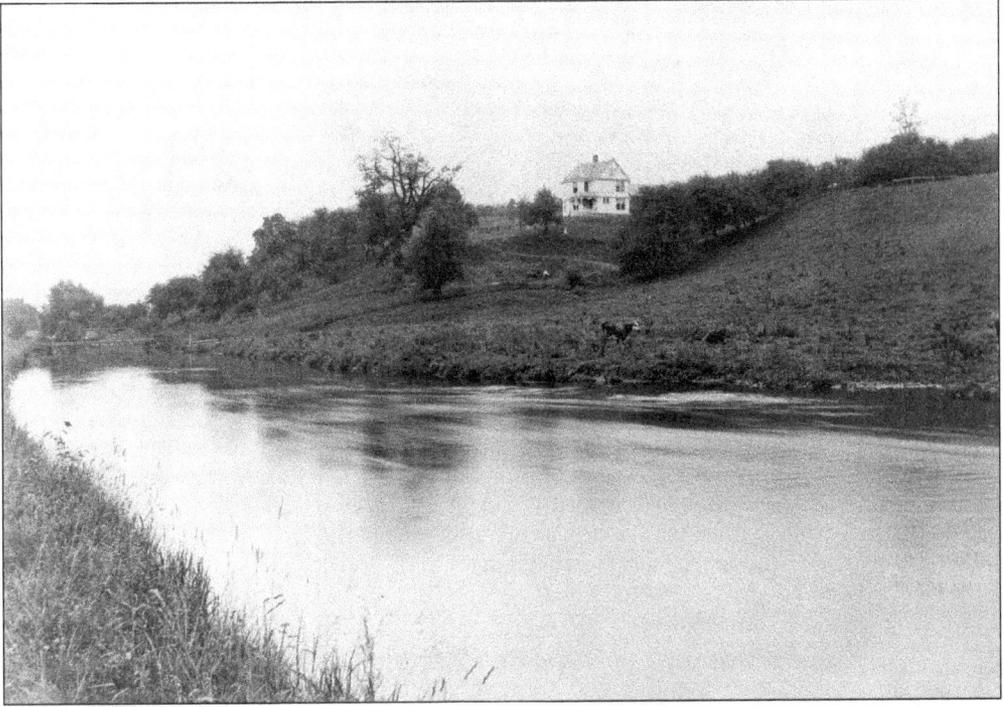

ALVIN EVANS HOME. Hillcrest is the name that was given to this home, which sat isolated on a hill overlooking the Hydraulic Canal and Highland Avenue. It was the only home built in that section of town between 1904 and 1906 and was owned by Alvin and his wife, Margaret Munson. Evans was an engineer for the state department, overseeing improvements to the Erie Canal in Herkimer and Mohawk. They had two sons, Archibald and Munson. After his wife died in 1921, Evans moved to Norwich, where he accepted a position as city engineer. Highland Avenue was a dirt road at that time and can be seen in the photograph to the right. The Hydraulic Canal can be seen in the photograph above. The home today has not changed much and remains a residence. The surrounding area has changed, with trees grown up and homes below. (Courtesy of Edith Evans Seveny.)

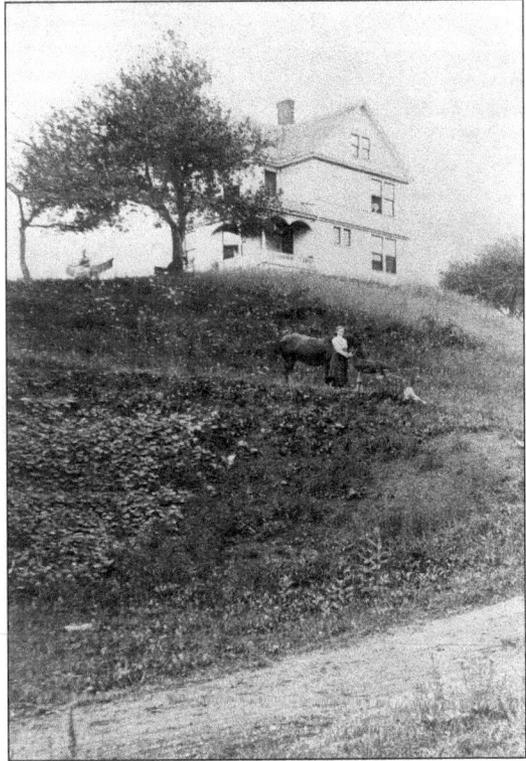

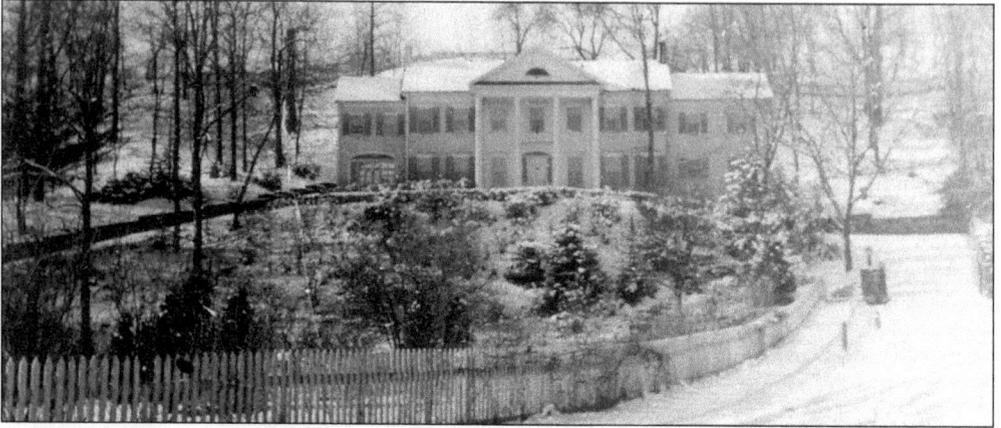

GEORGE W. SEARLES HOME. Built in the 1920s, the home of George W. Searles, president of National Desk Company for 25 years and brother-in-law of Henry G. Munger, sits on the hill facing West German Street between Henry and Margaret Streets. The living room spanned the house from front to back, with a view of the village from the large front window and water pouring from a lion head into a fountain on a stone wall in the back. It had gated entrances from both Henry Street and Margaret Street. (Courtesy of Marion Morse.)

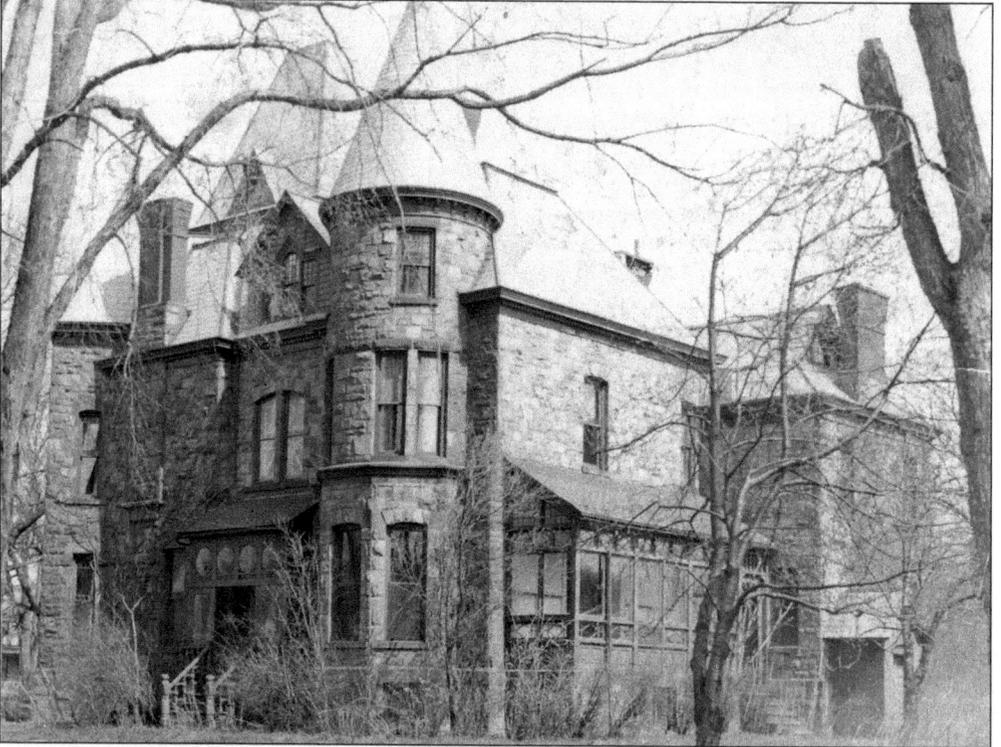

MORRIS MARK MANSION. This mansion, located at the corner of North Prospect and Church Streets, was built in 1885. Morris Mark owned a very successful mill on the east bank of the Hydraulic Canal that featured a dynamo allowing the new house to be the first electrically lit in Herkimer. Its ornate interior featured jeweled Tiffany windows and ornate woodwork. It stood empty from 1936 to 1946, when it was purchased by realtor Frank Basloe, who deeded it to the Temple Beth Joseph congregation to build a temple on its site.

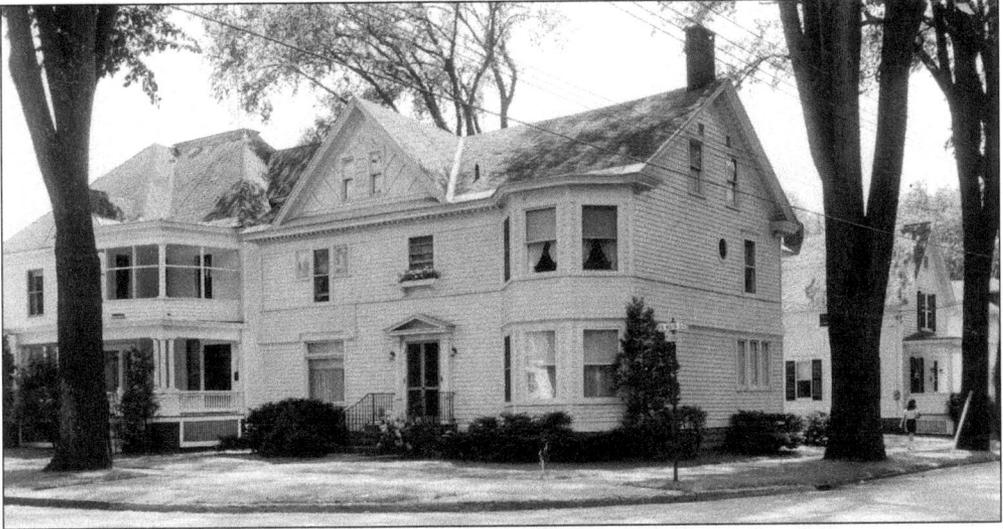

WILLIAM HOMYK HOME. Two friends built two houses, and the first to marry had the house of his choice. This home was built around 1789 by attorney Gaylord Griswold and Dr. James Ferrill; Griswold was the first to marry and brought his bride to this house on the corner of Main and Mary Streets. The house had several owners, including the Episcopal Church, before it was moved up the street by Capt. Horatio Witherstine. In 1908, it was moved to its present site at West German and North Main Streets and became the home of William Homyk.

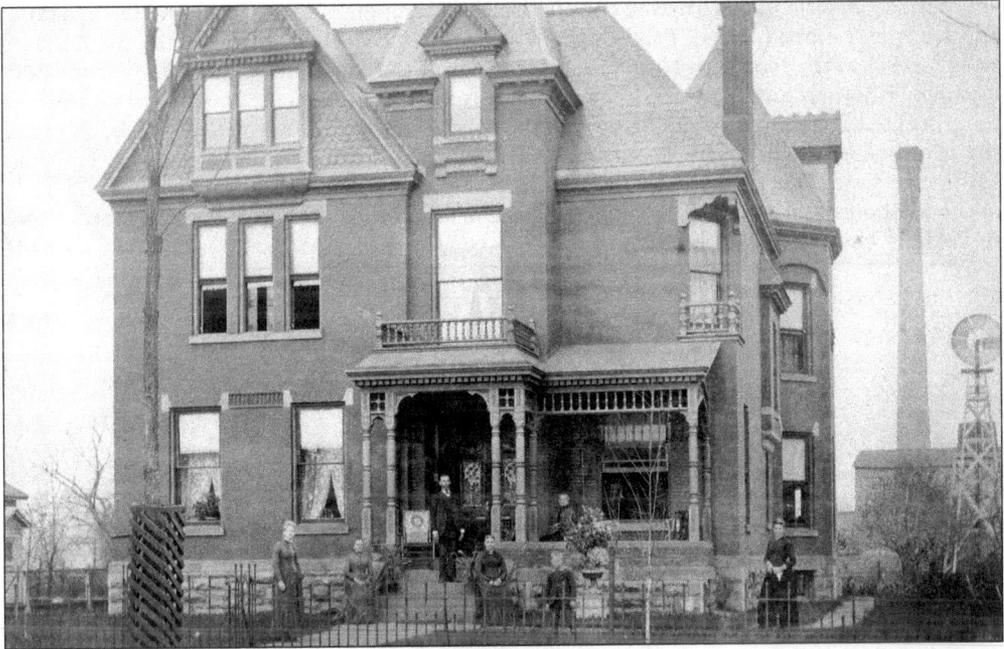

HASLEHURST-CURTIS HOME. Alexander Haslehurst and his wife, Iola, lived in this ornate brick mansion on 122 North Washington Street in the early 1900s. He was president of Herkimer First National Bank until his death in 1909. Their daughter Florence inherited the home and lived there with her husband, Raymond Curtis, until it became part of the Folts Mission Institute property after 1921. The home was razed so that the present Wakeman wing of the Folts home could be built in 1961. (Courtesy of Meta Pierce Campbell.)

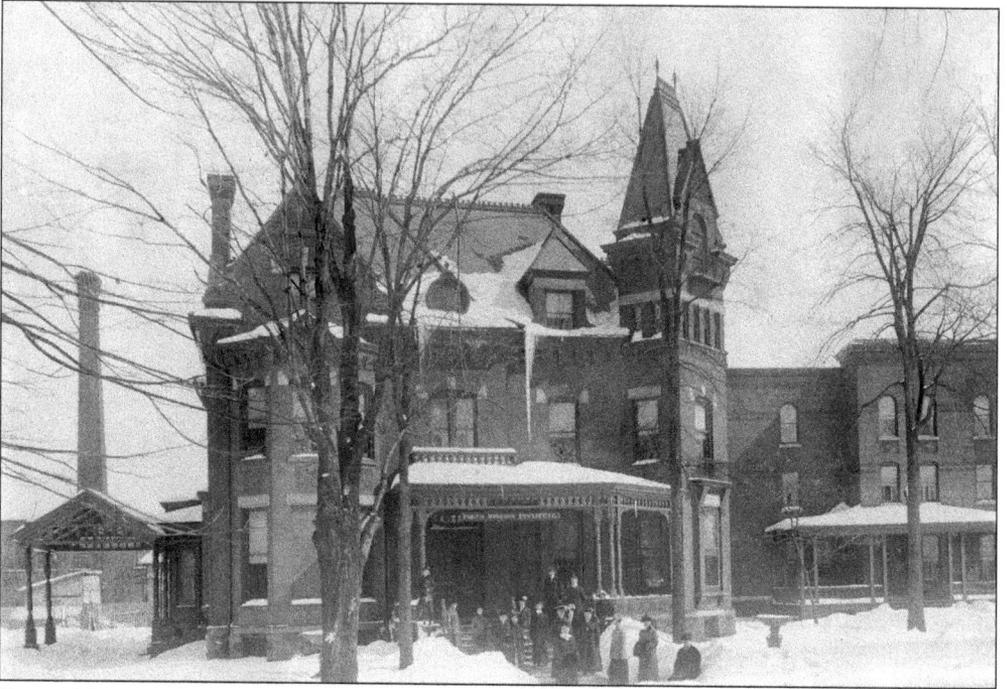

FOLTS MISSION INSTITUTE. The mansion that became the Folts Mission Institute was built around 1868 by John and Catherine Folts on North Washington Street. Their son George Philo and his wife, Elizabeth Snell, lived in the home until 1883, when they donated the building and property to the Northern New York Conference of the Methodist Church for a missionary institute. Another building (now known as the Tucker building) was constructed in 1892 for the institute. A section of it can be seen in the photograph below on the left. The buildings to the right housed professors for the institute. The Mark Mill can also be seen nearby. The Folts Mission Institute later came under the jurisdiction of the Women's Foreign Missionary Society of the Methodist Church in 1914 and then became established as the Folts Home for the Aged in 1943. (Below, courtesy of Jim Greiner.)

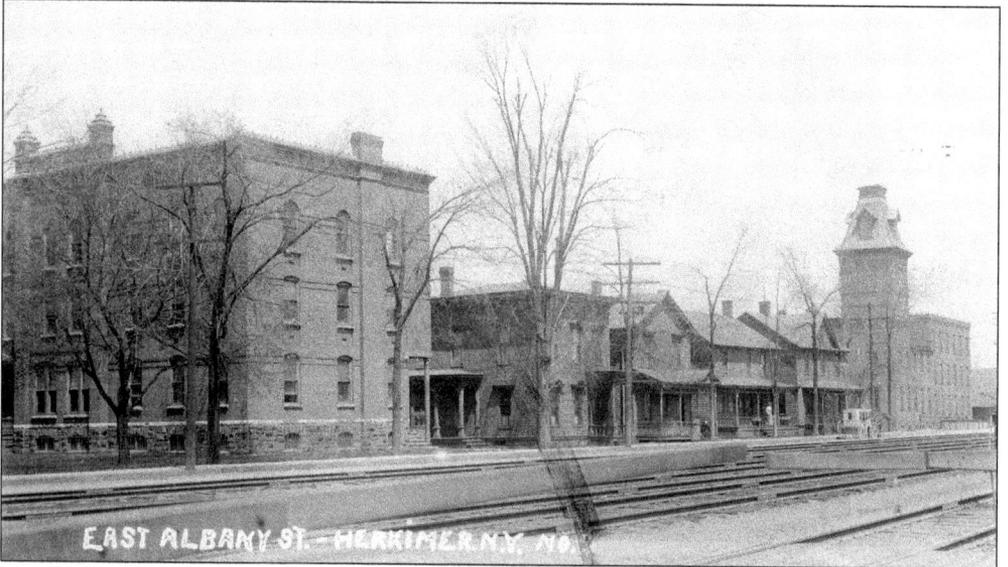

MUNICIPAL HALL. The Village of Herkimer board met for the first time on August 21, 1905, in the new municipal building constructed that year on Green Street. Also located in the building at that time was the police department, a kindergarten class conducted by Emily Stout, and the fire department. It was razed to make way for a new municipal building in 1991. The stately clock tower that graced the top of the original structure was saved and placed atop the new village offices. (Courtesy of Jim Greiner.)

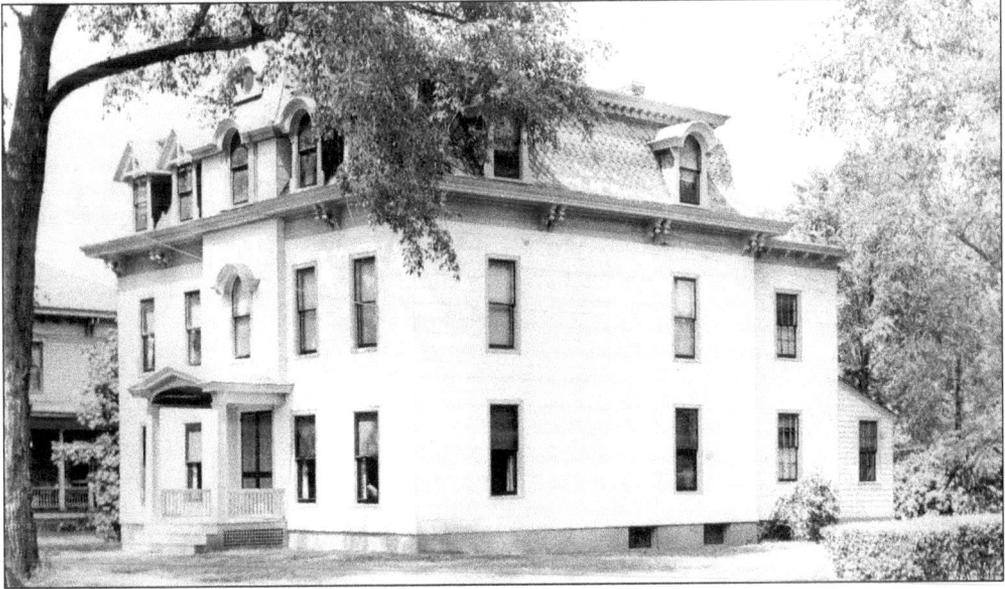

KNIGHTS OF COLUMBUS. The Knights of Columbus opened a chapter in the village of Herkimer in 1901, meeting first in the Manion Block and later purchasing the Burgess property at 241 North Main Street. Patrick Dineen was the first grand knight and F. Arthur Fagan the first deputy. In 1938, the Catholic fraternal society purchased the 214 North Washington Street home of William B. Howell, who operated a furniture and undertaker business there. The building today is the home of Adirondack Bank, which opened its branch in 2003.

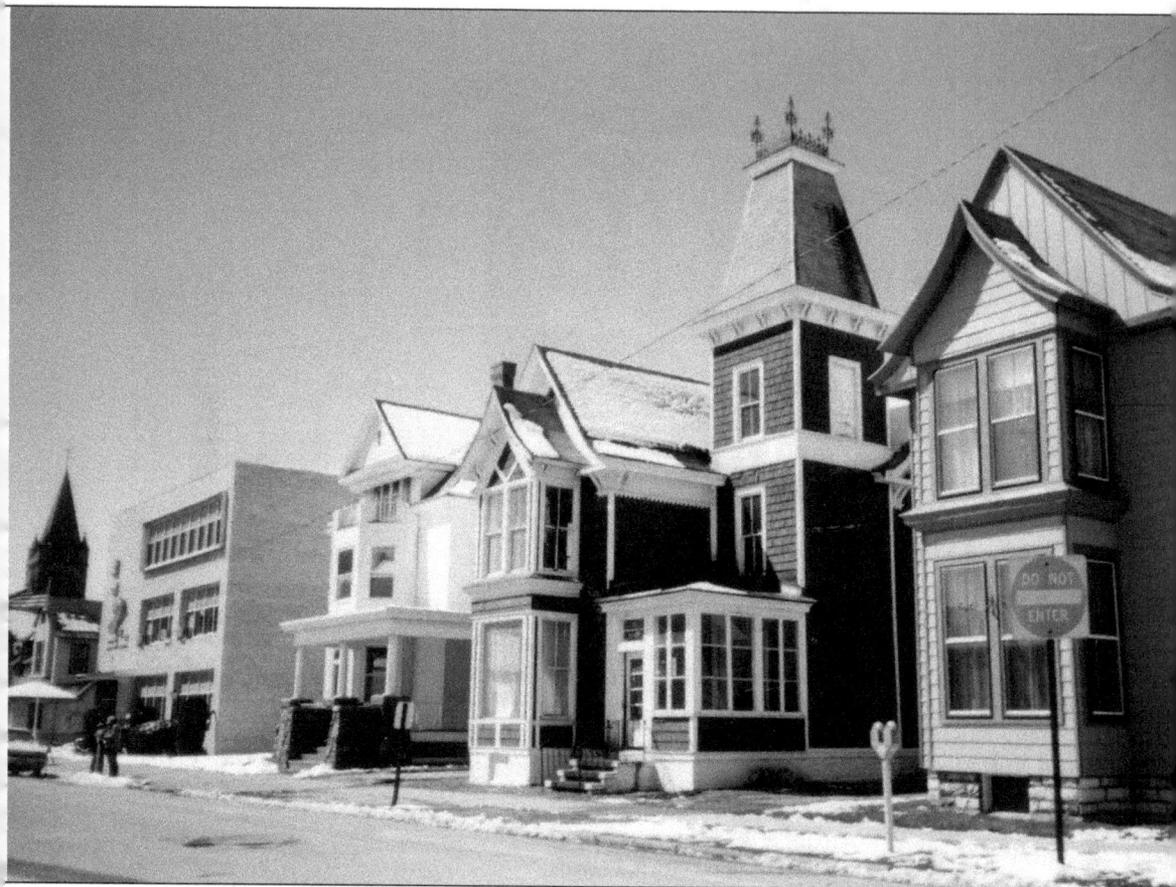

MARY STREET BUILDINGS. Even the youngsters will remember this view of Mary Street in 1997. From left to right are Christ Episcopal Church, the Herkimer County office building, Dr. Harold Golden's home and office (later the mental health department office), Philip O'Donnell's law office, and the Mohawk Valley Abstract Corporation. The last three buildings were taken down soon after this picture was taken to make way for a park displaying flags, representing the county's 19 towns and one city, and the new Herkimer County office addition.

Three

NOTABLE EVENTS

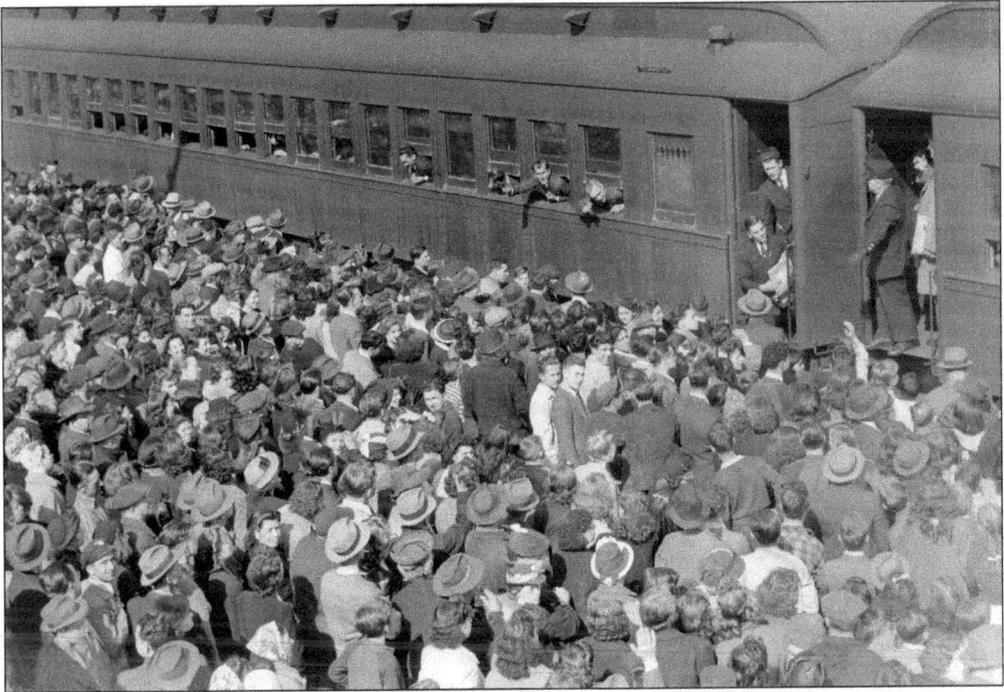

HERKIMER'S LARGEST DRAFT CONTINGENT. On April 24, 1942, less than five months after the bombing of Pearl Harbor, the largest draft contingent from this area boarded a train at the Herkimer railroad station. More than 2,000 people lined Main Street to see the men march to the station where another 2,000 or more family members and friends were gathered. The Herkimer High School band played "The Star-Spangled Banner" as the train left for Utica.

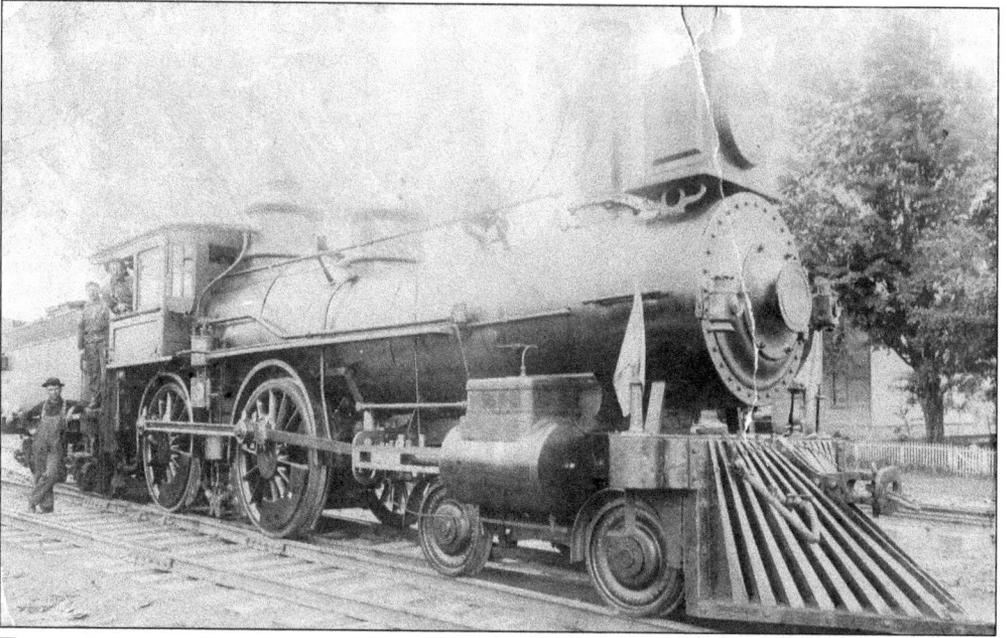

TRAIN ACCIDENT. Dan O'Donnell leans out the window of Engine No. 473 (above) that was in a train accident on the Mohawk and Malone Railway, which followed the west bank of the West Canada Creek from Herkimer to Middleville and northward. On January 6, 1899, as No. 473 was crossing a trestle over the West Canada Creek heading to the water station just east of the village, the trestle gave way, and John Brennan, Andrew Moore, and Will Brown were thrown into the raging water (below). Brennan and Brown were able to swim to shore, but Moore, of Eureka Avenue, was caught between the cab of the engine and the tender and was killed. An estimated 5,000 people braved the bitter cold to watch wrecking crews raise the nearly submerged locomotive. Moore's body was not recovered until spring.

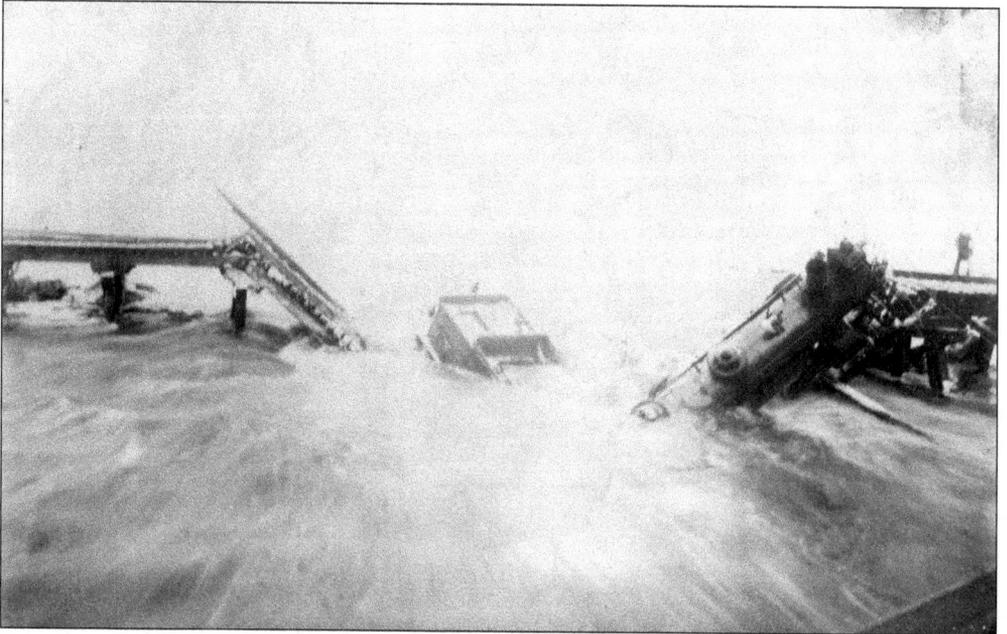

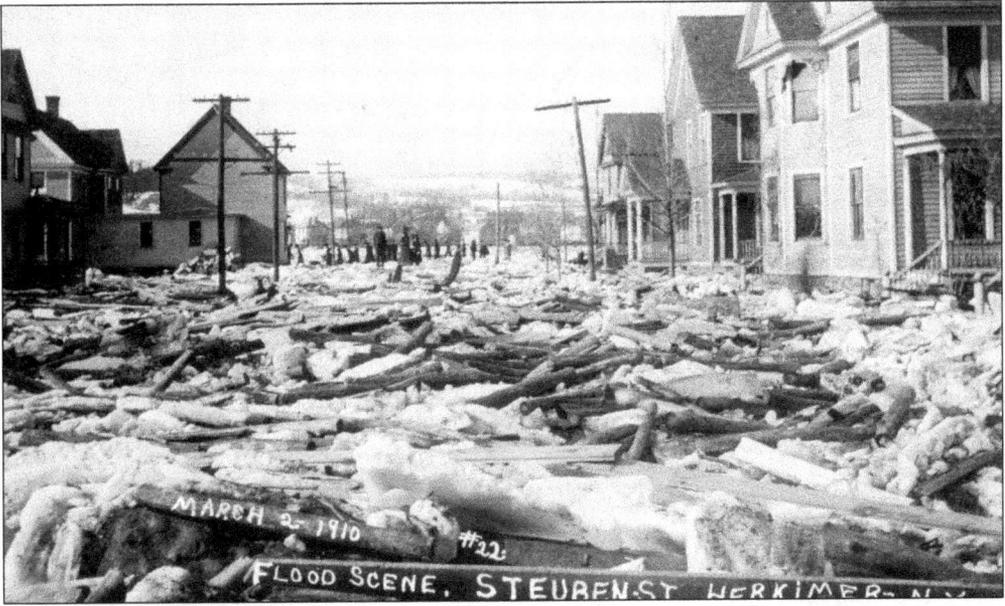

THE GREAT HERKIMER FLOOD. The Herkimer flood of February 28, 1910, was the result of giant blocks of ice and freezing water choking the West Canada Creek, making it break out of its banks and roll into town, extending floodwater all the way to Bellinger Street. Pictured is Steuben Street littered with blocks of ice and debris on March 2.

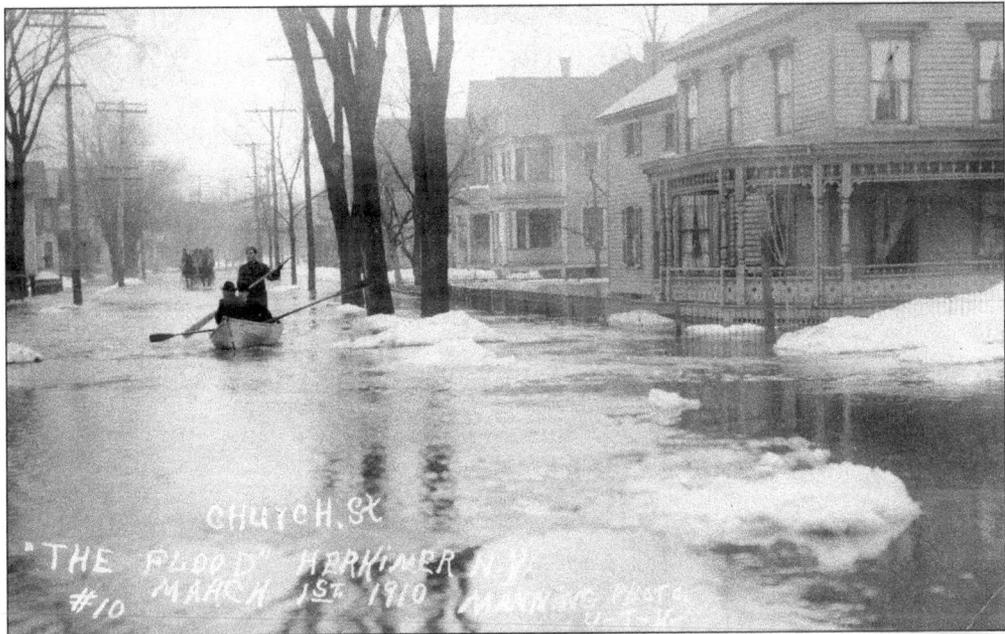

ROWBOATS ON THE STREETS. Rowboats were the recommended form of transportation on Church Street, as seen here, during the great flood of 1910. Most of the homes in the usually safe high-ground areas experienced flooding. The great ice jams had to be dynamited, drawing a great crowd of onlookers, and the only fatality caused by the flooding was observer Michael Roscop, who was struck on the head by a large piece of ice following one of the blasts. (Courtesy of Joe Putnam.)

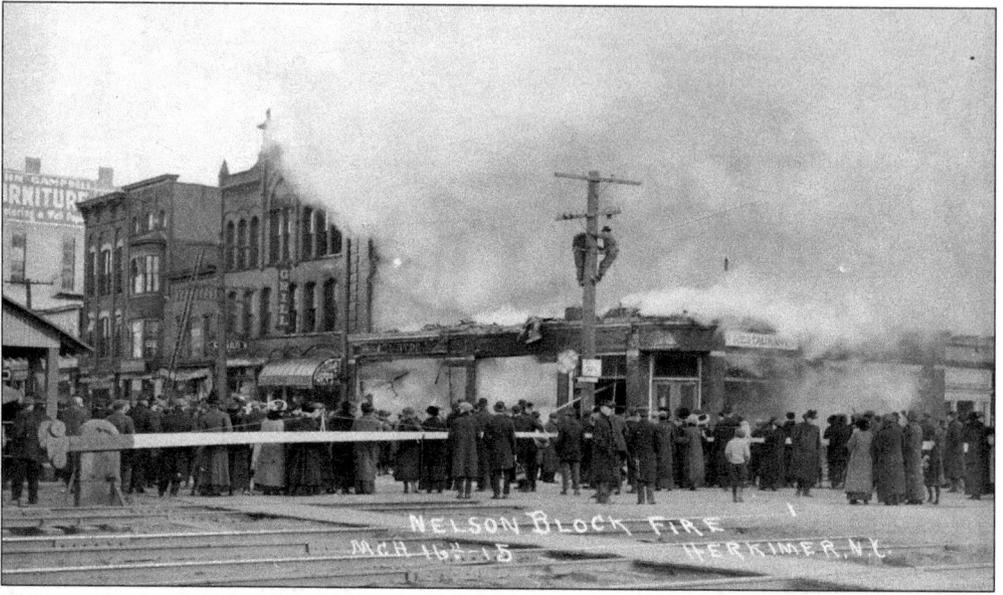

NELSON BLOCK FIRE. A fire destroyed one of the most notable blocks in Herkimer, located on the corner of East Albany and North Main Streets, on March 16, 1915. The fire spread rapidly, destroying the businesses located within the structure, such as P. J. Dinneen's men's clothing, Charles Lombar's café, Marshall Hyde's Ladies Store, and apartments, including the residence of the building's owner, John H. Nelson. It was immediately rebuilt and was the second in the village to have a reinforced concrete floor.

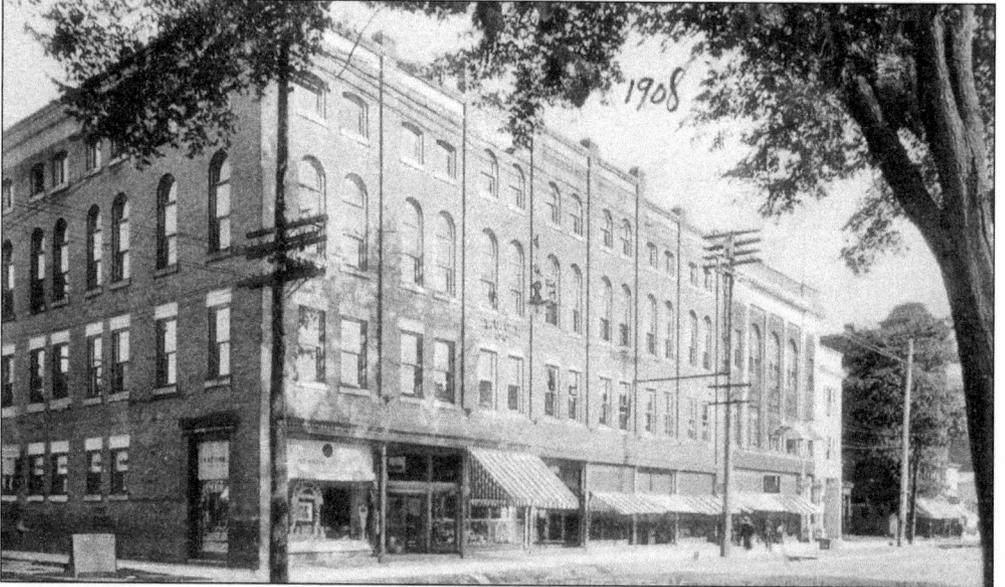

EARL BLOCK. This postcard picture taken in 1908 shows the Earl Block and Masonic temple before the major fire in 1917. These buildings were built on the corner of Green and North Main Streets in 1898. The Earl Block housed Whitehead's Pharmacy (later Gallinger's), Model Clothing Company, and several law offices. The Independent Order of Odd Fellows (IOOF) had its temple on the third floor. The Masonic temple housed the H. G. Munger store on the first floor.

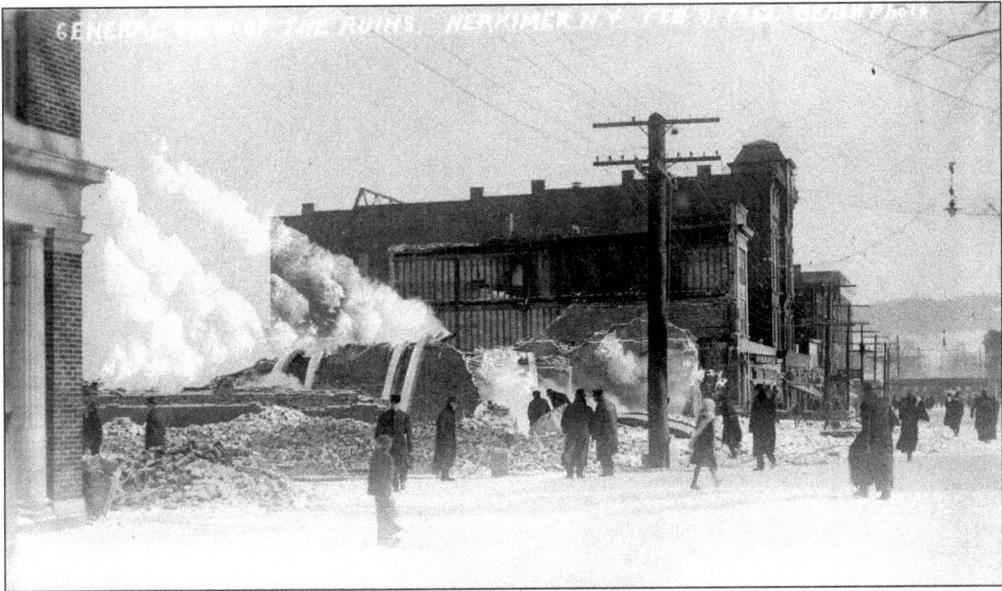

EARL BLOCK FIRE. One of the worst blazes in the village's history was the Earl Block fire, which took place on February 9, 1917. It started from an explosion in the basement of the H. G. Munger store. The fire destroyed three business blocks, which included the First National Bank, Masonic temple and the Grange, the *Evening Telegram* plant, law offices, and other professional offices and apartments. The estimated loss was at least a half-million dollars. (Courtesy of Jim Greiner.)

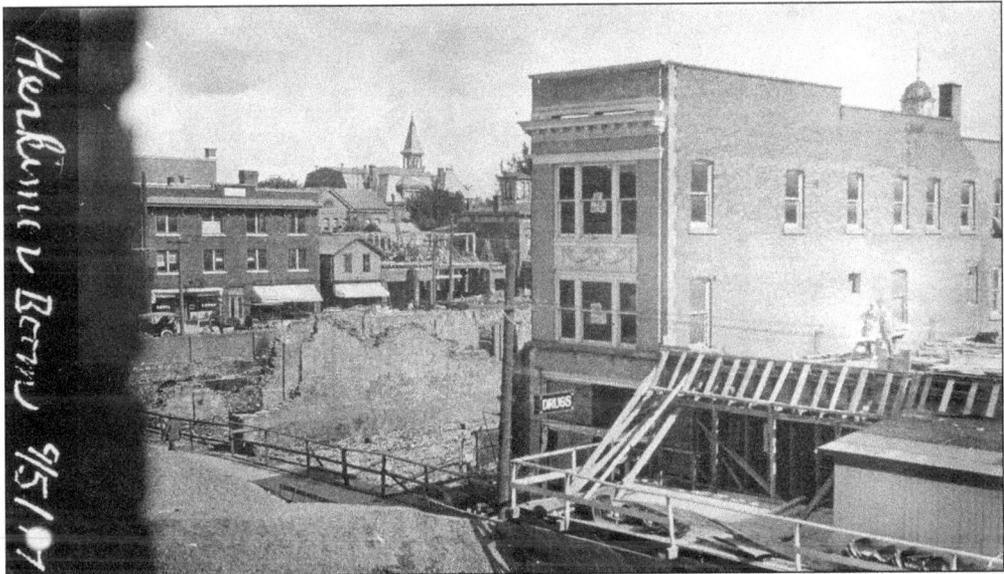

EARL BLOCK RECONSTRUCTION. This photograph shows the Earl Block being rebuilt after the fire. From the ruins, fine new buildings arose, including the First National Bank; the Liberty Theatre building; the In and Out shop run by George Out, which sold candy and newspapers and had a slogan of "Look In and See Out"; the Hines building, which housed Gallinger Drugs; and the H. G. Munger Department Store. (Courtesy of Bob Murphy.)

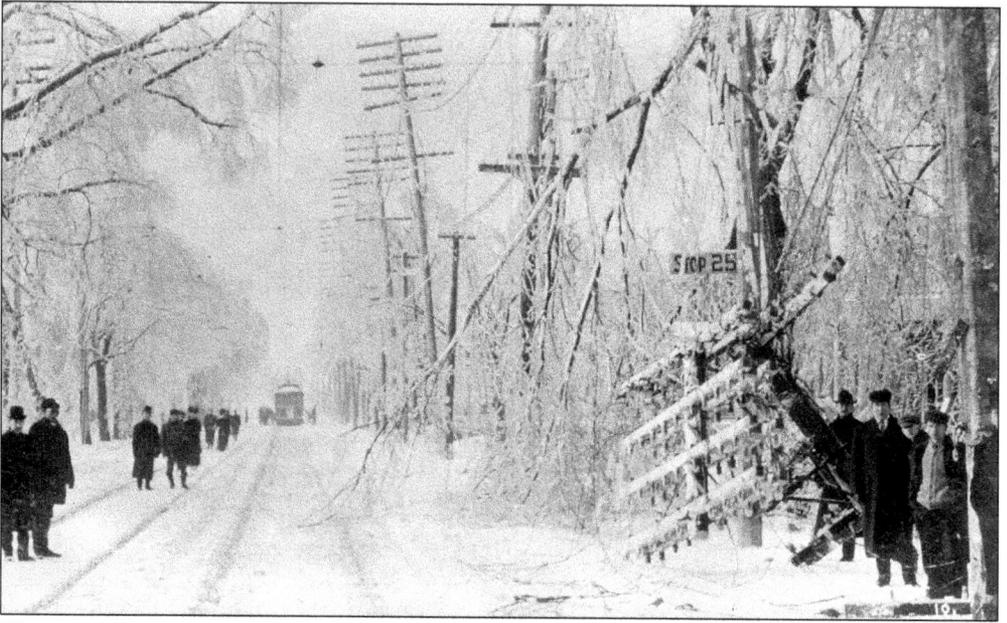

WINTER STORM IN 1909. In February 1909, one of the worst winter storms hit the Mohawk Valley, covering the area with sleet and snow for several days. Trees and power lines were downed, causing havoc for Herkimer's residents. The falling sleet paralyzed train and trolley service, as it froze immediately on the rails. The trolley on Mohawk Street can be seen here, ground to a halt. (Courtesy of Jane and Don Bellinger.)

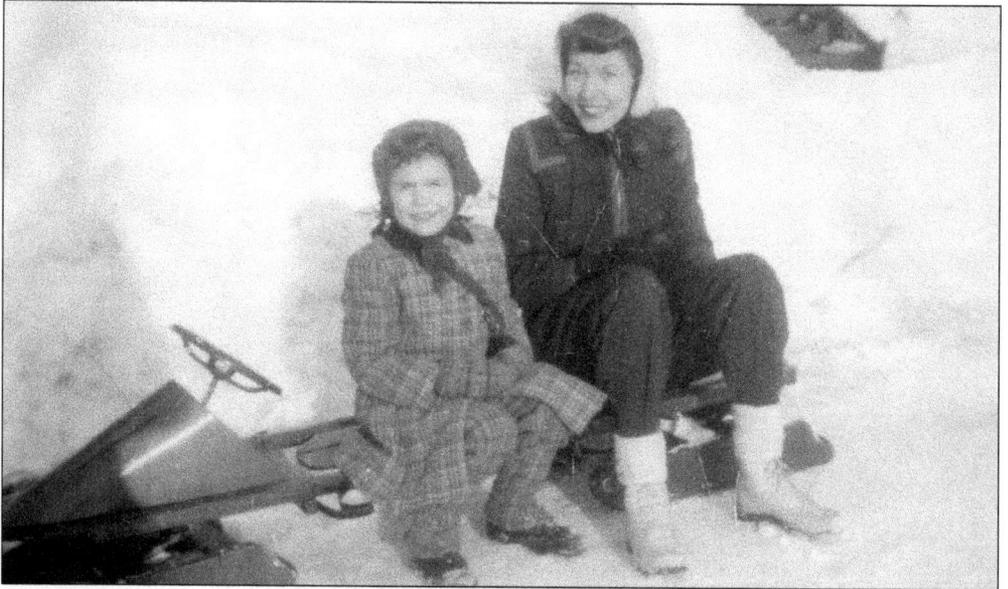

BOBSLEDDING IN HERKIMER. In the 1920s, bobsledding was a great sport using the snow-covered streets of the village. A bobsled was really two sleds secured to each other with one in front of the other. A long board was placed over the two to become the seat. Steuben Hill Road in Herkimer attracted large numbers of bobsledders. By 1930, automotive traffic made it unsafe to use a bobsled, and the sport was banned on village streets. Pictured are Margaret Pierce and her mother, Elsie. (Courtesy of Meta Pierce Campbell.)

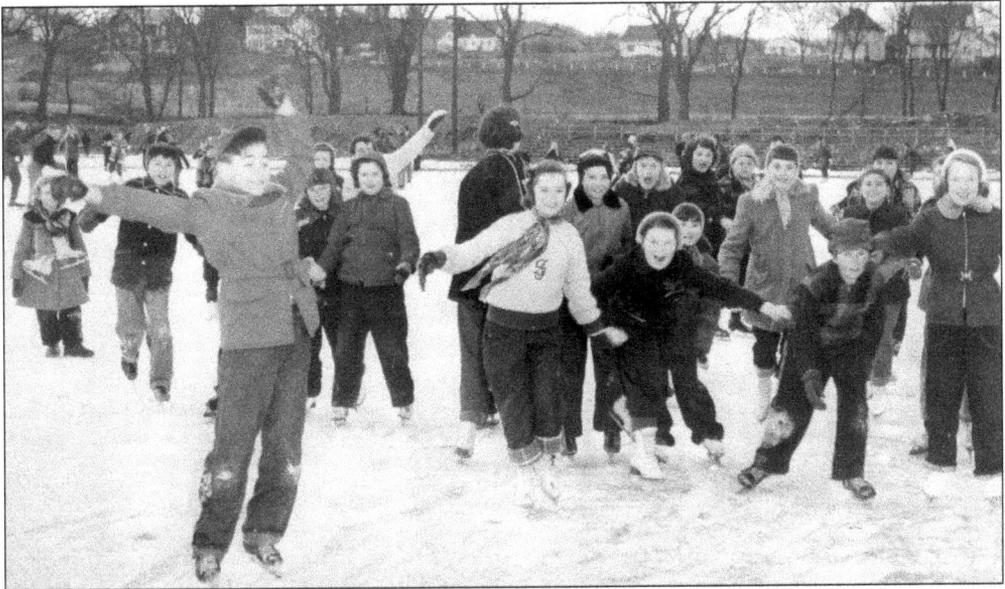

ICE-SKATING ON HARMON FIELD. Before Harmon Field, ice-skating on local ponds and lakes was very popular. Some of the older skaters used the Erie Canal between Little Falls and Frankfort. Harmon Field was named after an outside donor in 1924. William Harmon, a real estate businessman from New York City, set up 117 playgrounds in 34 states. Harmon Field was used all year long either as an ice rink or athletic field. The rink had a warm shanty, bright lights for night skating, and amplified music. (Courtesy of Edith Evans Seveny.)

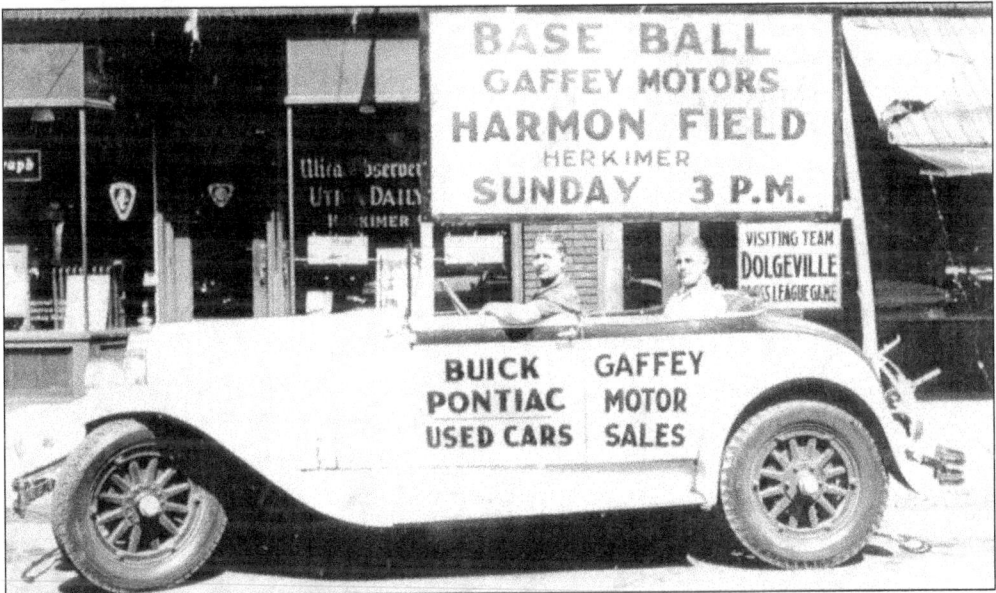

BASEBALL AT HARMON FIELD. Baseball was a hot sport locally, as can be seen in this picture taken about 1938. The *Utica Daily Press* sponsored the Press League, which attracted teams from Frankfort to Canajoharie and awarded a trophy to the winners. Pictured are manager Buster Syllaboch and pitcher Burt Masten of the Gaffey Motor Sales team in a 1928 Buick touring car. The hottest rivalry was between Herkimer and Dolgeville, which attracted great crowds to Harmon Field. (Courtesy of Henry Gaffey.)

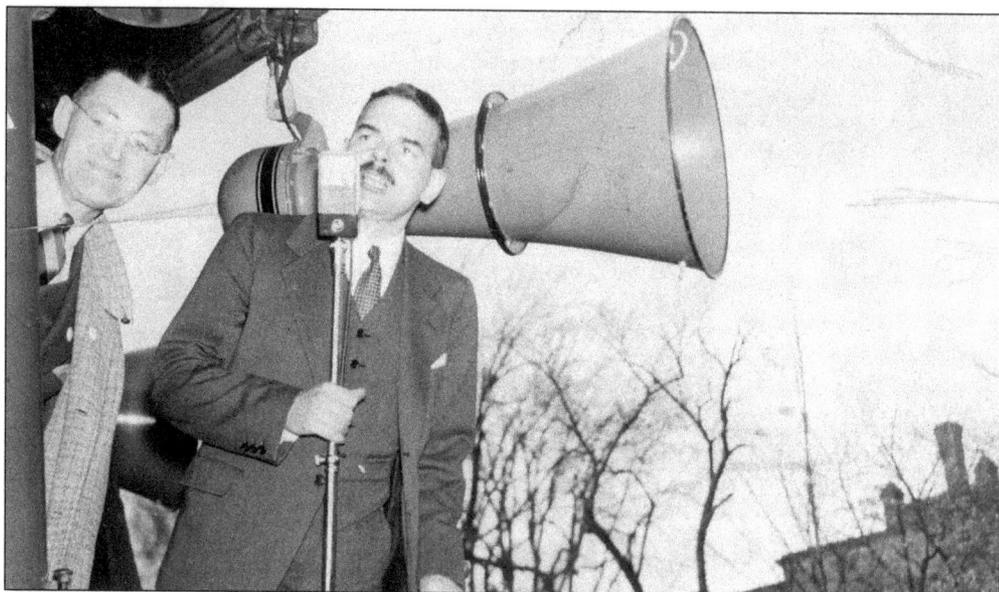

THOMAS E. DEWEY ARRIVES IN HERKIMER. On October 21, 1938, Republican Thomas E. Dewey made a whistle-stop on his campaign trip through upstate while seeking the New York governor's office. Dewey is shown here with Leo A. Lawrence, a local candidate for assemblyman. Dewey served three terms as governor after serving as a crime-busting district attorney in New York County. He was also an unsuccessful Republican candidate for president in 1940, 1944, and 1948. (Courtesy of Jim Greiner.)

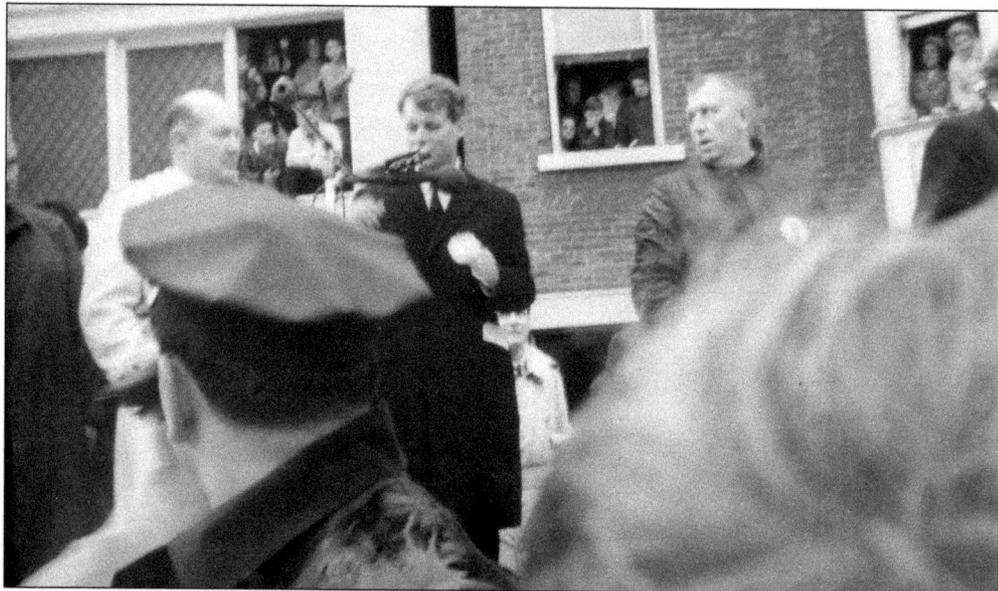

ROBERT KENNEDY VISITS HERKIMER. As part of his campaign to be the junior United States senator from New York in 1964, Robert Kennedy made a tour of Upstate New York. At each stop, he drew large and enthusiastic crowds. Although he mainly stuck to policy speeches, he delighted his Herkimer listeners by pointing out that he was the unemployed father of nine. This photograph shows Kennedy addressing the crowd on Albany Street. With him are Robert Castle (left) and Herkimer mayor Ted Pryor (right). (Courtesy of Mary Losito.)

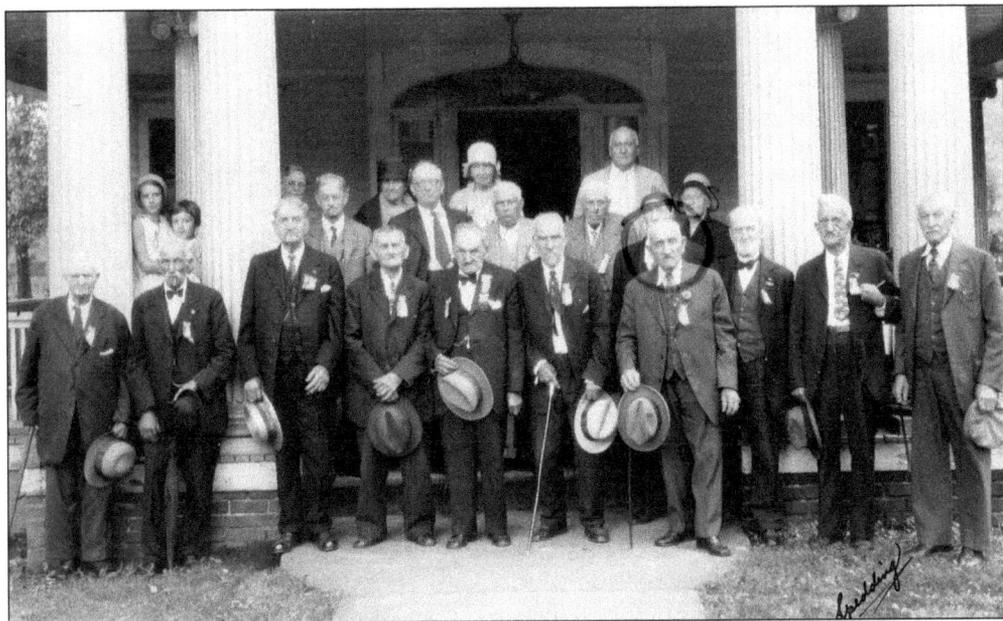

CIVIL WAR VETERANS REUNION. On August 27, 1931, the 2nd New York Heavy Artillery held its 51st reunion at the Down and Out Club in Herkimer. Seven of the still living survivors attended. They were Theodore Musson, president of the association; Benjamin Soules; Christopher Pierce (pictured with the circle around his head); John Waterman; James Whiting; Vedder Lasher; and Alton Cobb. (Courtesy of Meta Pierce Campbell.)

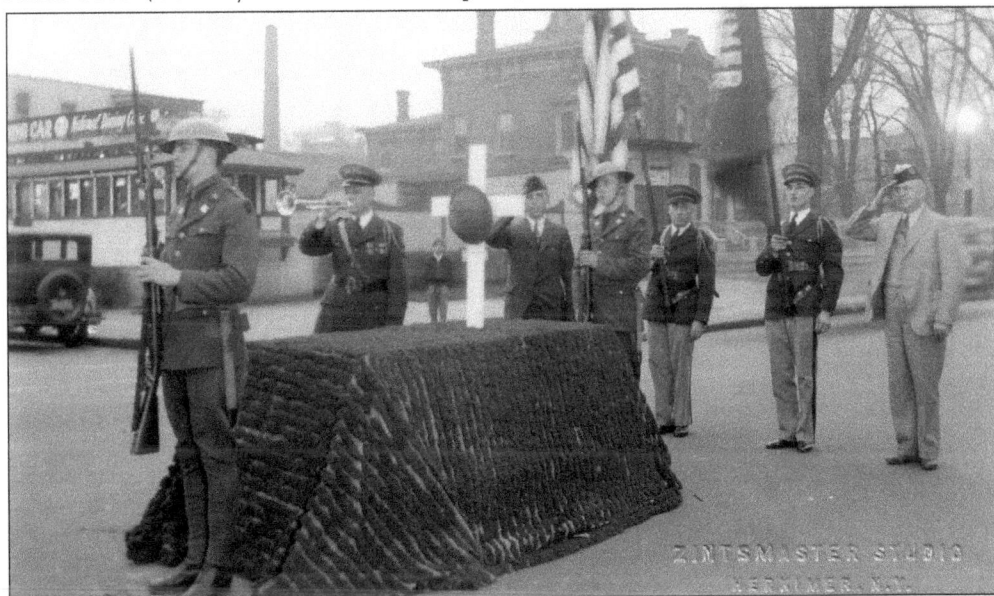

ARMISTICE DAY. The first Armistice Day (now called Veteran's Day) was proclaimed on November 11, 1919, by Pres. Woodrow Wilson, commemorating the end of World War I. People in Herkimer took time to remember the day, as shown in this photograph from about 1939. A catafalque was erected in the intersection of Main Street and Park Avenue, and solemn ceremonies were conducted by the Herkimer American Legion. Note the National Diner and the Herkimer Free Library in the background. (Courtesy of Richard Ruller.)

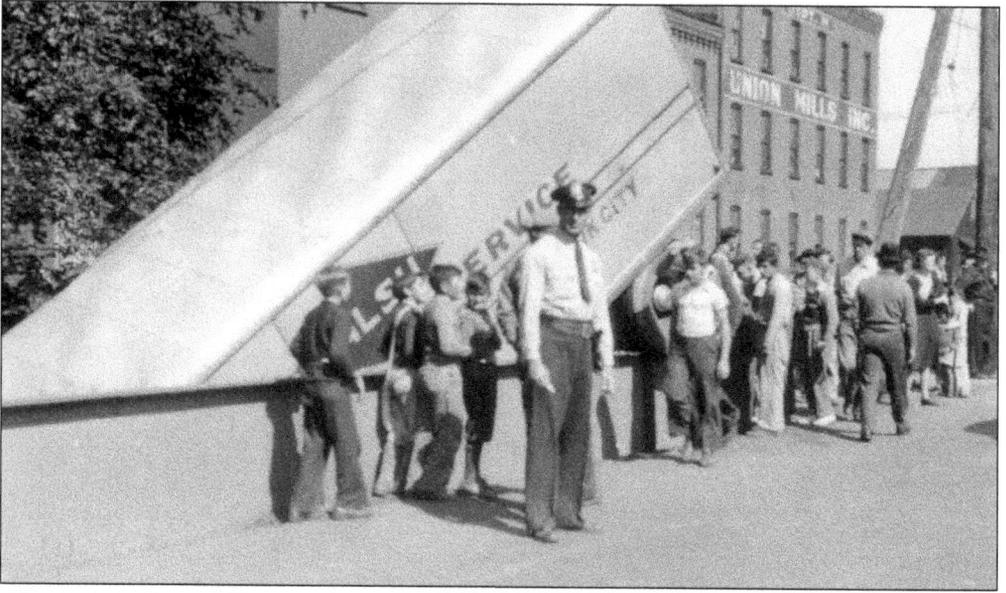

HYDRAULIC CANAL TRUCK ACCIDENT. Before the removal of the railroad tracks that cut through the village, Albany Street was Route 5. It was a narrow two-lane street that ran parallel to the railroad. In time, it became heavily used by tractor trailer trucks. On September 22, 1939, trucker Paul Heffelfinger from Hogansburg had trouble at the Hydraulic Canal on the "Bottleneck Bridge," located east of Washington Street, when he applied his brakes and they locked after he spotted a car on the narrow bridge. (Courtesy of Richard Ruller.)

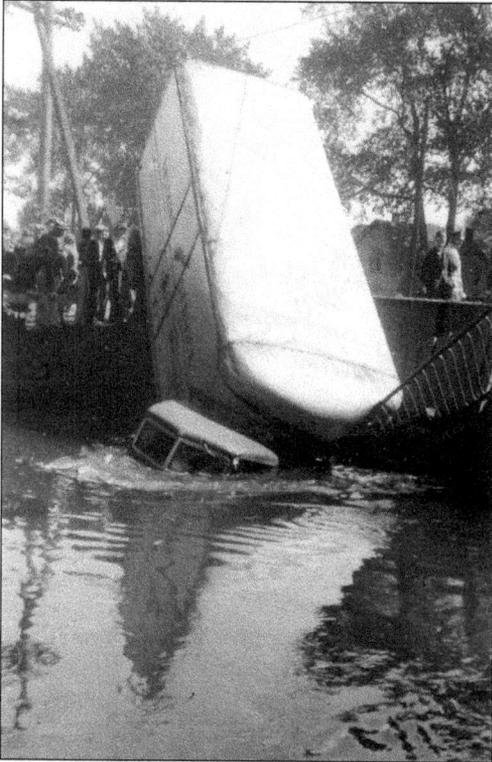

SUBMERGED DRIVER RESCUED. The tractor trailer plunged over the pedestrians' walk after crashing through the steel guardrail and into the Hydraulic Canal. The driver remained at the wheel until the tractor settled on the bottom of the canal and then made his escape from the submerged cab. Dominick Beauchamp, who was nearby, heard the crash and hurried to the scene where he helped the driver out of the cold water. This area is now the site of part of the Bassett Healthcare complex. (Courtesy of Richard Ruller.)

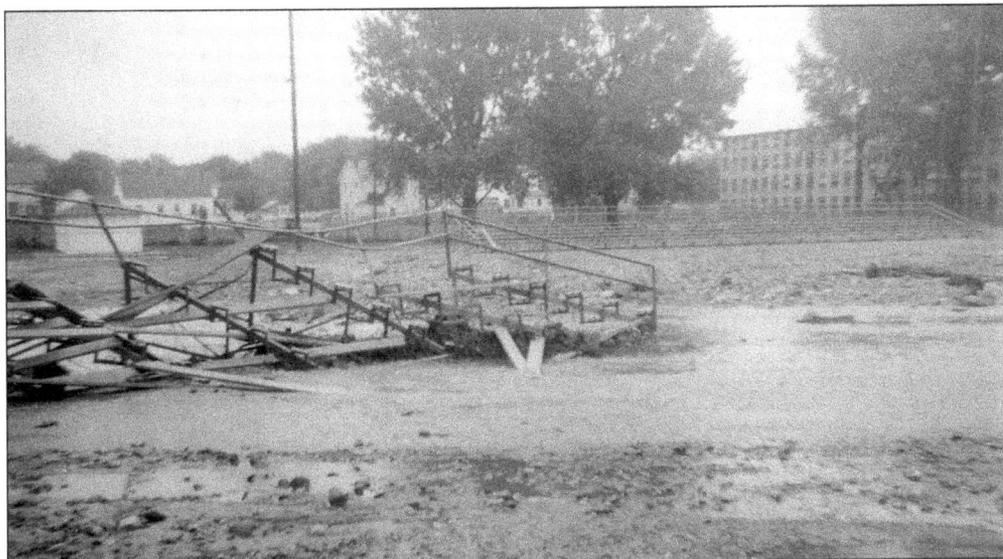

FLASH FLOOD IN HERKIMER. The description of September 10, 1950, as "just a good rainy day" by Leonia Adrean, a statistician at the water bureau's South Utica reservoirs, could have been challenged by Herkimer residents. The good, rainy day caused Bellinger Brook to overflow, destroying the bleachers at Harmon Field that were located below the brook. Residents on Graham Street had flooded yards, and on Church Street, the front porch of the Fred Bayer home nearly washed away. (Courtesy of Arthur Brown.)

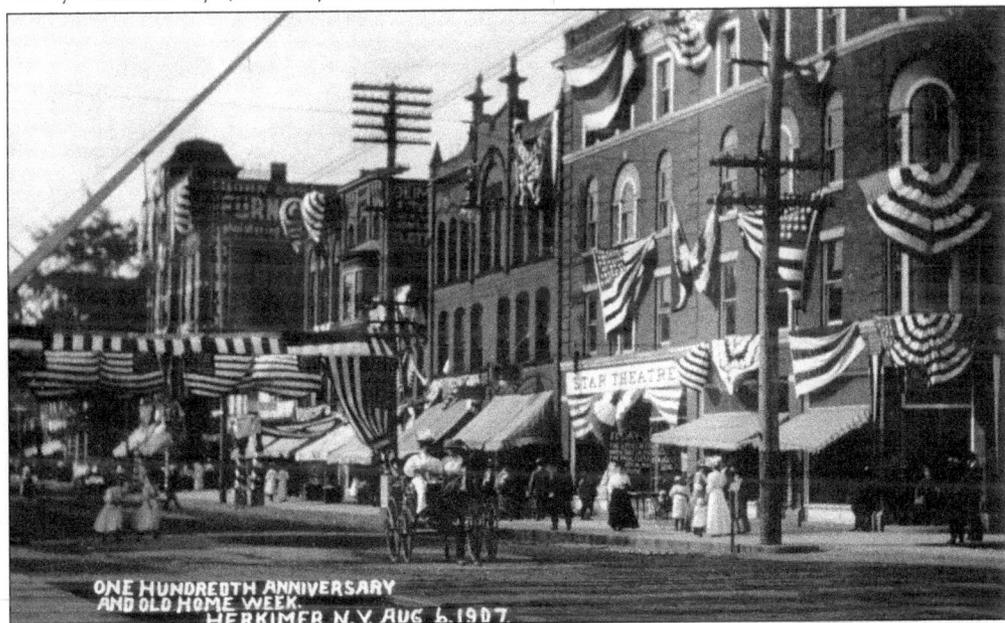

HERKIMER CENTENNIAL ANNIVERSARY. Herkimer was decked out in its finest to celebrate the village's centennial in August 1907, as a proud resident shows off a new horseless carriage. In this picture, looking north on Main Street from the railroad tracks, the second building from the right is the Monroe building. Today its spires are gone, but its facade remains unmistakable. The Star Theatre can also be seen, which opened in the Nelson Block in 1908 and only had wooden benches for seating. (Courtesy of Jim Greiner.)

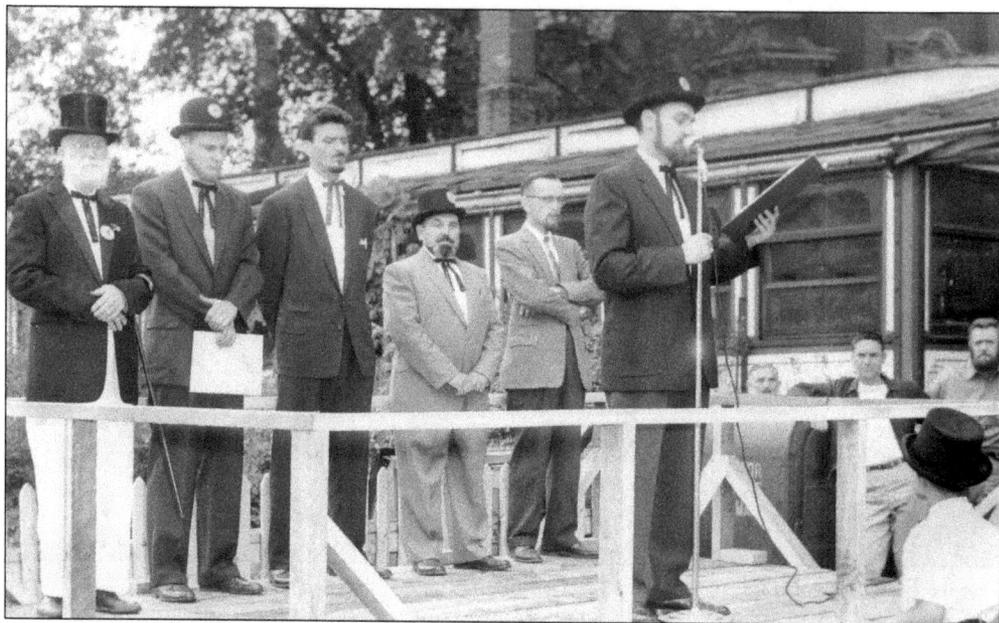

HERKIMER SESQUICENTENNIAL CELEBRATION. Celebrating Herkimer's 150th anniversary in 1957, the village commemorated the occasion with eight full days of activities from August 26 to September 2 and an official opening ceremony led by Mayor Donald Mitchell at the corner of Park Avenue and North Main Streets. Pictured from left to right are Martin Murphy, trustee Harrison Hummel, Frank Whitney, trustee Alfonso Annotto, trustee John Zuris, and Mitchell.

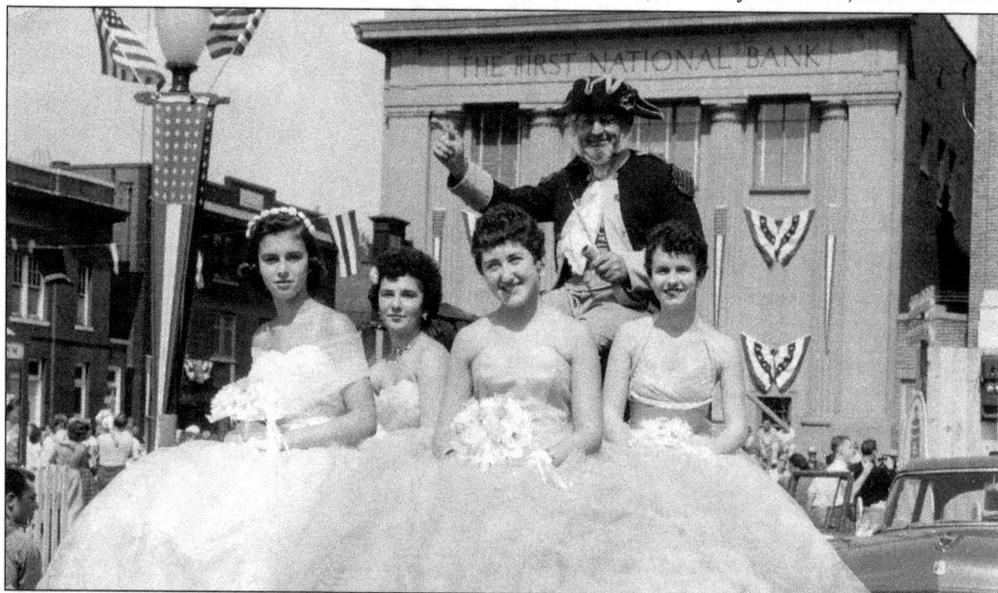

HERKIMER SESQUICENTENNIAL PARADE. The activities included agricultural and industrial exhibits, a "Drama 'Long the Mohawk" pageant, fireworks, and a spectacular parade held on August 31, 1957, with 2,000 participants and a crowd of 35,000 people watching. Pictured is the General Herkimer Hotel float with LeRoy Ruller dressed as Gen. Nicholas Herkimer and, from left to right, Andrea Scialdo, Vicky Cirillo, Jo Ann Scialdo, and Sally Brothers. Ruller was well known as the postmaster of Herkimer and the town historian. (Courtesy of Richard Ruller.)

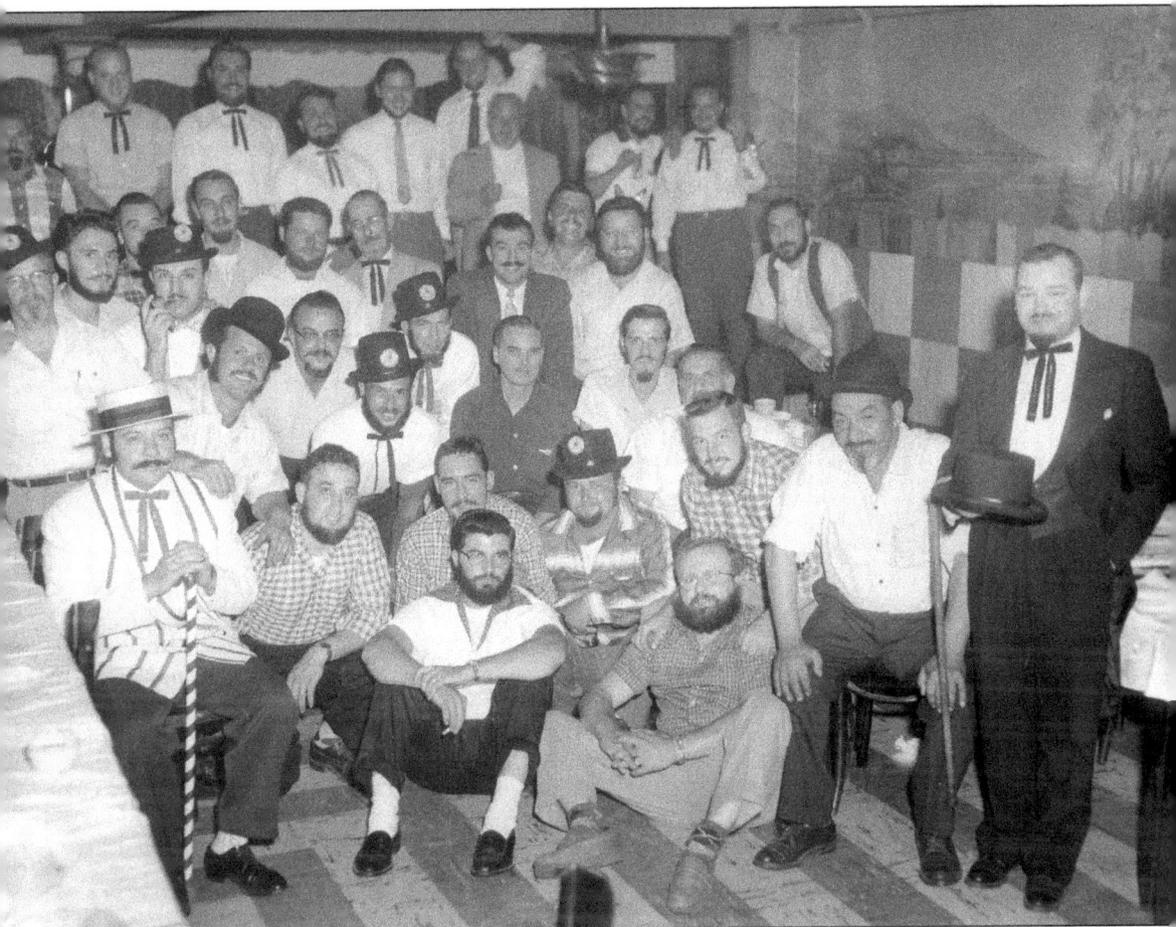

BROTHERS OF THE BRUSH. As part of the sesquicentennial celebration, Mitchell called on all Herkimer male residents to take part in a beard-growing contest to help make the village look as it did 150 years ago. This picture was taken at Big Bills Grill on South Washington Street. Pictured from left to right are (first row) Joe Ferrucci and Ernie Waterbury; (second row) Dominick Grande, Vito Losito, Jim Piper, Jim Bennett, Bob Entwistle, Jim Surace, and Tony Belmonte (standing); (third row) Carmen Netti, Dominick Frank, John Servello, ? Jackson, Paul Favat, Gabby Gabarino, and Mario Angelotti; (fourth row) Charlie Tripolone, Peter Cirillo, Frank Cimino, Frances Chirico, Don Adams, Gordon Hough, Don Adams Sr., Joe Cirelli, Nick Netti, Whoppie Lanza, and Frank Baggetta; (fifth row) Annutto, Hummel, Mitchell, Ralph Blasting, three unidentified, and Dick Risi.

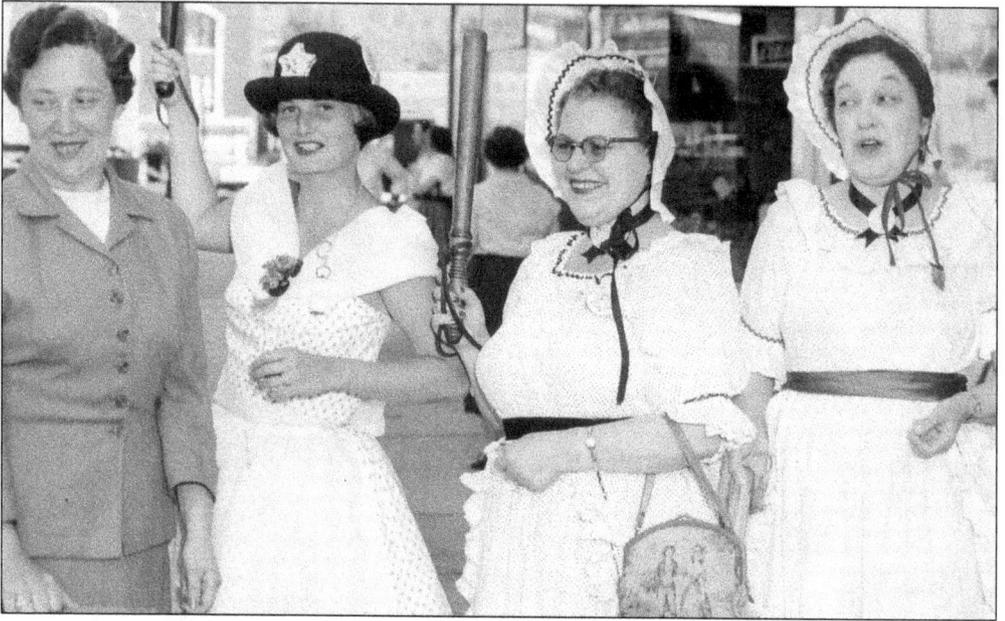

KEYSTONE KOPS. In answer to the Brothers of the Brush, the women were called to join the Sisters of the Swish, which banned cosmetics, jewelry, and perfume during the summer of the sesquicentennial. A special female police force was established to enforce the decree, called the Female Keystone Kops. Pictured from left to right are Winifred Cumm with keystone kops Joanne Strait, Norena Seaman, and Olive Case.

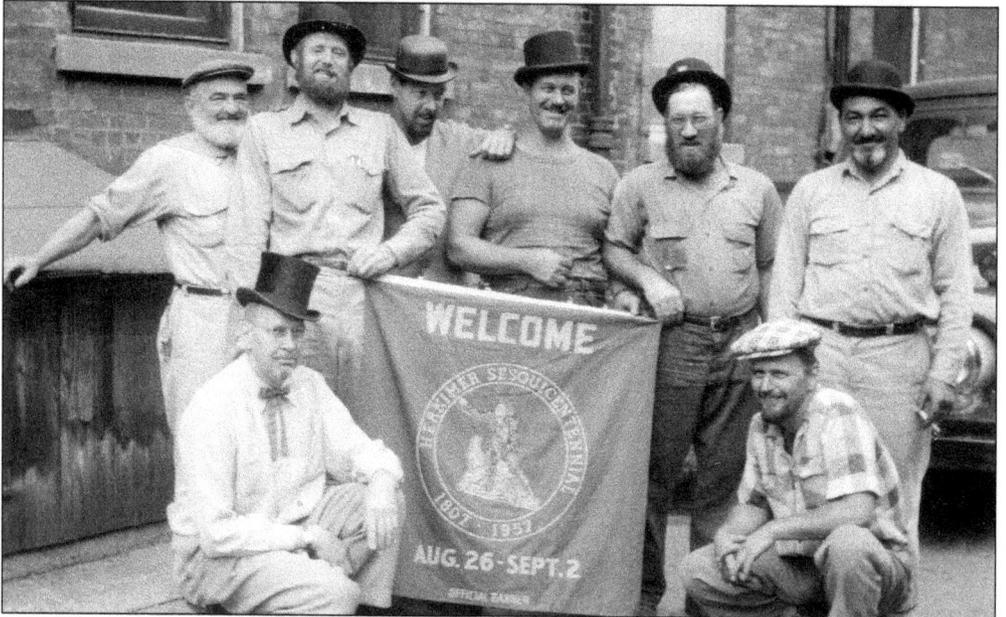

WELCOME TO HERKIMER. Holding the welcome flag for Herkimer's sesquicentennial event are the employees of the village's municipal commission, standing in front of the municipal building on August 30, 1957. From left to right are (first row) Brayton Stadler and John Doxtader; (second row) Homer Thuot, Walter Scram, Charles Schanthal, Kenneth Harter, Jesse Sharp, and Jamie Surace. (Courtesy of Brayton Stadler.)

HERKIMER COUNTY'S BICENTENNIAL
COMMEMORATION. In 1991, a weeklong
celebration of Herkimer County's 200th
birthday was held June 8 through June 16,
starting with a giant parade that was held
in the village of Herkimer. Some of the
other activities that were held included
the *Birthday to Remember* Broadway revue,
a 1991 celebration choir, a boat flotilla,
and an industry trade show. The logo
for the county's 200th anniversary, seen
here on the flag, was designed by Gordon
Ackerman of Little Falls.

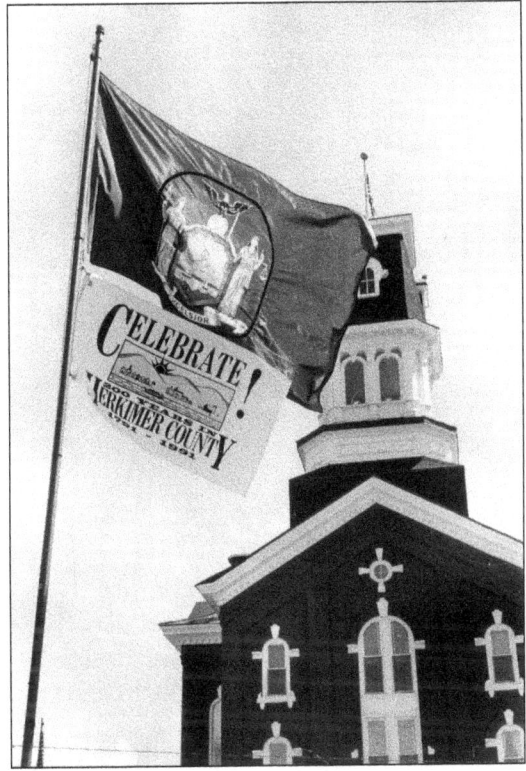

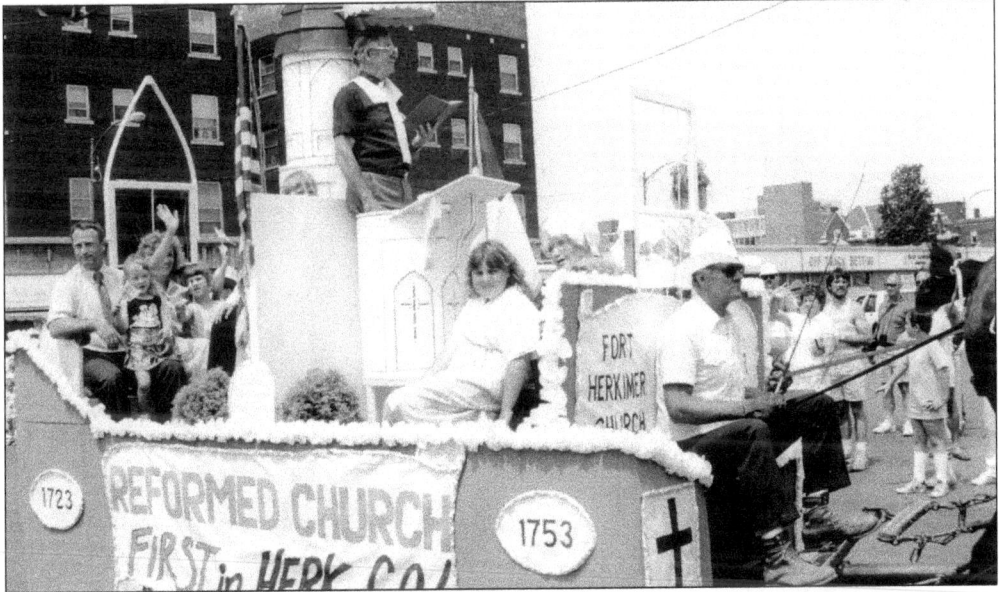

HAPPY 200TH. Over 30,000 people lined the streets of Herkimer to watch the Herkimer County
bicentennial parade, held on June 8, 1991. The four-hour parade was a cooperative venture of the
Herkimer County Bicentennial Committee and the Herkimer County Desert Storm Welcome
Home Celebration. Pictured is the Herkimer Reformed Church float with the Saunders family
in back, Doug Anderson at the pulpit, and Heather Geno (left) and Ida Mae Batchelder in front
of him.

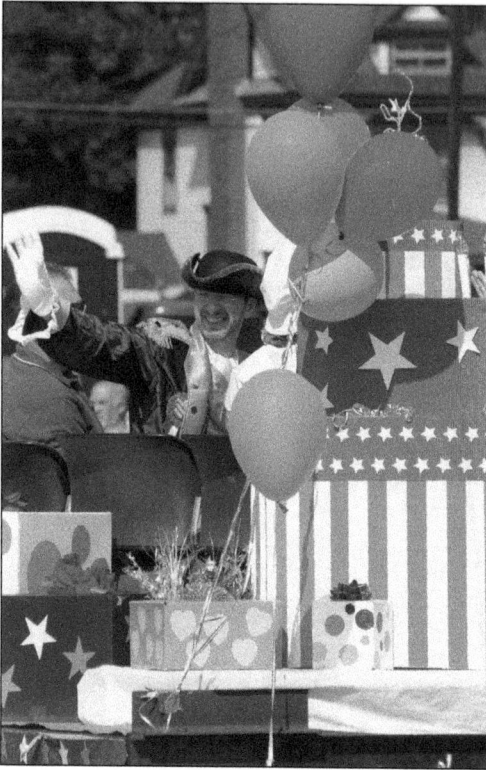

HERKIMER CELEBRATES 200 YEARS. The village of Herkimer celebrated its 200th anniversary in 2007 with events that were held throughout the year. Some of the activities included a General Herkimer's History Hearth and Home weekend, a home brew contest, a performance by the Syracuse Symphony Orchestra in Myers Park, fireworks, and a grand parade. Shown is village mayor Mark Ainsworth dressed as Gen. Nicholas Herkimer to help start off the parade. (Courtesy of Arthur Kineke.)

HERKIMER BICENTENNIAL PARADE.
A spectacular parade was held on September 22, 2007. The grand marshal was 100-year-old Vernon Lee Sr., seen waving in the front seat, who was a well-known educator and principal of L. W. Bills School. Four generations of family members rode in the car, including his son Rev. Vernon Lee Jr. seated in the middle. Stanley Biasini, a former guidance counselor at Herkimer High School, was the driver and later took Lee Sr. around the village on his first ride in a convertible. (Courtesy of Arthur Kineke.)

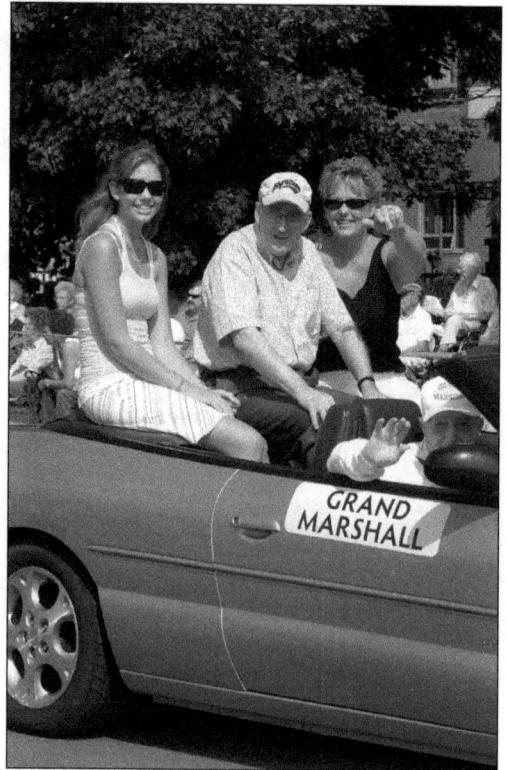

THEY CAME TO HERKIMER. The Herkimer County Historical Society float for the Herkimer bicentennial represented the immigrants who came to the village in the late 19th and early 20th centuries to start a new life in this country. Pictured is Jane Spellman, representing Margaret Tuger, a well-known figure in Herkimer who always loved a parade, and members of the Ilion Little Theater who dressed as immigrants. The backdrop for the float of New York Harbor was created by Marge Anderson. (Courtesy of Arthur Kineke.)

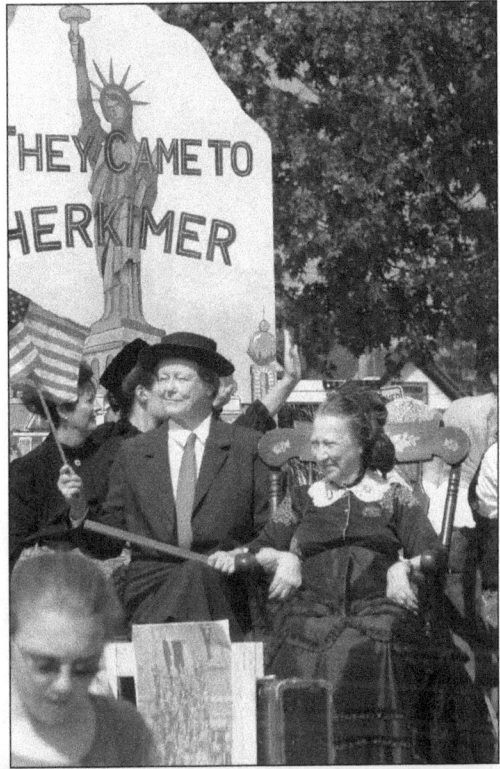

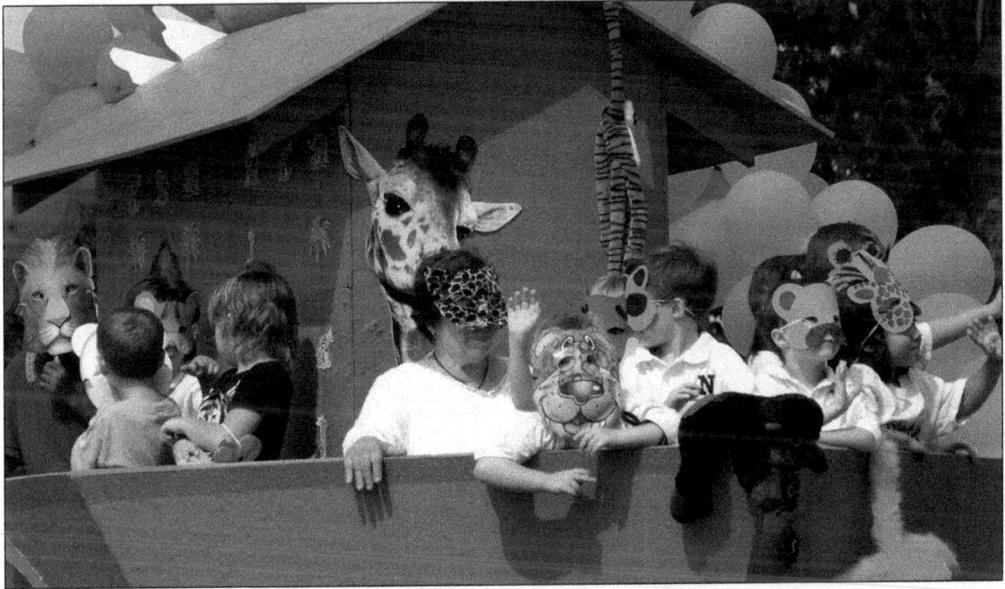

HERKIMER BICENTENNIAL TOP FLOAT. The parade featured over 100 units, including 10 bands and 35 floats, drawing a crowd of about 15,000 people. The first prize winner for best float was the colorful Noah's Ark float submitted by St. Francis de Sales Church, with young students from the school dressed up as an assortment of animals. The Herkimer bicentennial celebration officially ended with a time capsule being buried on April 6, 2008, at the Herkimer Fire Department. (Courtesy of Arthur Kineke.)

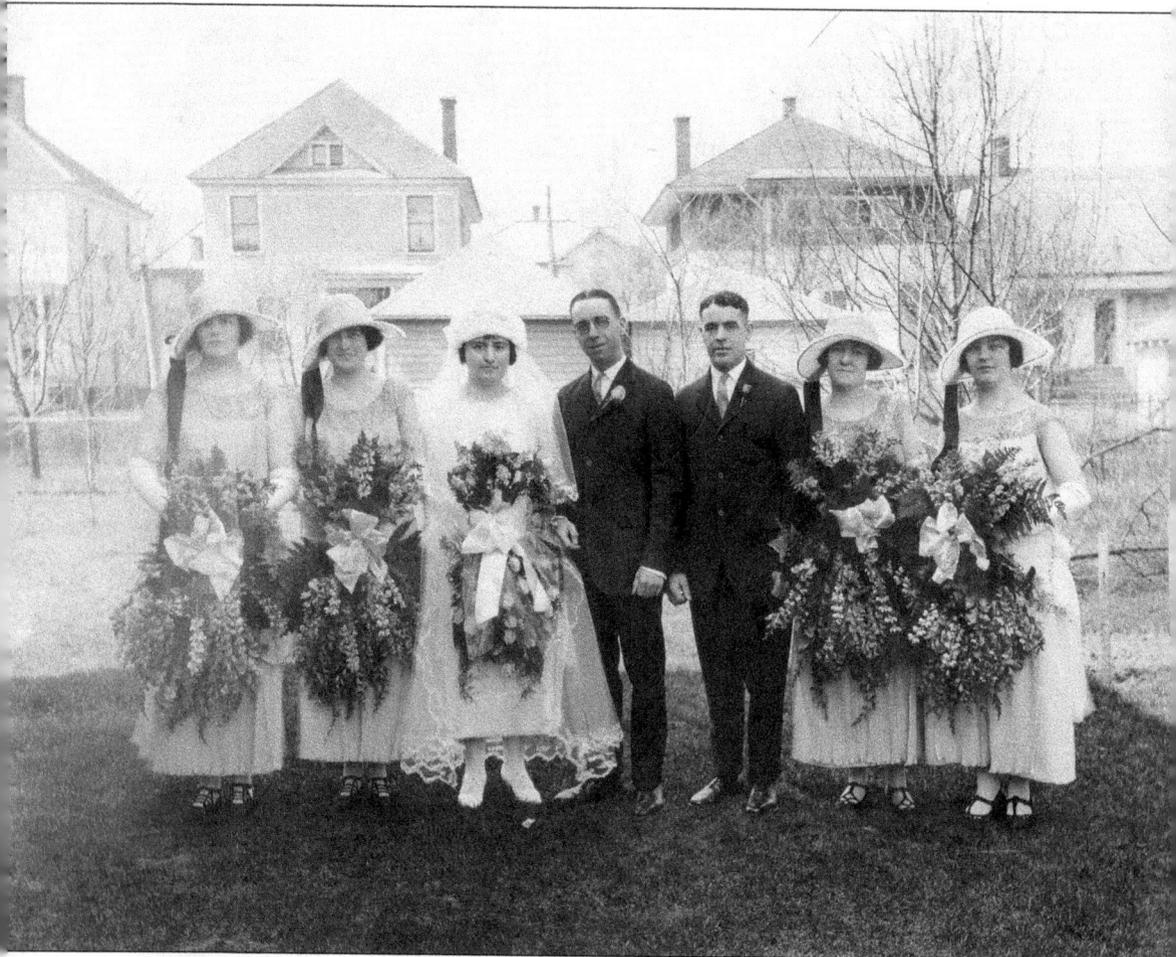

BURNS-FALK WEDDING, 1924. On April 29, 1924, James F. Burns and Gertrude M. Falk were married in Herkimer. The wedding party can be seen here behind their house at 407 Henry Street. Pictured from left to right are Margaret Fletcher, Natalie Sullivan, Gertrude Falk, James F. Burns, John Burns, Monica Sullivan, and Carolyn Race. James was a well-known funeral director in Herkimer and was a home-service officer for the Red Cross during World War II. (Courtesy of Jim Greiner.)

Four

CHURCHES

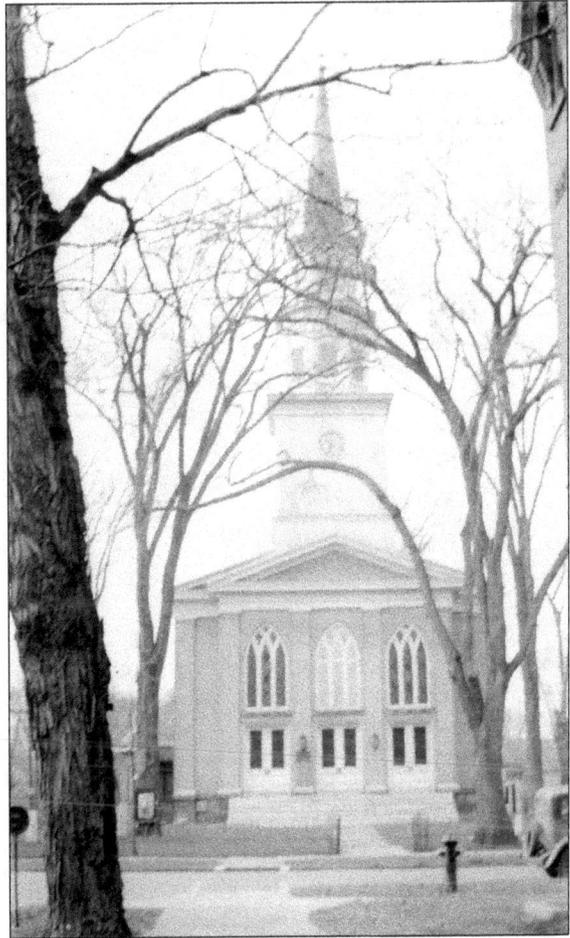

REFORMED CHURCH. Founded in 1723 by German Palatines, the first church building was erected here sometime before 1734 later to be burned down in 1757 during the French and Indian War. A second church was burned in 1804, and a third church was erected, only to suffer the same fate in 1834. A new brick church of classic revival style was opened in 1835 and still exists here today. One of the best-known ministers of its early days was Rev. John P. Spinner (1768–1848), who liked to give his sermons in German.

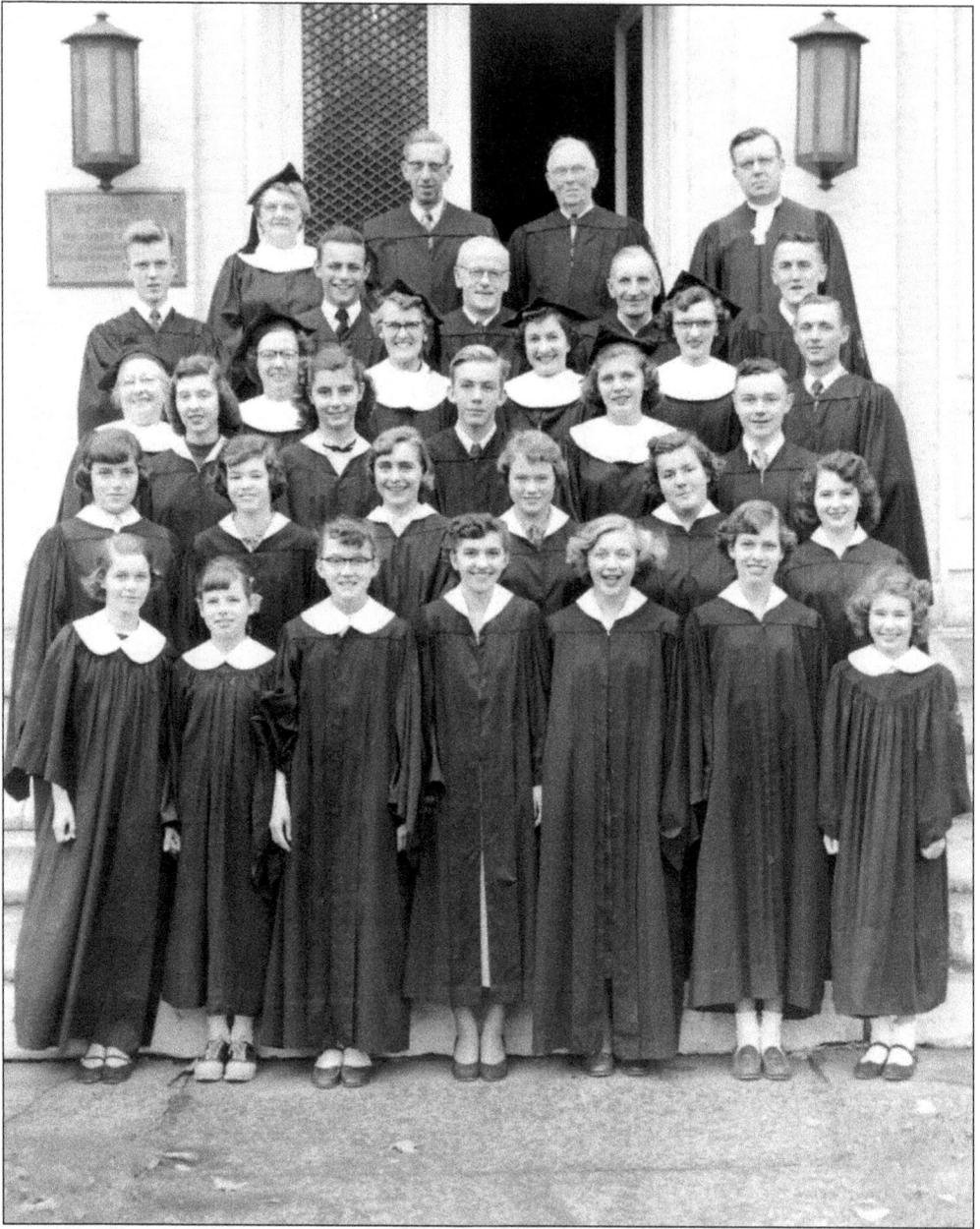

REFORMED CHURCH CHOIR. This picture was taken in the 1950s of the Herkimer Reformed Church choir, which is seen standing on the front steps of the church. From left to right are (first row) Nancy Hierholzer, Ellen Walrad, Annette Farber, Marion Helmer, Jean Van Delinder, Susan Edwards, and Jane Hierholzer; (second row) Margaret Edwards, Mary Lynne Folts, Martha Van Delinder, Joanne Tapper, Diane Sluyter, and Sheila Blais; (third row) Phyllis Wagner, Helen Lee, Lee Van Delinder, Betty Van Delinder, and Myron Kaufmann; (fourth row) Gladys Curtis, Dorothy Hess, Anita Welwood, Jeanette Martin, Pearl Small, and Eugene Helmer; (fifth row) Dale Welwood, Karl Hoelrich, Duane Madison, William Mitchell, and Henry Smith; (sixth row) Jane Roberts, Edward Hess, Ward Miller, and Rev. J. Foster Welwood. (Courtesy of Herkimer Reformed Church.)

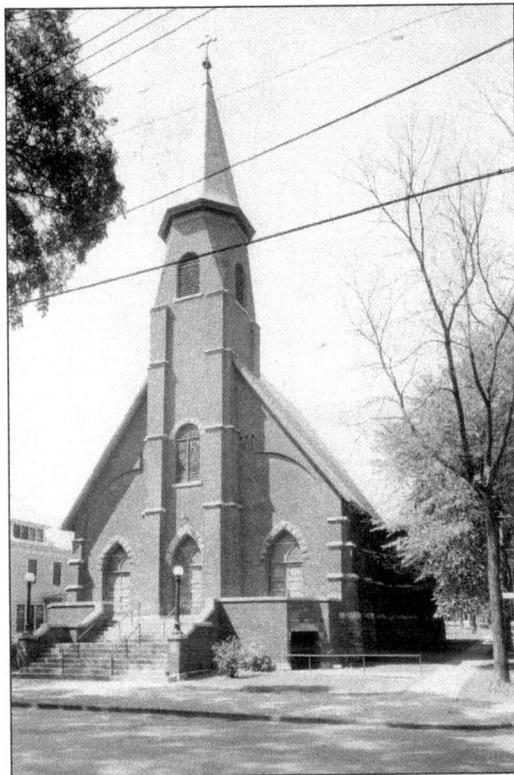

St. Francis de Sales Church. The imposing brick-and-stone church of St. Francis de Sales Roman Catholic Church stands at North Bellinger Street and Bellinger Avenue. The first Roman Catholic church in Herkimer was a frame structure at Green and North Washington Streets, purchased after the parish was organized in 1874. Construction of the new brick church began under the pastorate of Rev. James Halpin (1885–1906). Extensive renovations were undertaken at the time of the 1975 centennial of the parish.

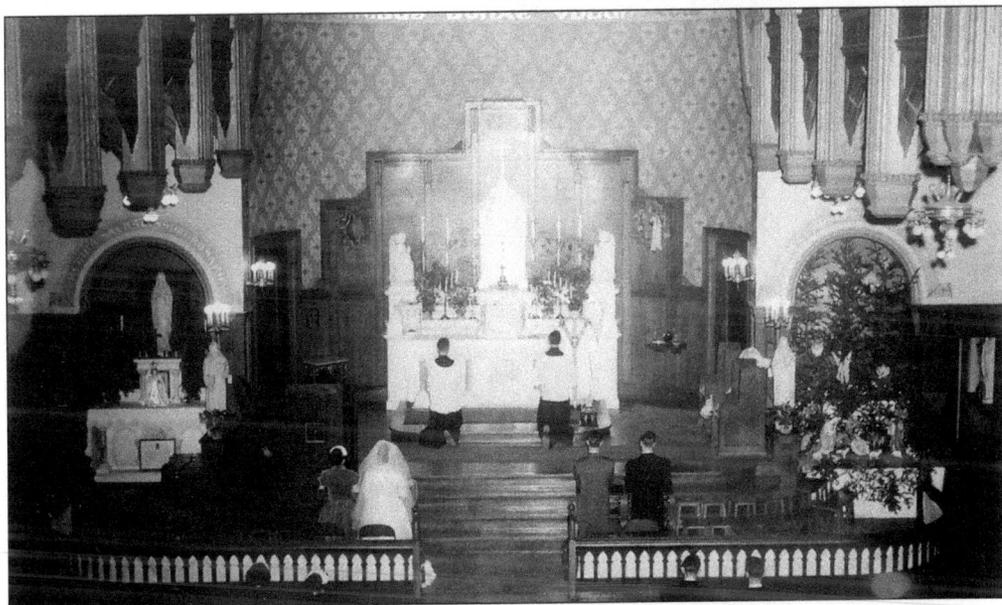

Interior of St. Francis de Sales. The most prominent feature of the church is the magnificent oak ceiling, which, since the time of its installation from 1929 through 1931, has been said to be the only one of its kind on the North American continent. The plans and details for the ceiling were that of Henry Emery, a famed New York architect, using 32,000 feet of red oak and 26,000 feet of oak veneer. The wedding pictured is that of John Riley and Mary Elizabeth Tallman on December 29, 1951, showing the sanctuary before the 1970s renovations.

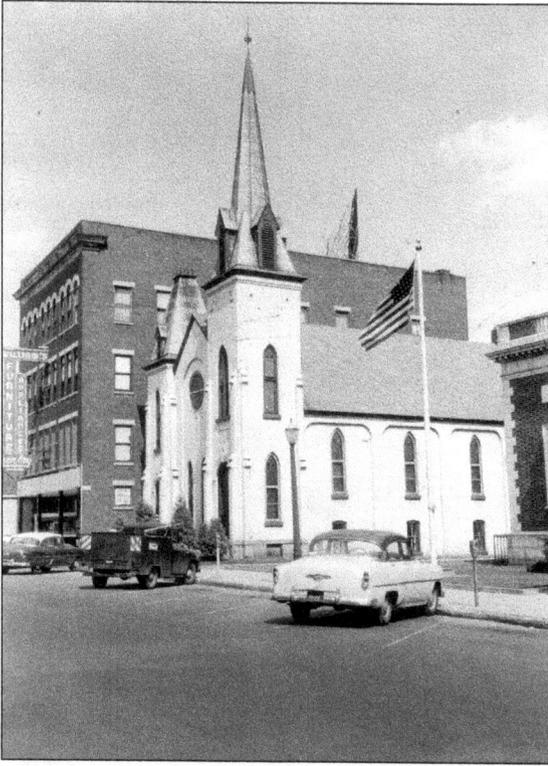

FIRST UNIVERSALIST CHURCH. The First Universalist Church of Herkimer was organized in 1881. In 1883, a brick church with a tower and a belfry was built on Park Avenue. In 1965, when the national Universalist and Unitarian denominations merged, the Herkimer church changed its affiliation and became the Congregational-Universalist Church. With a dwindling congregation, the church conducted its last service in 1977. It was razed in 2000, and its former site is now the post office parking lot.

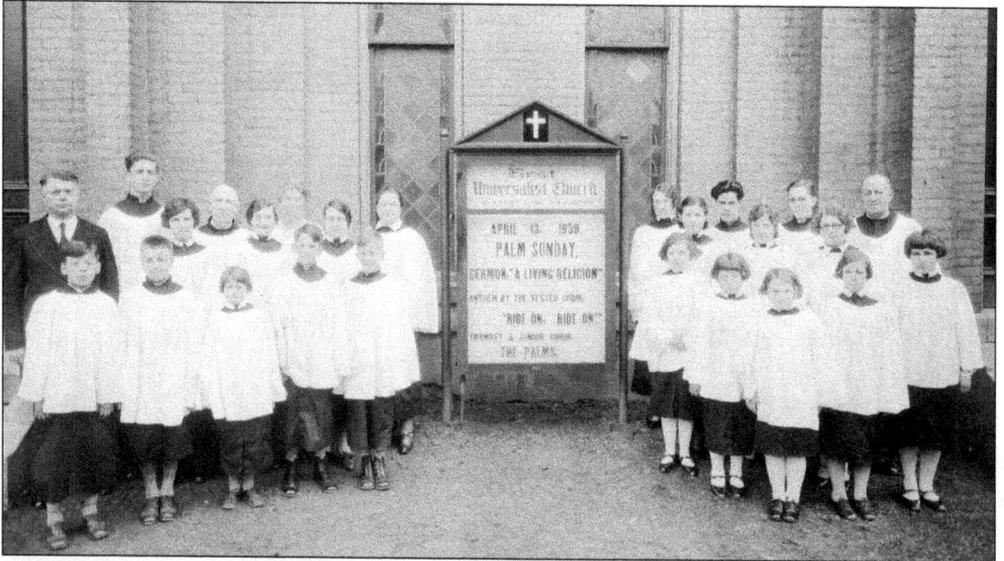

PALM SUNDAY, 1930. Pictured standing outside the First Universalist Church on the left are (first row) Leland Walrath, William Jackson, Edith Mower, James Burney, and Thomas Burney; (second row) Rev. W. H. Skeels, Kathlyn Bell, Emily Yale, Rowena Nielson, and Betty Beacon; (third row) Richard Yale, Irving Ellis, and Lucretia Bothwell. On the right side are (first row) Betty Robinson, Ruth Porter, Inita Sexton, unidentified, and Clara Oldfield; (second row) Viola Cole, Agatha Ingersoll, and Lillian Miller; (third row) Rosemary Miller, Edwin Bennett, Robert Babcock, and Grover Ingersoll.

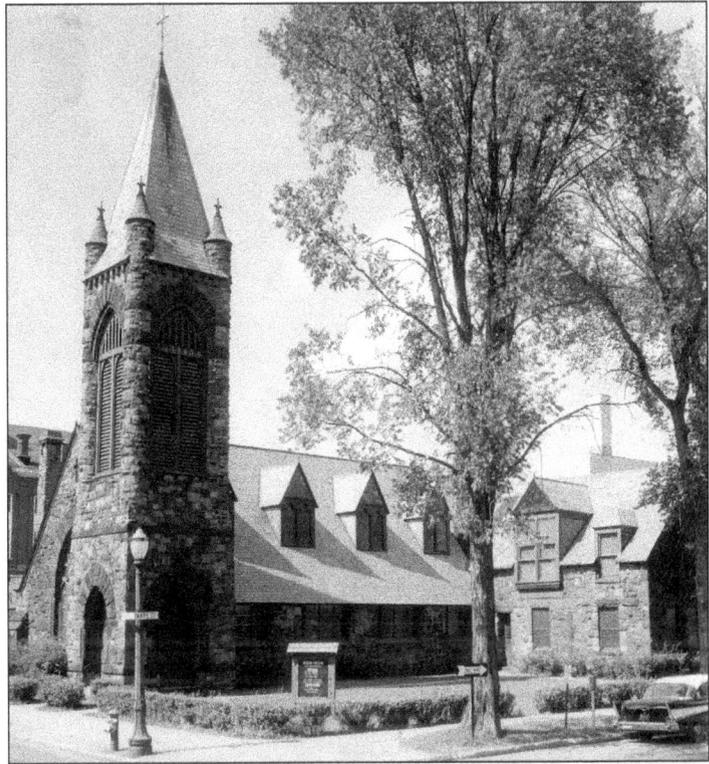

CHRIST EPISCOPAL CHURCH. This lovely stone church at the corner of Main and Mary Streets was built in 1889. Generations of well-known Herkimer families worshipped here, including the Mungers, Earls, and Searles. Their names can be seen throughout the church for memorials underneath the beautiful stained-glass windows. The parish house, built on Mary Street as a wing of the church, was originally designed as a rectory. A separate rectory was later built on Henry Street, and the wing was made into offices and meeting rooms.

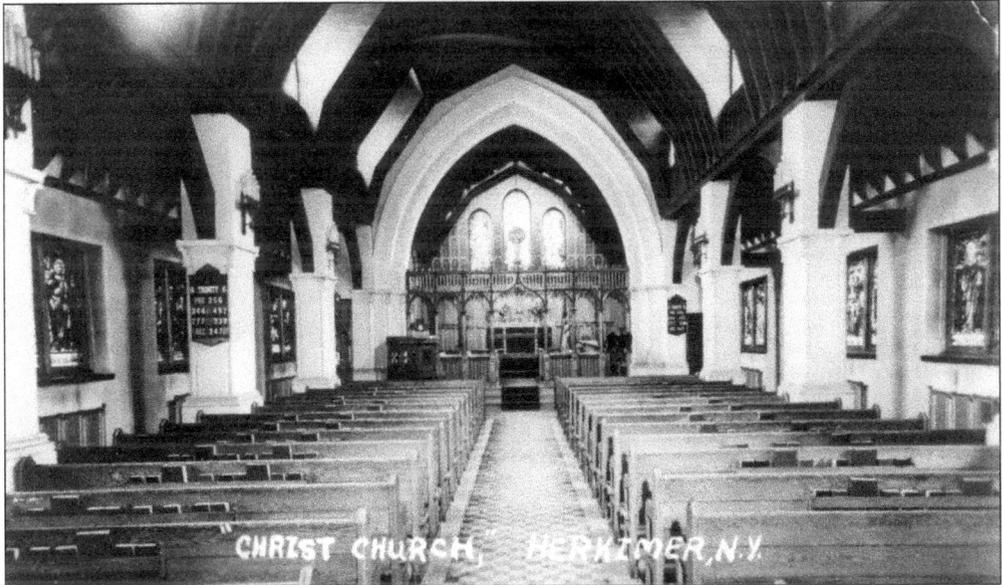

INTERIOR OF CHRIST EPISCOPAL CHURCH. This picture shows the interior of Christ Episcopal Church before renovations were made in the 1960s. The main feature that can be seen is the rood screen, an ornate screen constructed of wood, which divided the chancel from the main part of the church. It was later taken down, while the main centerpiece still remains in the back of the church. The stained-glass windows, depicting the life of Christ, are a work of art designed by the English firm Heaton, Baynes, and Butler. (Courtesy of Christ Episcopal Church.)

59

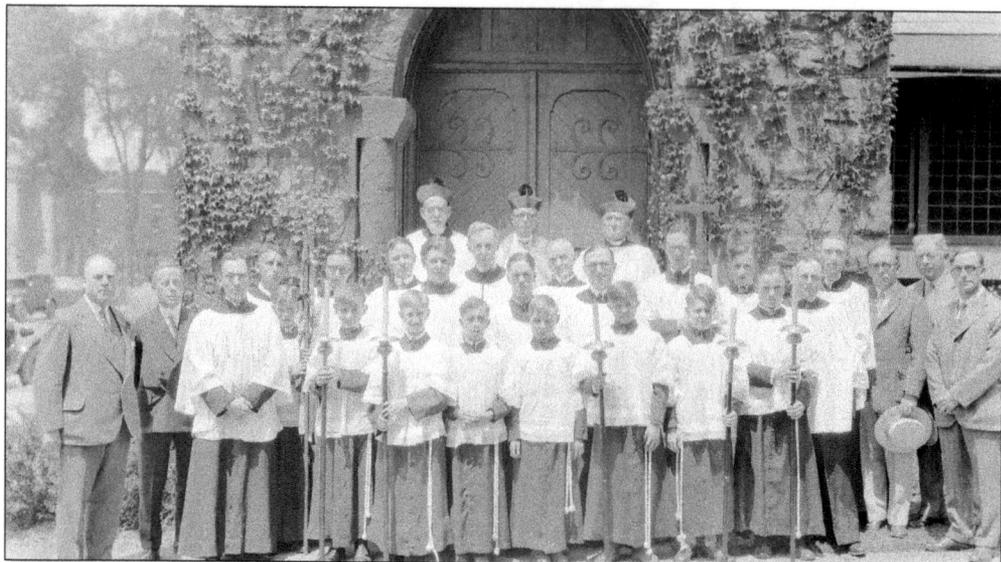

CHOIR AND ALTAR BOYS. Here is a 1923 photograph of the Christ Episcopal Church choir and altar boys. From left to right are (first row) John Henderson, A. Elting Brayton, Howard Murray, "Pete" Brayton, ? Wills, H. P. Brayton Jr., Fred Fox, ? Wills, ? Hart, Ward Wood, George Pratt, Michael Volkert, Charles Murray, Stanley Cassidy, Frank Carroll, and Charles Sprague; (second row) Lansing Morse, ? Morse, Charles Gloo, unidentified, George Searles, William Pratt, Al Williams, George Steele, and Kenneth Harter; (third row) Rev. Charles Edmonds, Rev. L. Curtis Denney, and Rev. William C. Prout.

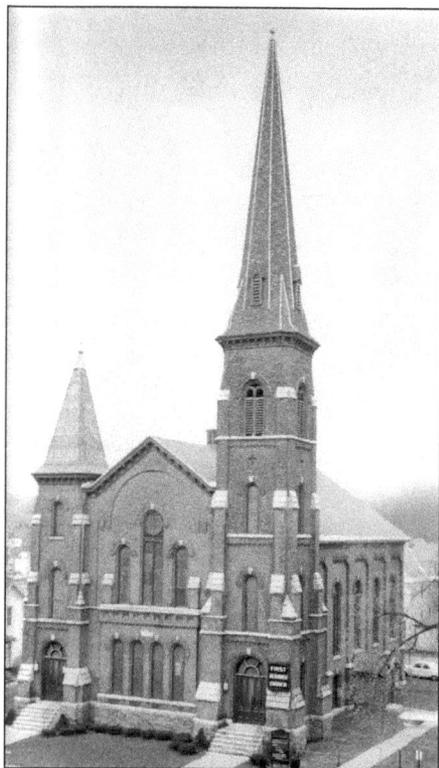

FIRST UNITED METHODIST CHURCH. Methodism came to Herkimer through circuit-rider preachers in 1793, and the first church was incorporated in 1832. The congregation's first meetings were held in the old Herkimer County Courthouse and later at the old North Washington Street School until a frame church was built at North Washington and Green Streets and designated the First Methodist Church. The present large brick church at Park Avenue and Prospect Streets was dedicated on April 23, 1874, with the cornerstone being laid in 1873.

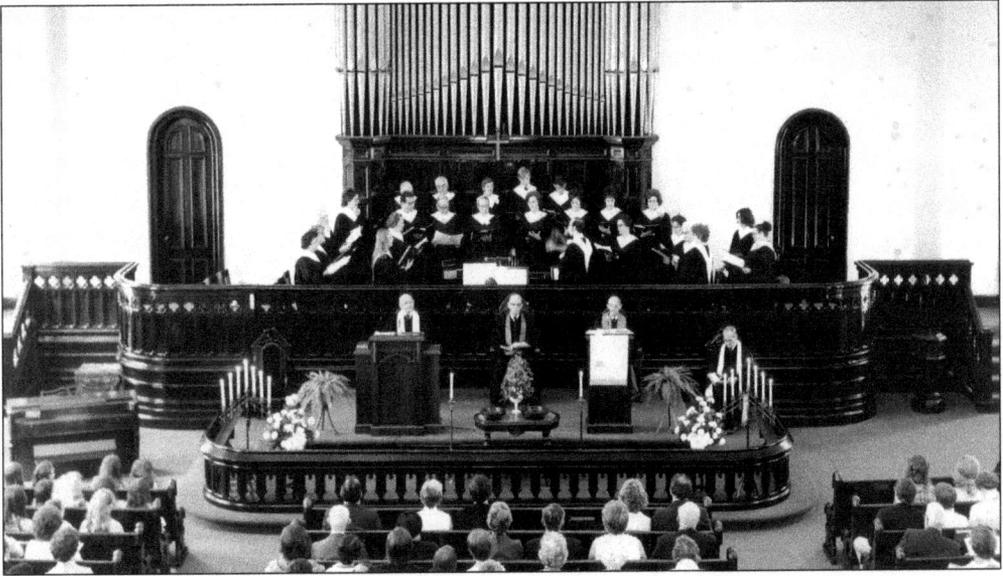

FIRST UNITED METHODIST CELEBRATION. The church and its congregation were rededicated on June 3, 1973, on the occasion of its 100th anniversary of the present church structure and the 180th anniversary of the founding of Methodism in Herkimer. The photograph above shows the service commemorating the anniversary with the incumbent minister, Rev. Merle Brown, on the right behind the candelabra, and the main speaker, Rev. Fred Cotnam (center), a former minister at the church. The honor of cutting the anniversary cake was given to the church's oldest members at that time. From left to right are Lillian French, who became a member in 1909; Lillian Carney, 1909; Iva Wood, 1901; Grace Folts, 1907; and Leah Clark, 1907. (Courtesy of Herkimer Methodist Church.)

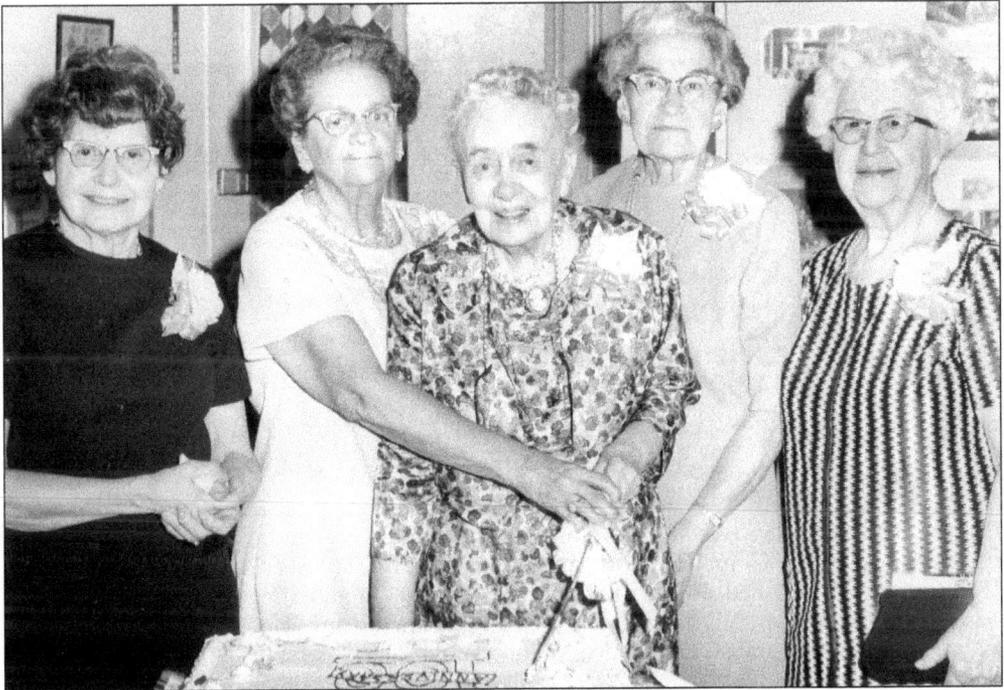

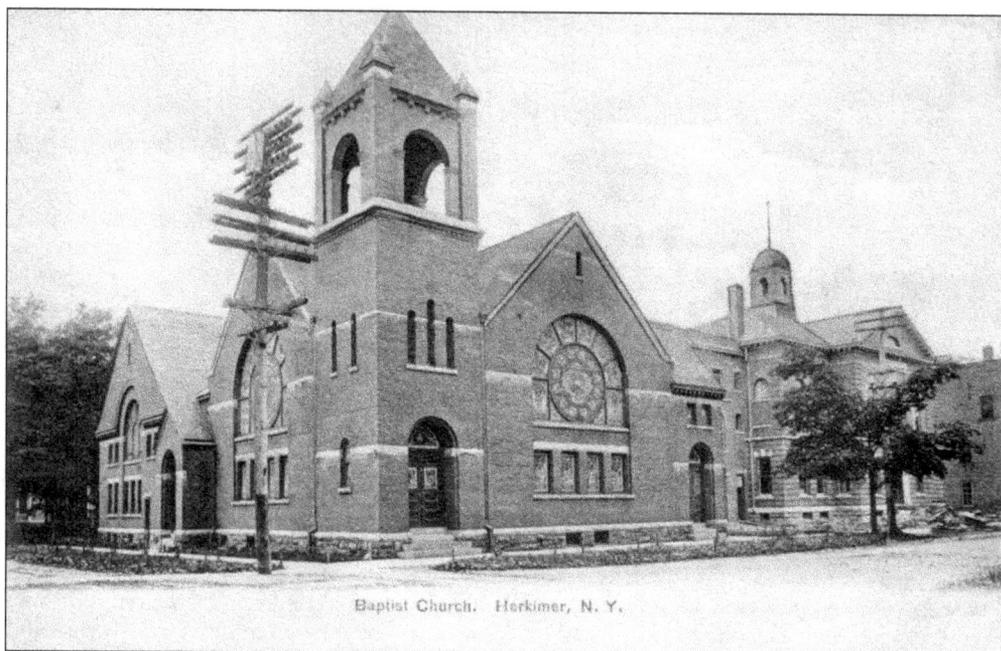

Baptist Church. Herkimer, N. Y.

FIRST BAPTIST CHURCH. The large brick First Baptist Church of Herkimer at North Washington and Green Streets was dedicated in 1902. This picture was taken prior to 1917 because the Earl Block still stands. In the center is the municipal building with its clock tower. Herkimer had two clock towers at one time—this one and the Reformed Church. These clocks were often called "four-faced liars" because each of the four facings showed a different time at the same time. (Courtesy of Tod Waterbury.)

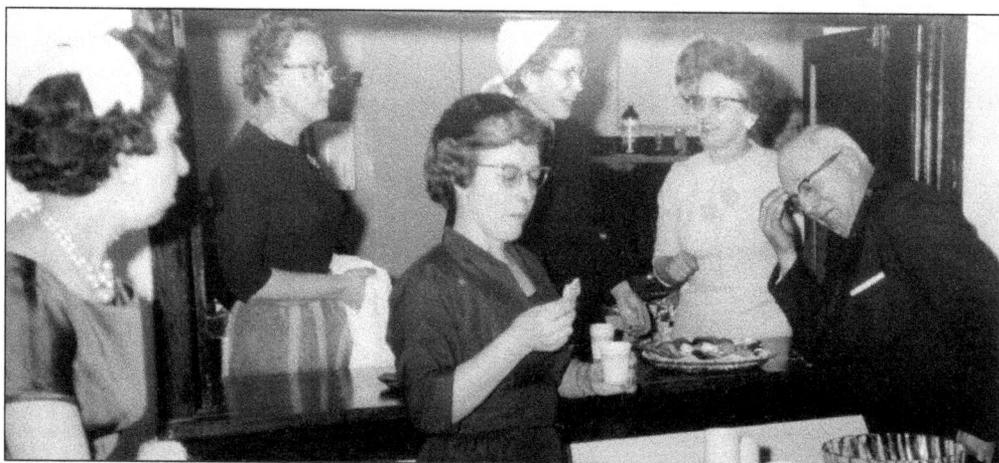

BAPTIST CHURCH ANNIVERSARY. An anniversary dinner, celebrating 75 years, was held by the Herkimer Baptist Church in 1963. The present church succeeded a small chapel, built in 1889 and since demolished, on North Prospect Street near Church Street after the congregation was formed on February 17, 1888. From left to right are Thelma Hecox, Helen Keller, Edna Failing, Madeline Fagan, Eleanor Hadcock, and Harold "Dutch" Shults. (Courtesy of Herkimer Baptist Church.)

62

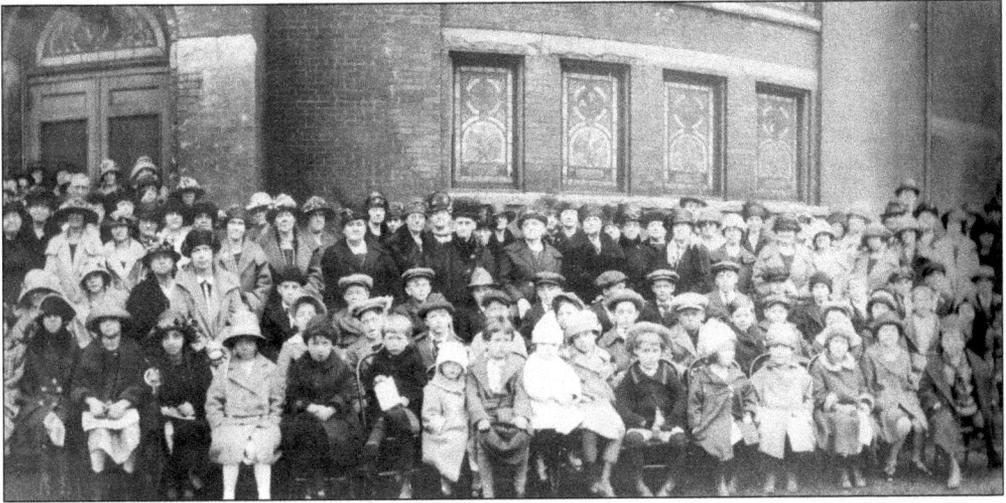

SUNDAY SCHOOL ATTENDANCE CONTEST. The Herkimer and Little Falls Baptist Churches had a Sunday school attendance contest in 1924. Herkimer won and was entertained by Little Falls with a gala evening. Shown are the Herkimer Sunday school members outside of the church. A very young Tod Waterbury is in the picture in the third row, third from right. (Courtesy of Herkimer Baptist Church.)

BAPTIST CHURCH SUNDAY SCHOOL. This photograph was taken at Christmas in 1955. From left to right are (first row) Bruce Bull; (second row) Laraine Waterbury, Jan Waterbury, Barbara Turner, Darlene Maxfield, and Ellen Maxfield; (third row) Jane Hadcock, Ronald Fralick, Burt Comstock, and James Maxfield; (fourth row) Jimmy Sharp, George Lafayette, Jimmy Comstock, David Shults, Terry Wissick, Larry Bull, and Patricia Hadcock; (fifth row) Linda Sweeney, Jimmy Fralick, Bobby Harrod, Gail Wells, Anne Sullivan, Sandy Ruehl, Jimmy Kieser, and Martin Bull; (sixth row) Sandra Blackman and Jake Lafayette. (Courtesy of Herkimer Baptist Church.)

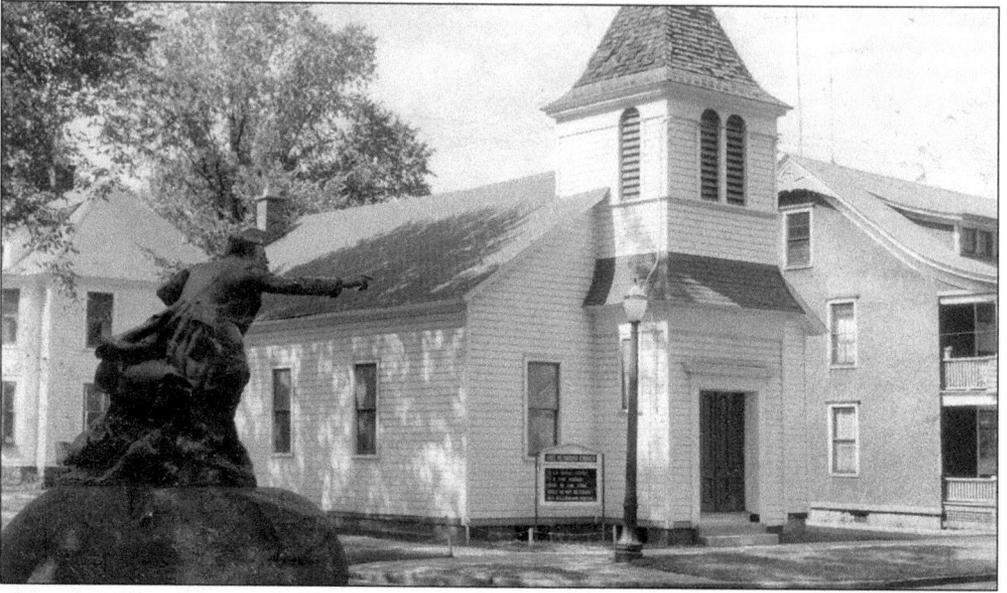

HERKIMER FREE METHODIST CHURCH. The Free Methodist congregation was able to purchase property, originally housing a barn, on the corner of Park Avenue and Park Place and renovate it into a church in 1883. This structure was used until 1998, when a new church was constructed on West German Street and called Oak Ridge Free Methodist Church. Three-quarters of the old building was taken down, and a new structure was built on the existing foundation as the dentist office of Dr. Andrew Spindigloizi.

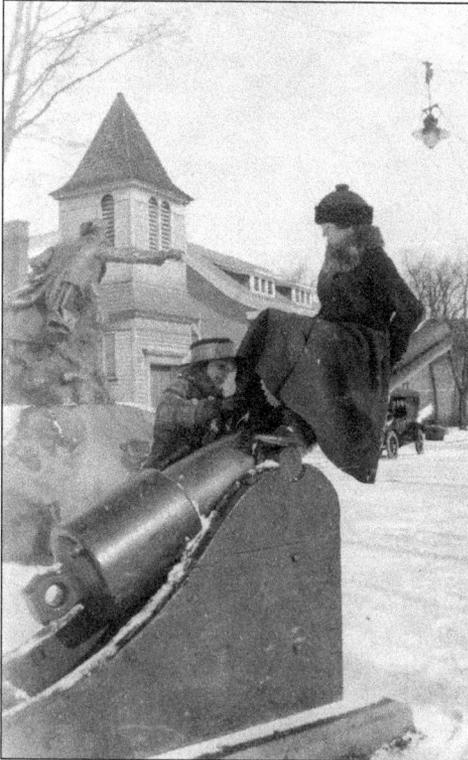

MYERS PARK CHURCH VIEW. Children on a winter outing in Myers Park play on a Civil War–era siege gun in this 1930s photograph, which shows the Herkimer Free Methodist Church in the background. The Gen. Nicholas Herkimer statue, erected in 1907, can also be seen. The siege gun no longer remains in the park, falling victim to a World War II scrap-metal drive. (Courtesy of Marion Morse.)

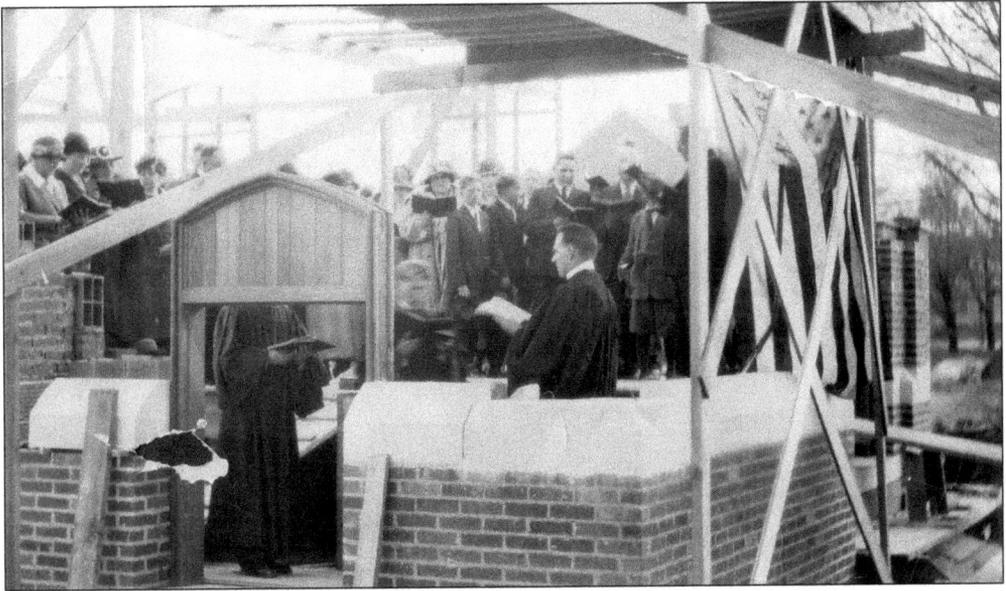

TRINITY LUTHERAN CHURCH. The brick Trinity Lutheran Church at West German and Henry Streets was dedicated on November 29, 1925, after the cornerstone was laid on May 3 of that year. Pictured is the cornerstone service, with Rev. Philip Luther at the pulpit conducting his first service as minister of the church. This building was the third structure that Trinity Lutheran Church occupied since 1887, when the congregation held its first meetings in a former blacksmith shop on South Main Street. (Courtesy of Trinity Lutheran Church.)

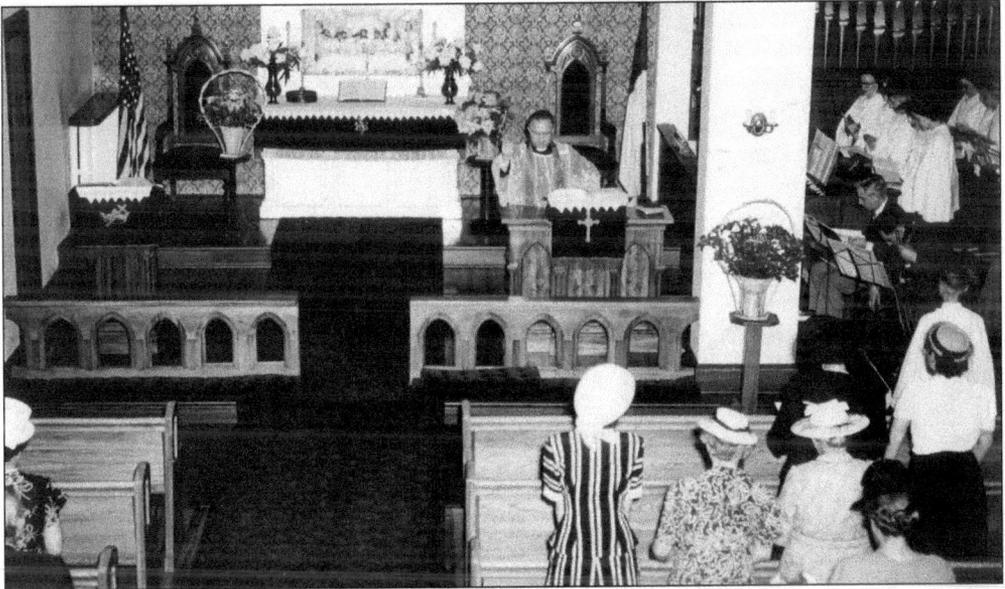

PEW DEDICATION CEREMONY. The Trinity Lutheran Church congregation built its second church on South Main Street in 1908 and sold it when a third church was built in 1925. In this photograph, the church held a pew dedication ceremony on June 24, 1948, with the recently installed minister Rev. Thomas Berg presiding at the pulpit. In the previous year, the interior of the church was completely renovated, with new chancel draperies on the wall behind the altar and a communion rail dedicated. (Courtesy of Trinity Lutheran Church.)

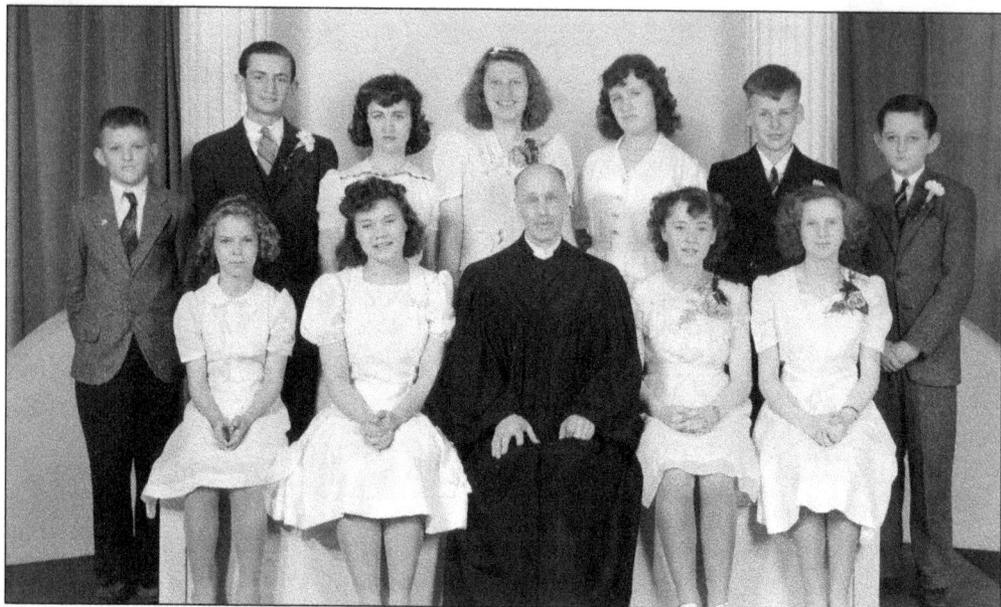

TRINITY LUTHERAN CHURCH CONFIRMATION. This photograph was taken on May 17, 1942, of the church's confirmation class. Pictured from left to right are (first row) Margaret Carter, Elizabeth Widmer, Rev. Luther B. Scheel (serving as pastor from 1940 to 1948), Lillian Marusic (Crossman), and Bertha Radzak; (second row) Richard Ruller, Samuel Skandera, Carolyn Scheel (Donlon), Mildred Kovac (Collis), Janice Scheel (Pope), Ernest Vogel, and Paul Kucerak. (Courtesy of Trinity Lutheran Church.)

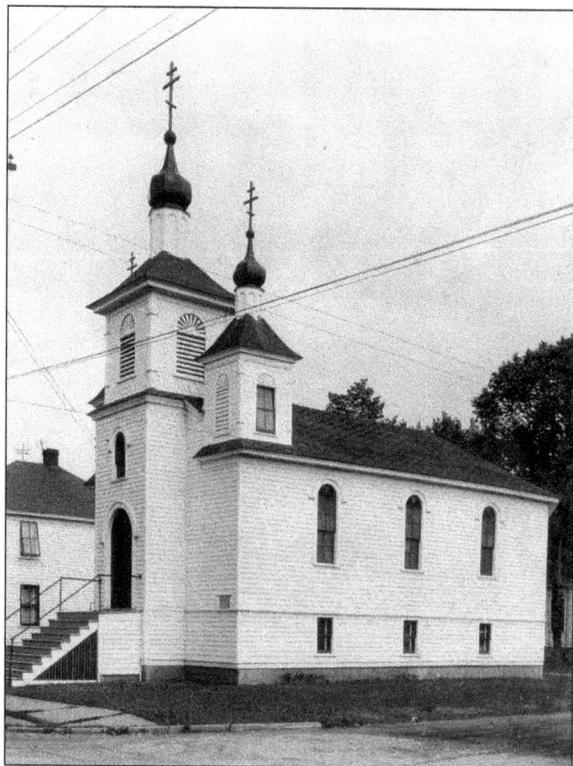

SS. PETER AND PAUL ORTHODOX CHURCH. In 1916, Russian refugees of the Orthodox faith founded the parish of SS. Peter and Paul. They met in temporary quarters until they were able to purchase a building on East Steele Street, which housed the pastor and the chapel. In 1921, plans were created to build a frame church next to the parish home. Much of the construction was performed by the parishioners, and the material came from Richfield Springs by horse and wagon. In July 1925, the new church was completed.

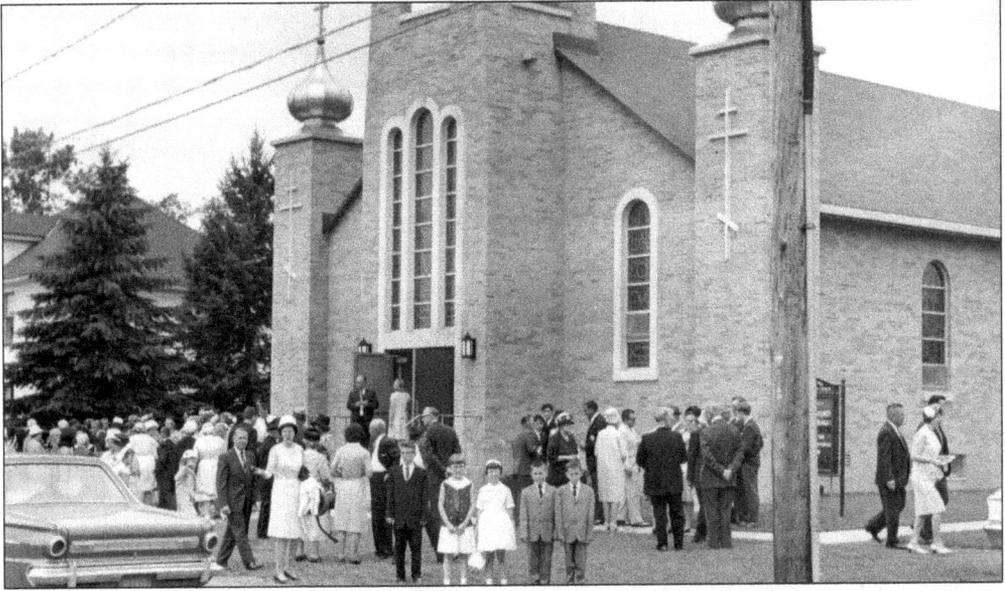

NEW ORTHODOX CHURCH IN EAST HERKIMER. Land was purchased in 1939 in East Herkimer for use as a cemetery. During the early 1960s, it became apparent that a bigger church was needed due to an increasing number of parishioners. In 1964, ground was broken in East Herkimer for the present church in the Byzantine architectural style, designed by Myron Jordan and built by Louis Cassella. The new house of worship was consecrated on August 1, 1965. (Courtesy of SS. Peter and Paul Church.)

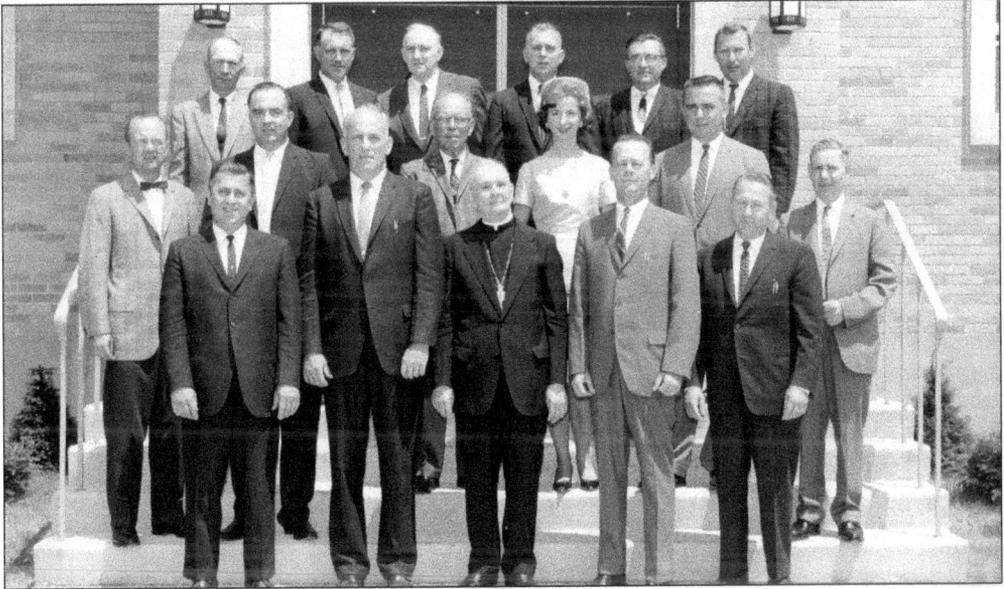

ORTHODOX CHURCH COMMITTEE AND TRUSTEES. Standing on the steps of the new SS. Peter and Paul Church from left to right are (first row) vice president Walter Sterzin, president Paul Sokol, Fr. Theo Kondratick, secretary Charles Anthony, and treasurer William Homyk; (second row) John Kowansky, William Pupcheck, George Bruska, Millie Sokol, and Mitch Chlus; (third row) Andrew Homyk, Nicholas Keblish, Walter Jovorosky, Leon Lepkowski, Michael Pupcheck, and John Gala. (Courtesy of SS. Peter and Paul Church.)

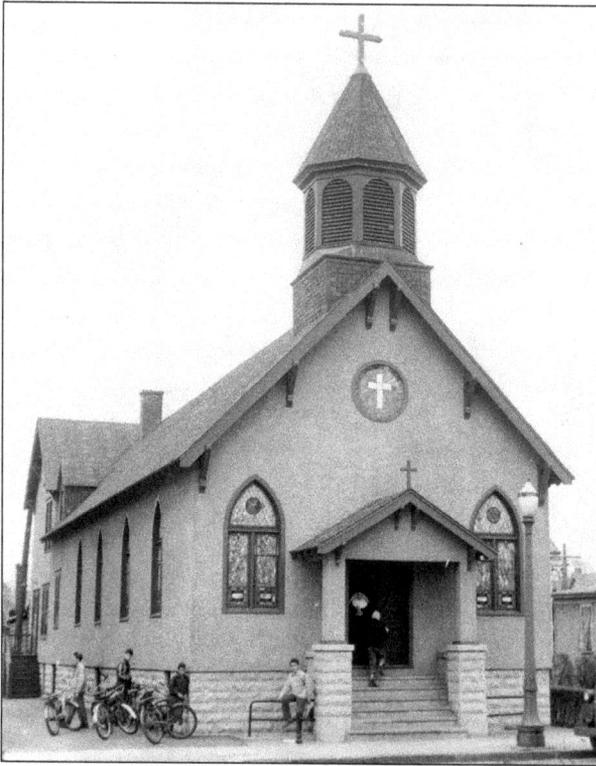

ST. ANTHONY'S CHURCH. The early Italian residents of Herkimer formed a St. Anthony's Society, which evolved into a church of its own in 1916. Antonio D'Ambrosio offered the use of his hall to hold church services while a structure was being built on South Main Street. On June 16, 1917, St. Anthony's Church was dedicated. The congregation grew, and a capital campaign was undertaken. In 1964, the new St. Anthony's Church was dedicated across the street from the original church.

GRADUATING CLASS OF 1947. This picture, taken on the steps of St. Anthony's Church of the 1947 graduating class, shows church members, including Vito Losito, Clam Falzaroni, Sam Servello, Robert Piani, Rocco Losito, Bob Nashton, Anthony Fusco, Carmen Netti, John Servello, Theresa Varano, Pauline Cirelli, Theresa Campagna, Yolanda Yetty, Jacklyn Donato, Theresa Angelotti, and Laura Caliguire. One of the most memorable pastors at the church was Fr. Gustave Purificato, who served the church from 1927 to 1970. (Courtesy of Vito Losito.)

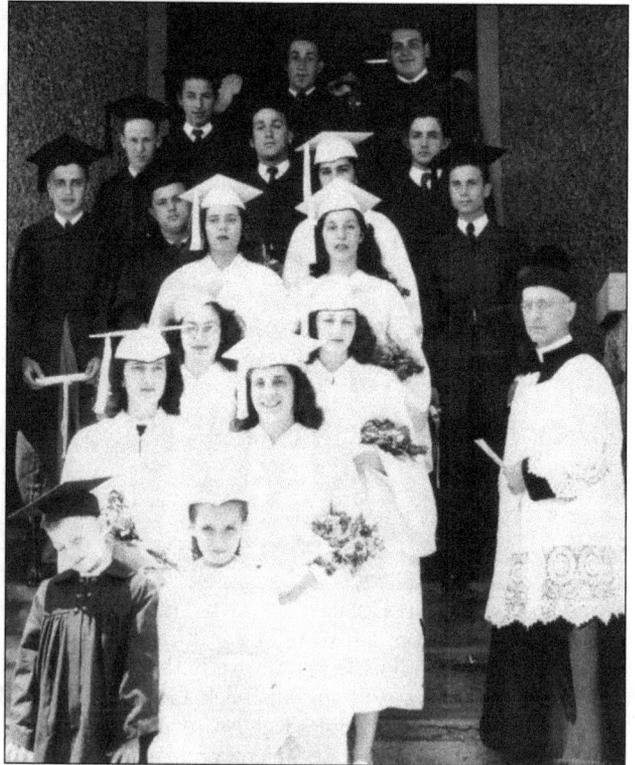

ST. JOSEPH'S ROMAN CATHOLIC CHURCH.

St. Joseph's Roman Catholic Church began in 1907 through the efforts of Herkimer's Polish and Lithuanian residents. A chapel was first erected on South Main Street, and as parish numbers doubled before World War I with the influx of Polish immigrants, a new, large brick church and parish house were built on South Washington Street. In 1957, a parish school with six grades, a two-story convent, and a social center were built on the east side of South Main Street.

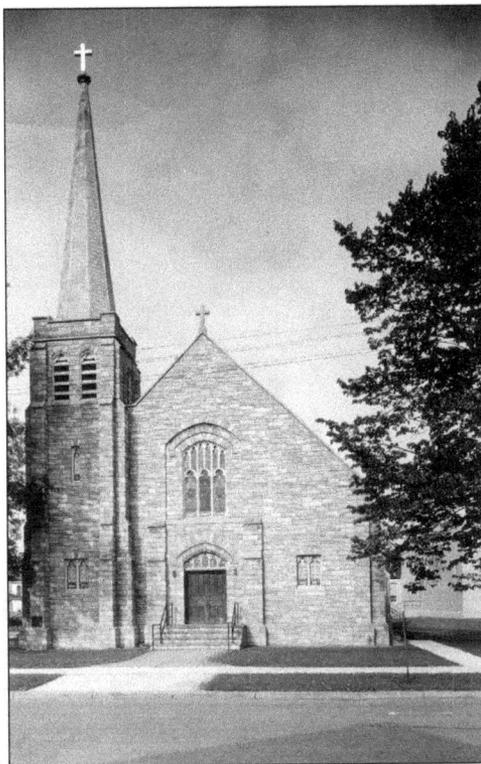

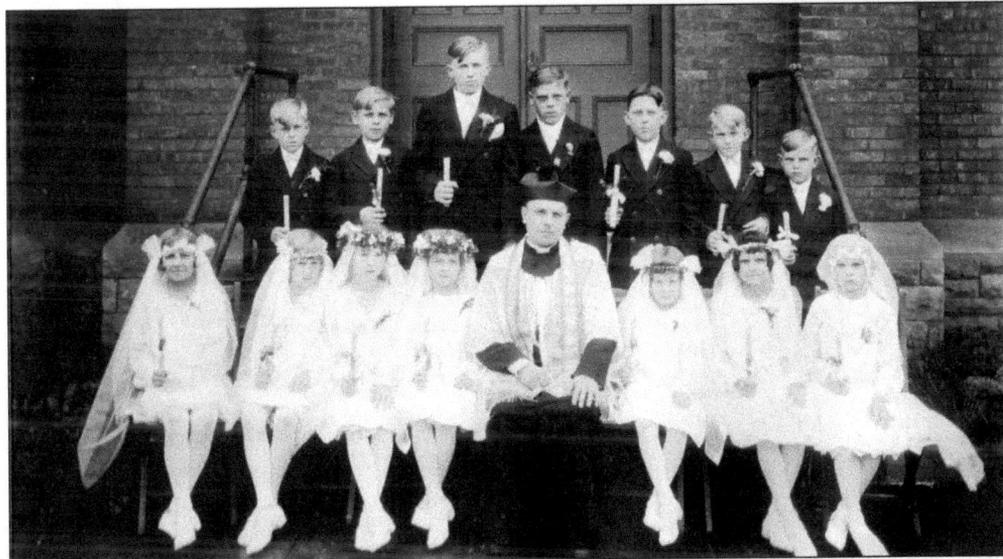

ST. JOSEPH'S FIRST COMMUNION. This picture of a First Holy Communion class is dated about 1930. The Reverend Joseph Blonkowski, who served St. Joseph's Roman Catholic Church from 1924 to 1937, is in the center. Only a few of the children are identified. In the first row, first on the left is Anna Rocky, third and fourth from the left are Helen and Mary Nasatowicz, and second from the right is Nellie Wezalis. In 1993, St. Joseph's merged with St. Anthony's Church and the building was torn down for the Herkimer Area Resource Center (HARC) parking lot. (Courtesy of Minnie Wezalis.)

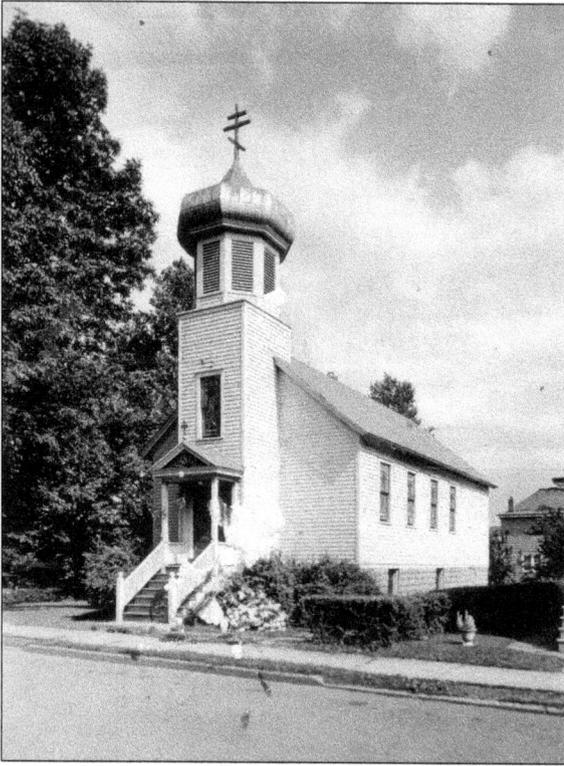

St. Mary's Ruthenian Roman Catholic Church. The first Ukrainian church established in Herkimer began in 1906, and five years later, two lots on Moore Avenue were purchased. Construction immediately began, and the cornerstone for the wooden church was laid in October 1911. On December 25, the first Divine Liturgy and consecration of the church building took place. The name of the church was the St. Mary's Ruthenian Roman Catholic Church. In 1930, a parish cemetery was purchased in East Herkimer.

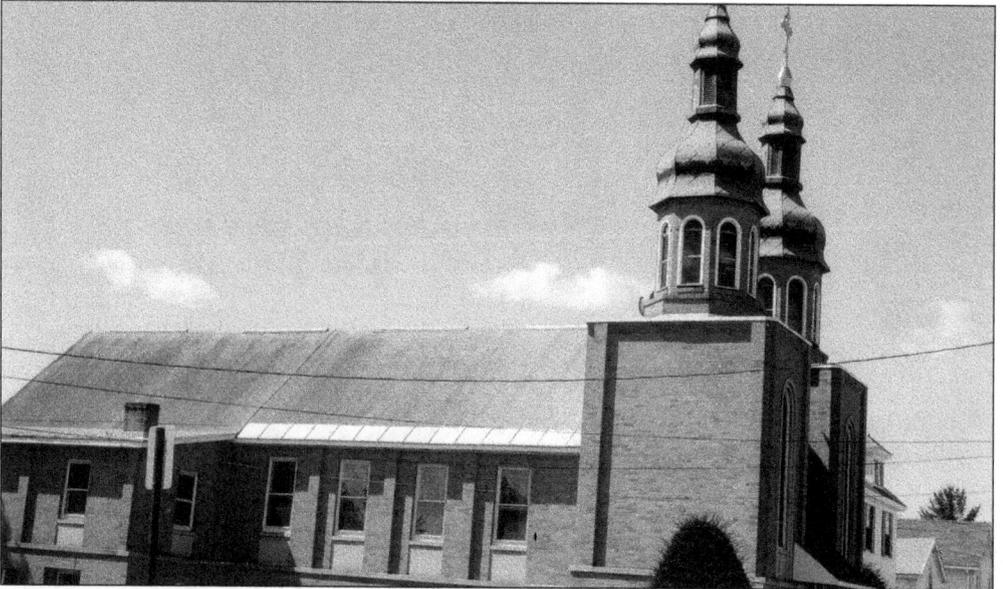

St. Mary's Ukrainian Orthodox Church. The rebirth of the Ukrainian Orthodox Church in the Ukraine spurred the Herkimer congregation to meet with the heads of the Orthodox Church. Ties were severed with the Greek Catholic church, and they became affiliated with the Ukrainian Orthodox Church of America. The new name for the church was St. Mary's Ukrainian Orthodox Church. In 1961, the wooden church was replaced with a major remodeling effort to its present brick edifice with two domes over the front section.

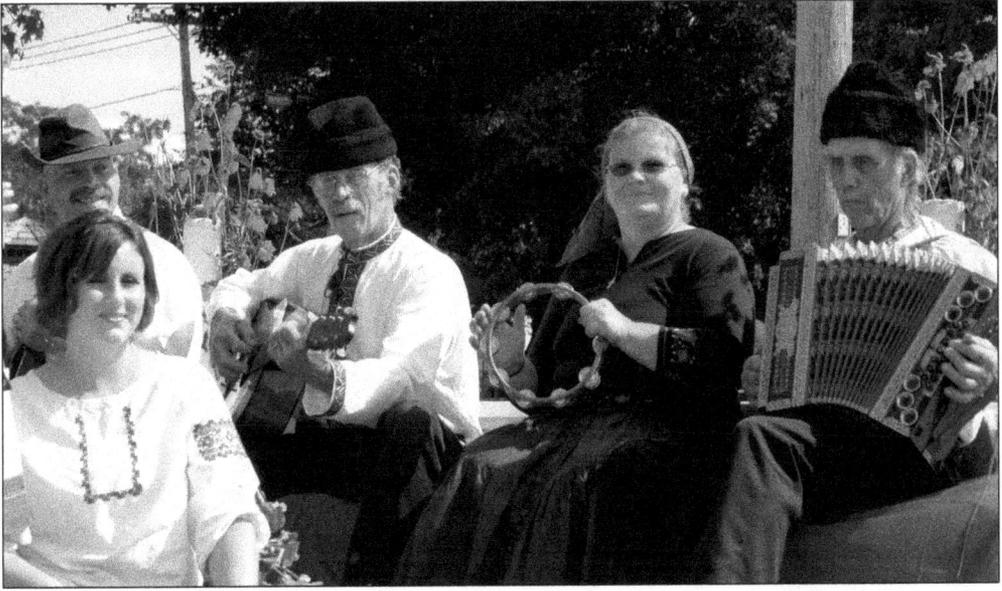

UKRAINIAN CULTURE LIVES ON. The first wave of immigration from the Ukraine region began in the 1870s and came to a peak in 1914 at the onset of World War I. Second and third generations living in this country kept the Ukrainian culture alive, like these Herkimer County residents in the Herkimer bicentennial parade in 2007, wearing traditional costumes and playing Ukrainian music. Pictured from left to right are Stephanie Mowers, Steven Hula, Nick Hula, Sandra Hula, and Wasyl Hula. (Courtesy of Arthur Kineke.)

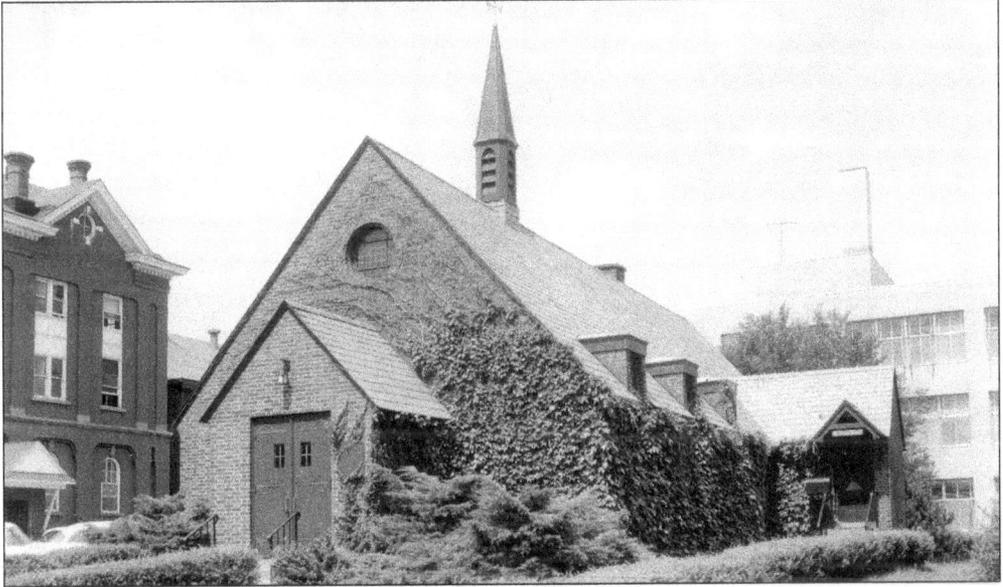

CHRISTIAN SCIENCE CHURCH. The first Christian Scientist Society was formed in Herkimer in 1899, and in 1902, it incorporated as a branch of the mother church in Boston. The congregation purchased the Steele property at 312 North Main Street and worshiped there until 1937, when it built a new church on the site. The church was dedicated in 1950, when it was debt free. The congregation dissolved in 1983, and the building was sold to Herkimer County. Plans are underway for it to be taken down to be used for a county parking lot.

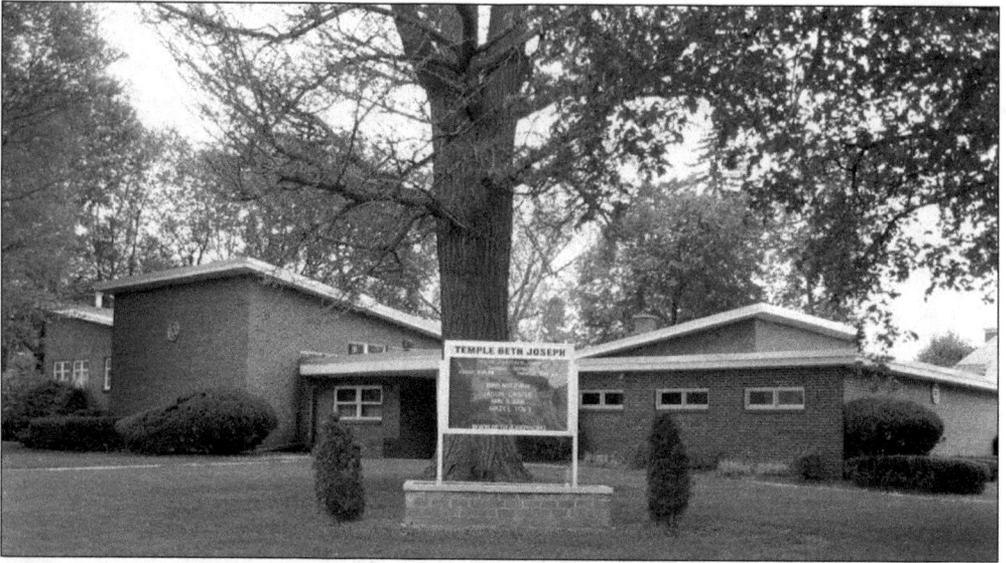

TEMPLE BETH JOSEPH. For the early Herkimer Jewish residents, temple services were held in homes of members, or halls were rented. In 1938, a charter was filed for Temple Beth Joseph. Frank J. Basloe purchased the old Mark property on the corner of Church and North Prospect Streets in 1946 and presented the site to the temple for its use. On September 18, 1949, a dedication was held for the new Temple Beth Joseph, named in memory of Joseph Basloe, one of the first Jewish settlers in Herkimer.

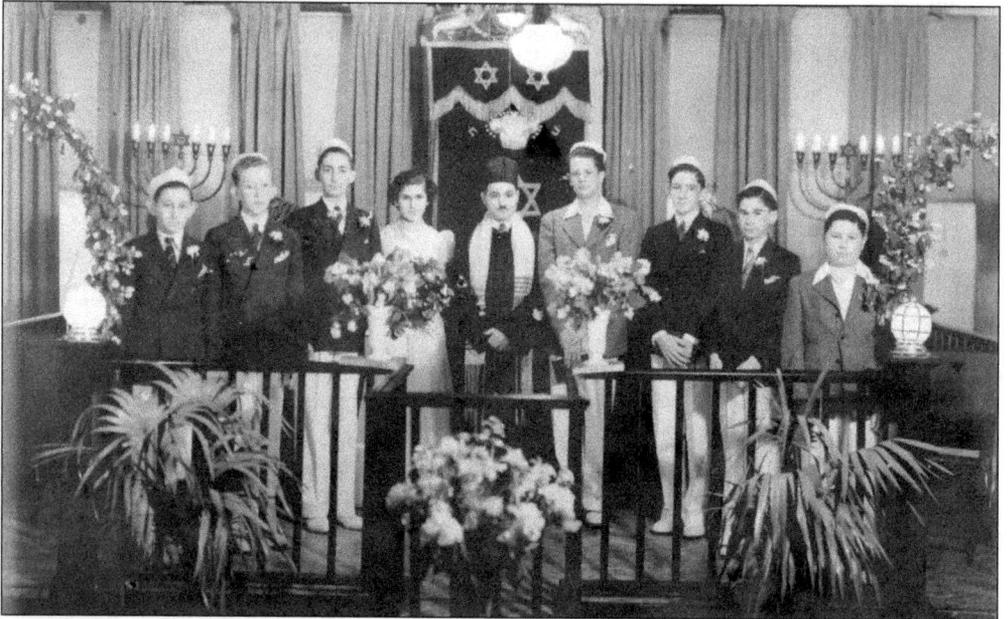

HEBREW HIGH SCHOOL GRADUATION. In 1957, the Ida Castle School addition was completed on Temple Beth Joseph. Another addition was completed in 1964 for the Rose Basloe Library. Shown are the Sunday school—Hebrew High School—confirmation graduation exercises in June 1940. Pictured from left to right are Irving Carroll, Leonard Levin, Earl Shaffer, Shirley Cohen, Rabbi Kumin, Malcom Eisenstat, Stanley Aberson, William Rosenfeld, and Kenneth Elow. (Courtesy of Temple Beth Joseph.)

72

Five

BUSINESS AND INDUSTRY

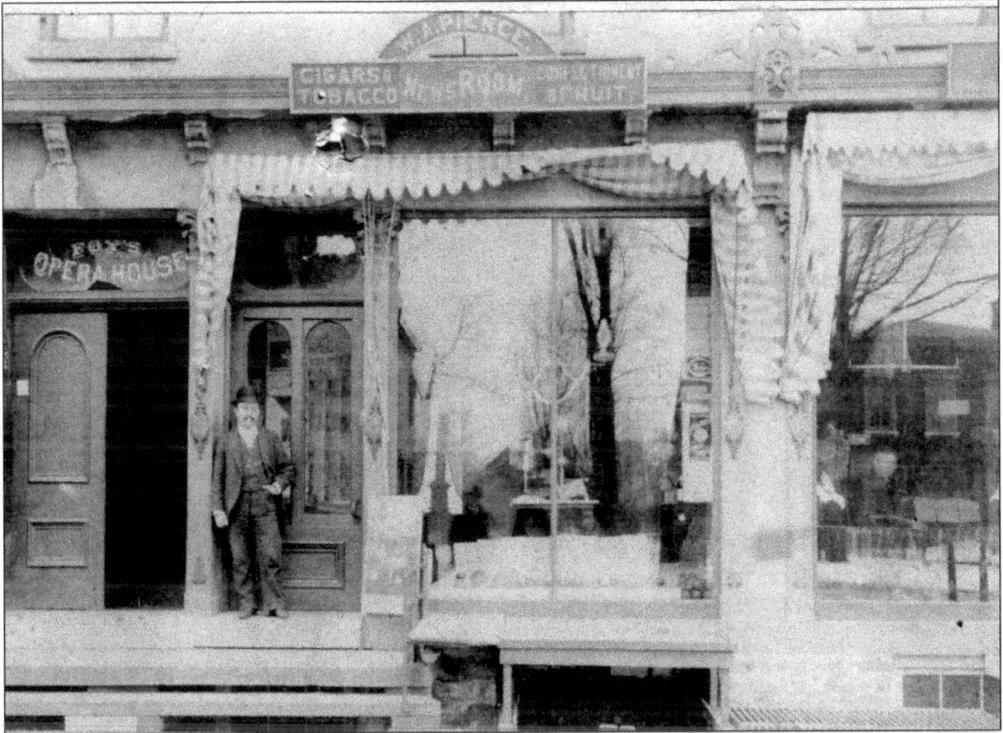

PIERCE NEWSROOM AND FOX OPERA HOUSE. William Pierce, shown here, started with an armful of newspapers and 12 years later employed 17 people, retailing 1,500 newspapers daily. The business on North Main Street near Fox Opera House was later moved to the Tower Block. The opera house was located near the Hotel Waverly (now Glory Days) in the Fox Block, erected by Charles Fox. The theater accommodated 600 people and showed Herkimer's first movie, *Fire and Flames*. (Courtesy of Meta Pierce Campbell.)

ALBERT LAWRENCE GROCERY STORE. Albert Lawrence, pictured with his wife, Elizabeth, operated what was considered to be the first neighborhood grocery in town, at the corner of Bellinger Avenue and Bellinger Street. The business was sold in 1917 to John Snyder when Lawrence acquired the Mohawk Grocery Company on Second Avenue, and he expanded the business into seven counties. The Lawrences had two sons: Leo, a longtime New York State assemblyman, and Albert, a prominent attorney. The building is now Francis Baggetta Opticians. (Courtesy of Marion Morse.)

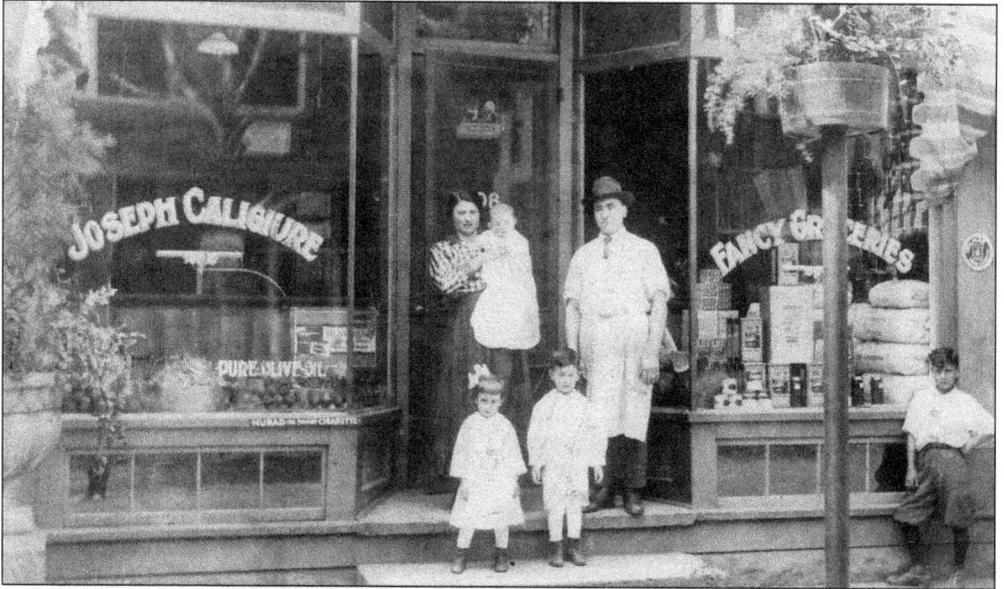

CALIGUIRE GROCERY STORE. One of the many family-owned shops started up on the south side of Herkimer by people making new lives for themselves from eastern and southern Europe in the early 1900s. Joseph and Rose Caliguire came from Italy and operated a grocery store on the corner of South Main Street and West Smith Street and raised a family of eight children. Pictured are Rose and Joseph with their three eldest children, Carrie, Peter, and baby Joseph Jr. (Courtesy of Florence and Laura Caliguire.)

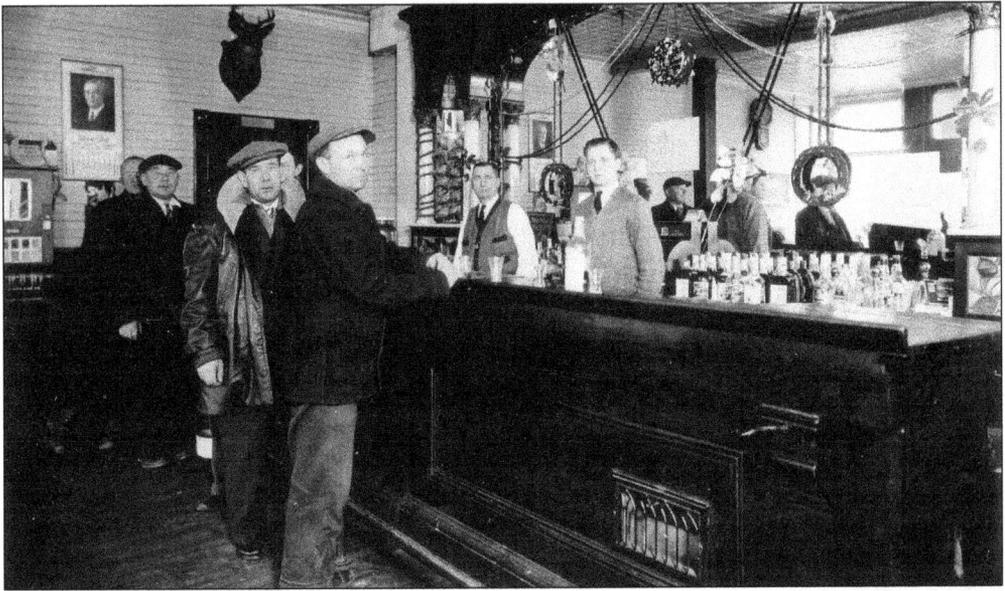

ALEX'S GRILL. Alex's Grill, on the corner of King Street and John Avenue, was a popular spot with the workingmen of Herkimer, especially around Christmas, as in this 1935 picture. Behind the bar are Alex Radaskiewicz and his son Bill serving up the holiday cheer. The bucket on the floor between the men's legs was probably used as a spittoon. In the mid-1950s, the business changed hands and became Little Tom's Tavern and then Jimbo's Restaurant in 1975. In later years, it was Community Action. (Courtesy of Bob Wilson.)

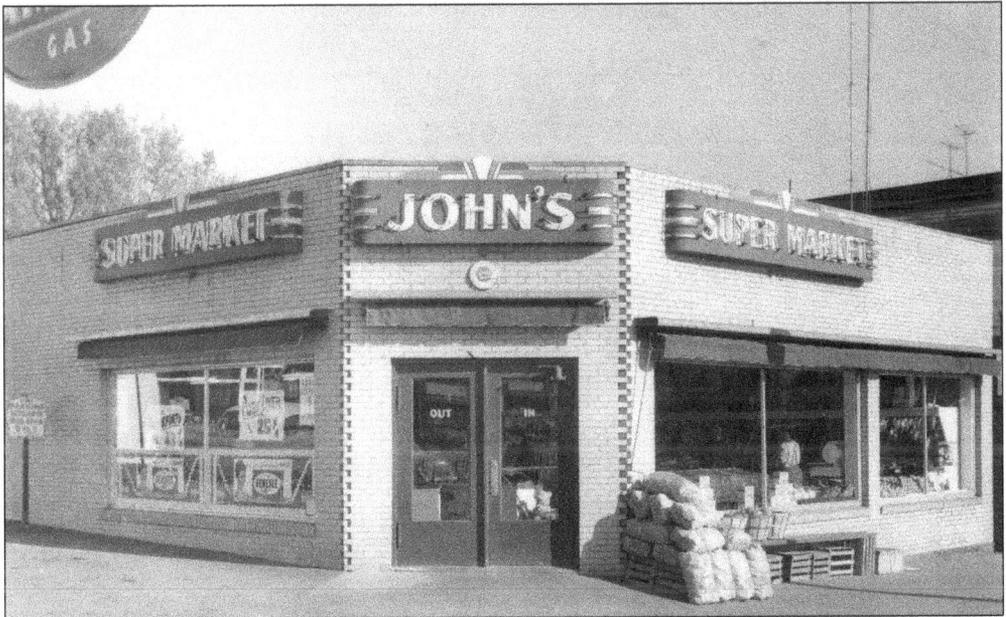

JOHN'S SUPER MARKET. Starting out as an employee of the Caliguire's Grocery and later Fazio's Grocery, John Cassella first opened a fruit market on Mohawk Street in 1937 and then a grocery at 101 South Main Street near the location of the old New York Central Railroad station. He operated the corner store until his retirement in 1970. It then became the Mohawk Bake Shop and later Rent-A-Vision. The shop still stands and houses the Western retail store Desperado's.

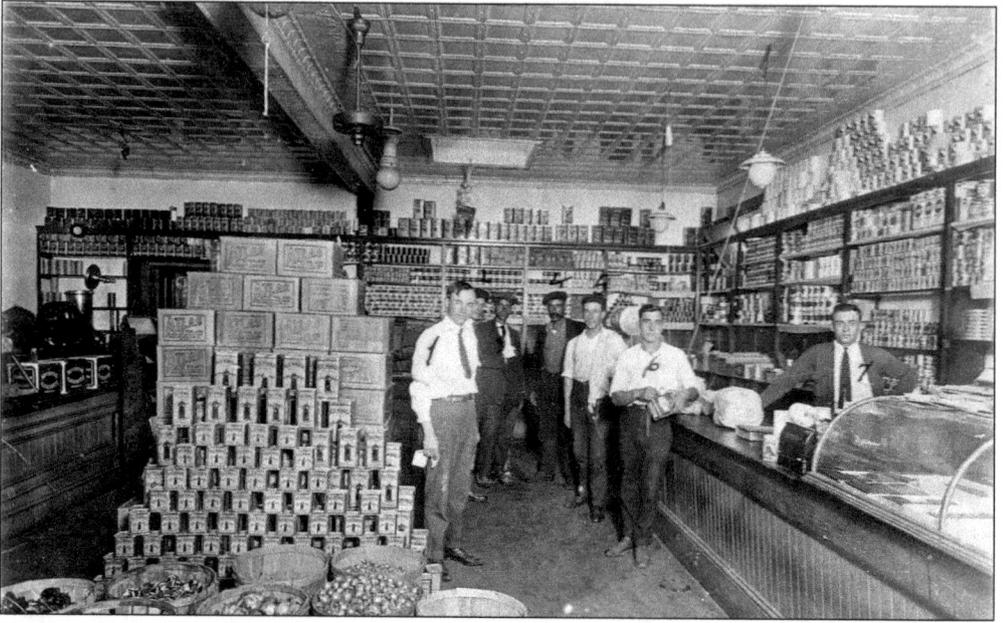

CHIRICO BROTHERS. Three brothers who emigrated from Pianopoli, Italy, went into partnership with each other and operated a successful business for over 40 years under the family name. They were Joseph, Perfetto, and Menotti Chirico, and their first venture was a grocery store at 125 West Smith Street around 1916. They soon expanded to include a bakery and then a restaurant in the 1930s, which became a south side hot spot. Pictured (above) in the grocery store are Joseph (far left), Perfetto, and Menotti (right). In the bakery is Menotti (left), and the little boy is Francis Chirico. In 1959, the business was sold outside the family but then later resold to a Chirico nephew Vincent Chirico, who operated Chirico's Restaurant. The building burned in 1985 and was razed two years later. (Courtesy of Charlotte Chirico Szarejko.)

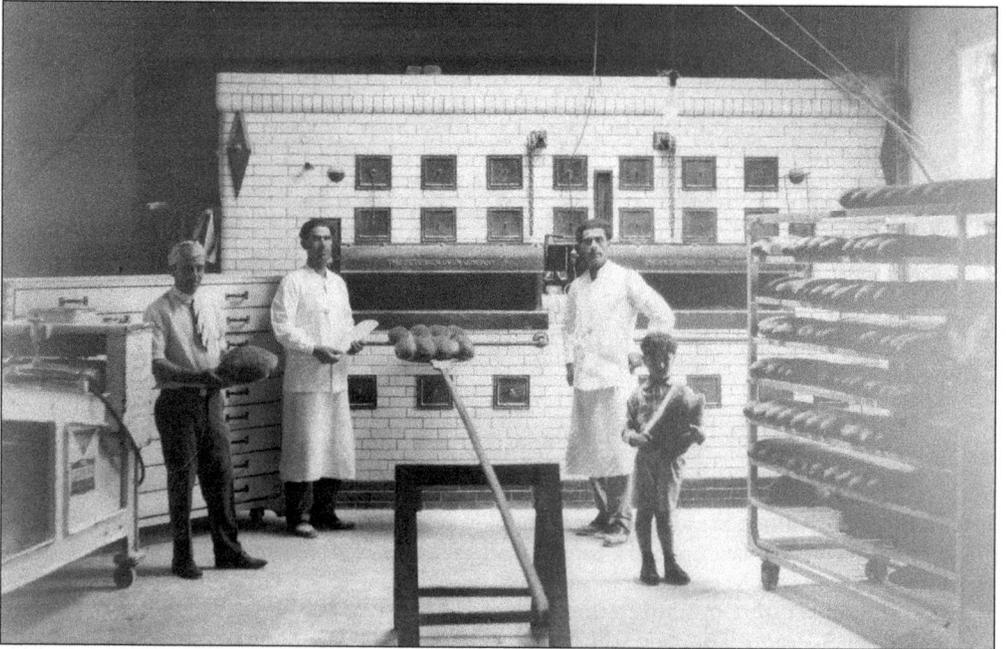

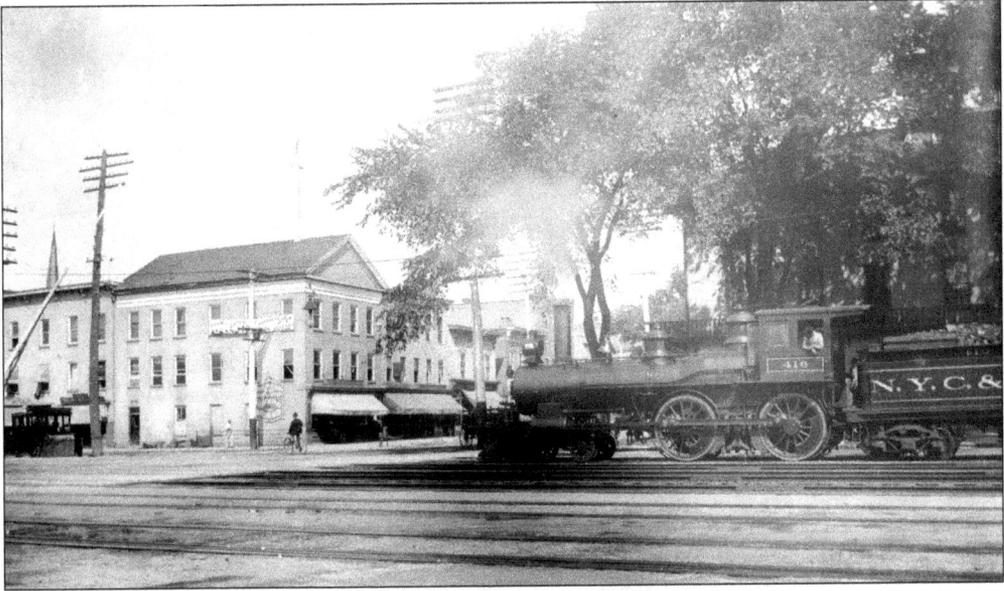

MANION AND FICK SALOON AND RESTAURANT. In 1899, Bartley Manion and Frederick Fick purchased the block that housed the newspaper offices of the *Herkimer Democrat* since the late 1850s. This picture shows the Manion and Fick saloon and restaurant on the corner of North Main and Albany Streets. After a brief partnership that was dissolved when Fick was declared mentally unfit in 1900, Manion continued the business on his own. The New York Central train is in the foreground heading west. (Courtesy of Lil Gaherty.)

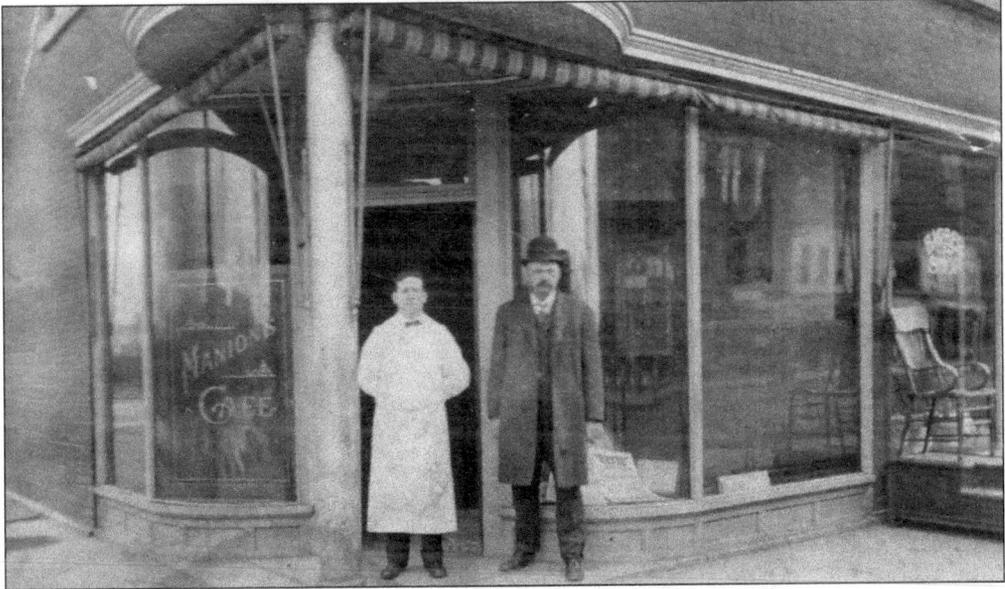

MANION CAFÉ. Shown is the Manion Café, operated by Manion after his partnership with Fick, with two unidentified men standing in front. In 1904, John and Bartley Manion built this brick building to replace the 1850s building. Next door was a barbershop run by Maurice Hartigan and Evert Jacobson. Bartley was a well-known business figure in the community, serving as undersheriff at one time. His business ventures eventually led to his bankruptcy in 1909. (Courtesy of David Hunt.)

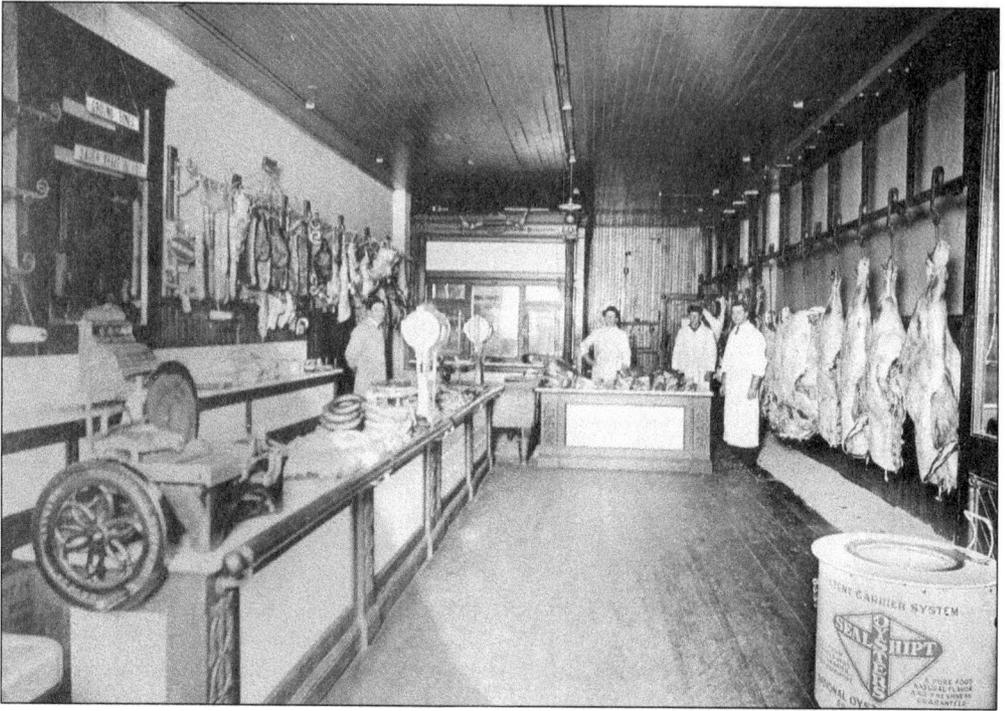

FALK MEAT MARKET. In 1910, Charles Falk and his son Carl bought the Mang and Barney Meat Market on North Main Street, where the AAA tourist agency is located now. They operated for a number of years under the name C. J. Falk and Company. Sanitary laws were less strict then, as can be seen by the meat hanging unrefrigerated along the wall. Note the very large container of oysters, a delicacy of the time, in the lower right corner. (Courtesy of Jim Greiner.)

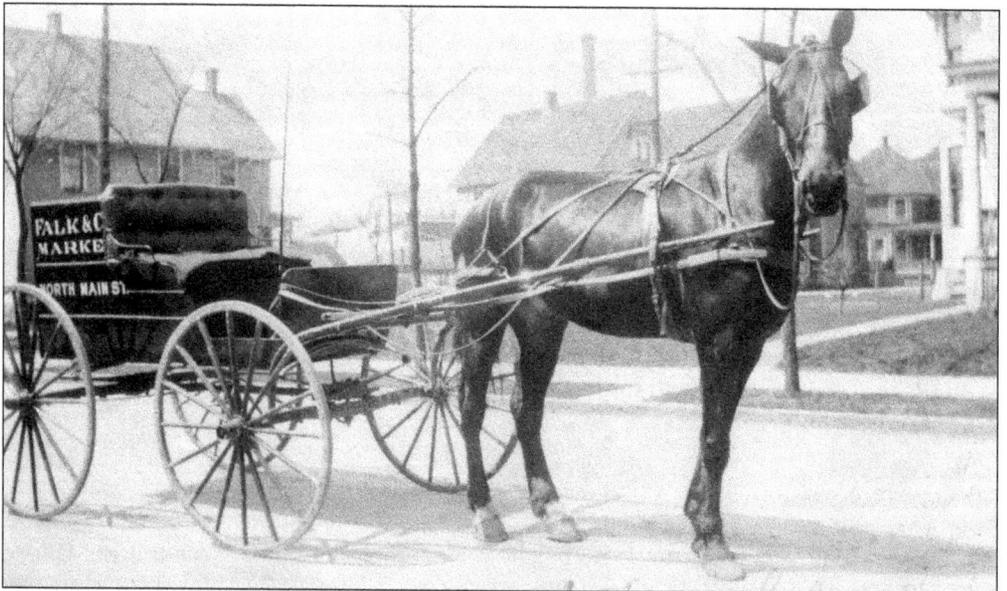

FALK DELIVERY WAGON. While none of the men in the photograph of the Falk Meat Market can be identified, their faithful delivery horse, Dick, is well remembered. (Courtesy of Jim Greiner.)

NATIONAL DINER. The National Diner was a popular eating establishment on the corner of North Main Street and Park Avenue. It first opened in 1928, supervised by Everett and Roy Dibble, and was replaced by a stainless-steel diner in 1937. The picture shown is of the interior of the diner in 1946. The owner at that time was Leon Facteau. It was later owned by John Manikas and Herkimer mayor Guy Marshall. One of the diner's regular visitors was Steve Clapsaddle, pictured with cook Frank Galvano. Clapsaddle was a popular newspaper reporter with the *Evening Telegram* and the *Observer Dispatch*.

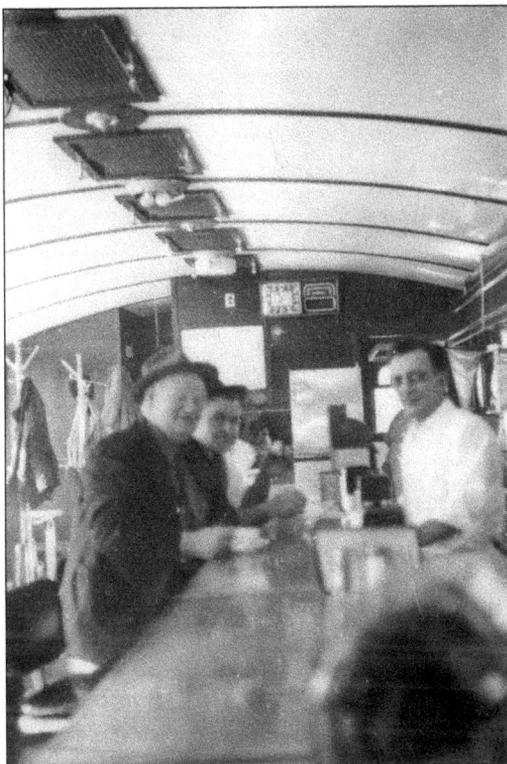

WAITRESSES AT NATIONAL DINER. The diner ran until 1953 and, in 1961, was reopened as the Westinghouse Laundromat. Pictured are waitresses Irene Facteau and Betty Jones, who are standing in front of the World War II memorial that was located on that corner.

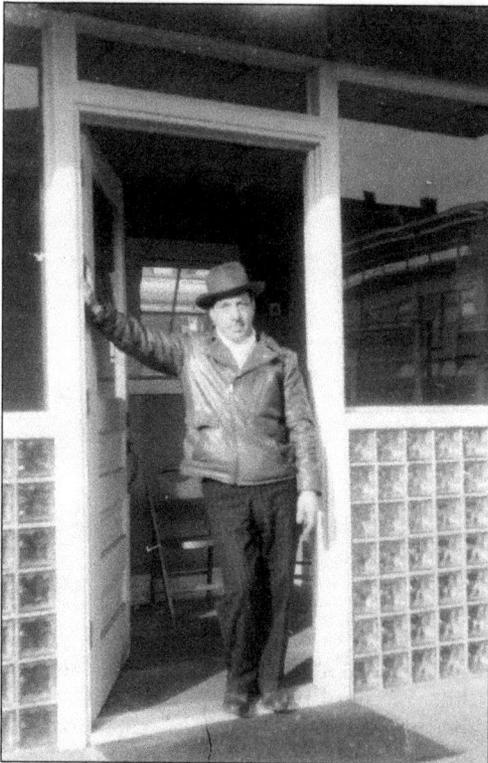

TAXI STANDS. Before cars became a staple in family households, taxi stands could be found around the village of Herkimer, offering 24-hour taxi service to residents. This taxi stand, pictured in 1946, was located on North Main Street near the National Diner and was operated by John DiPietro, who can be seen standing in the doorway. DiPietro operated the business until he entered World War II, serving with an army railroad battalion in Europe. He married Celestia Hadcock in Texas in 1951. They came back to Herkimer in 1961, where he was involved in construction until his death in 1970 due to a construction accident.

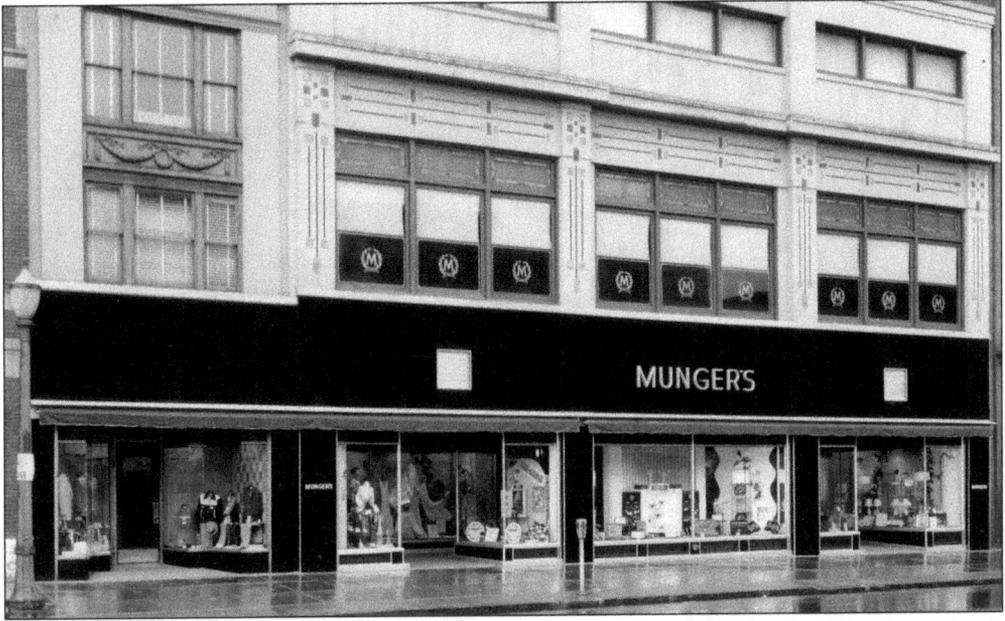

MUNGER'S DEPARTMENT STORE. Henry G. Munger opened his first dry goods store on North Main Street in 1869. From that small beginning grew a four-floor modern department store that offered everything with beautiful displays and an elevator, bringing people from as far as Schenectady and Syracuse to patronize the store. One could say Munger's was a big-city store in a small town. It closed its doors in 1971.

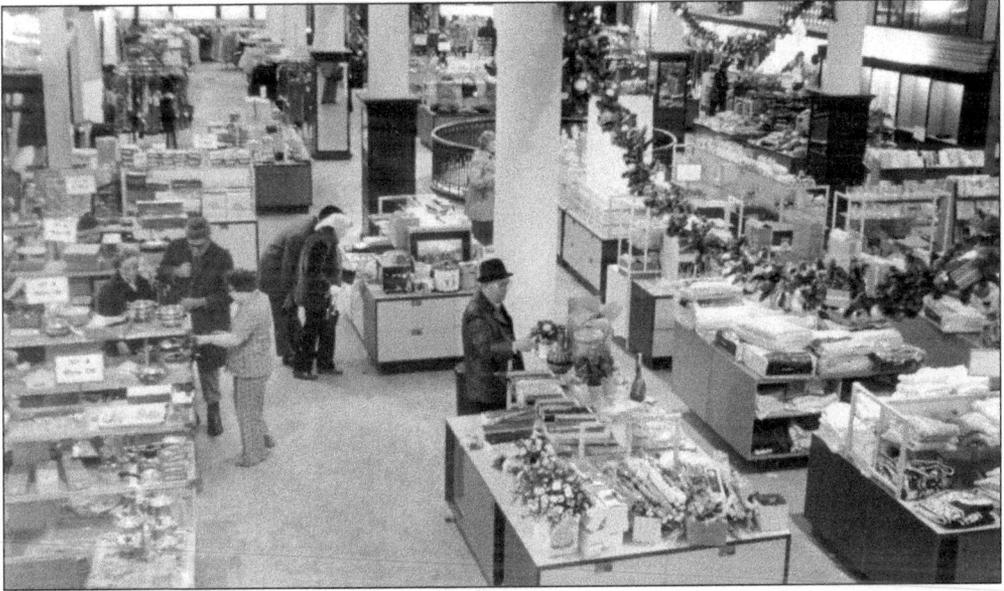

INTERIOR OF MUNGER'S. One unique item remembered about Munger's was the way it recorded its sales. It used a system of pneumatic tubes that ran from each department to the main office on the top floor. The clerk inserted the bill of sale and the customer's money into a small metal container, and the pneumatic tube sputtered and carried the container to a clerk in the top-floor office. In a moment, the metal container returned to the sales person with the proper change and a receipt.

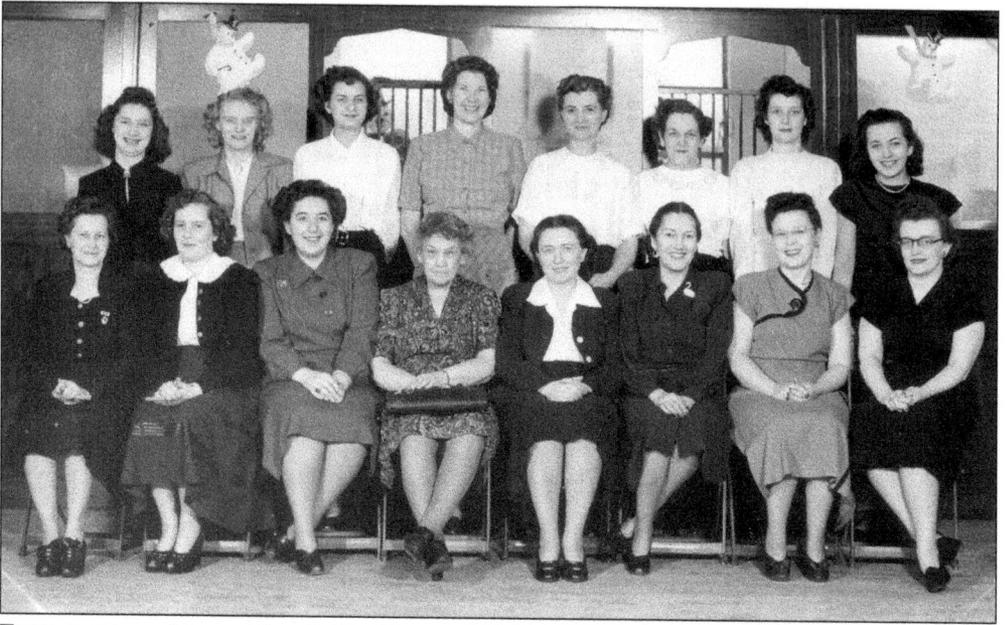

EMPLOYEES OF MUNGER'S, 1948. This picture of the employees of Munger's was taken in December 1948. Pictured from left to right are (first row) Vera Jones, Mrs. Windecker, Mary Falk, Lelia Walsh, Rose Pelichowski, Bertha Hewes, Arline Blais, and Betty Matis; (second row) Lois Brown, Emily Couchman, Betty Herkel, Jilda Wheeler, Margaret Nancarrow, Mary Fike, unidentified, and Miss Cristiano. (Courtesy of Mary Falk.)

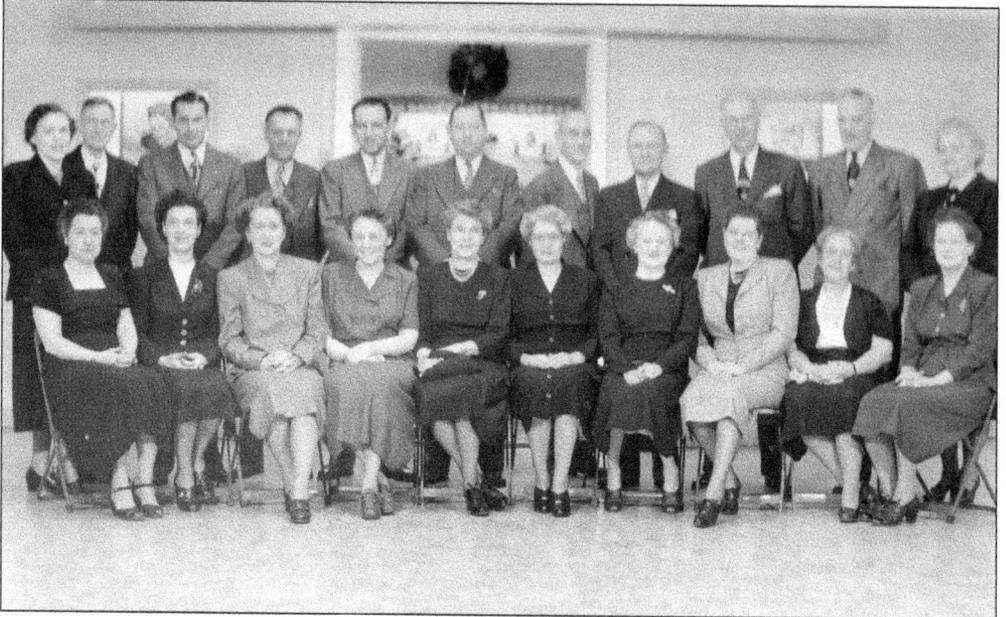

BUYERS FOR MUNGER'S, 1948. The buyers for the store, from left to right, are (first row) Clara Olyer, Ruth Crill, Mary Zeitler, Mary Facteau, Reba Talcott, Mae Cramer, Mildred Cole, Bess Burns, Maude Houpt, and Mary Jones; (second row) Flora Draheim, William Denny, Bill Bleau, John Wood, Paul Peknik, Leon Harris, Winn Denney, Don Miner, Bert Lee, Al Magee, and Eva Allen. (Courtesy of Mary Falk.)

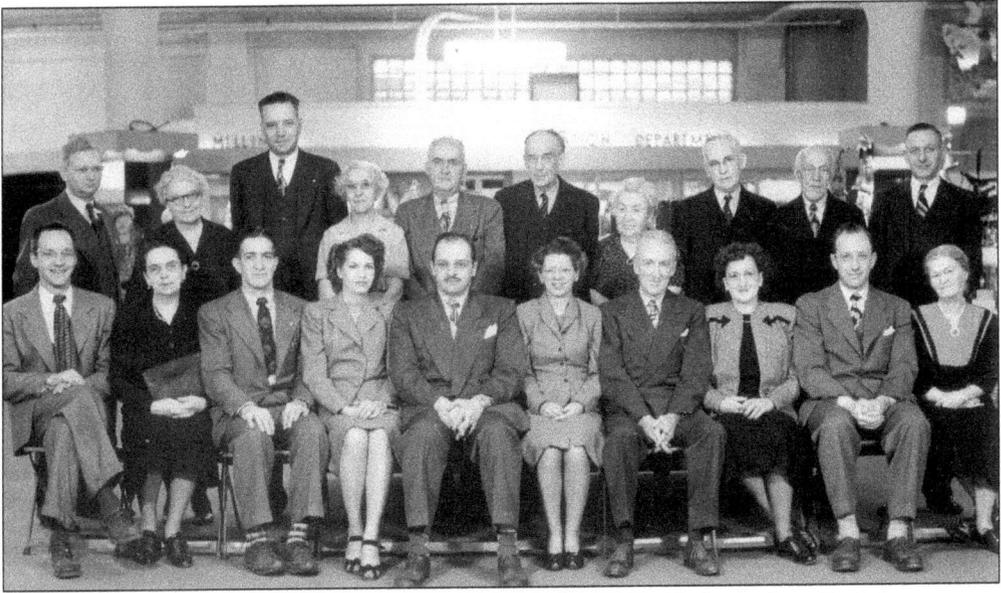

CLERKS AND STAFF OF MUNGER'S, 1948. Pictured are the clerks and staff of the store in 1948. From left to right are (first row) Robert Hamilton, Frances Perry, Frank Cancelino, Ethel Fullington, John ?, Laura Talbot, Ralph Webb, Edna Charron, James Doxtader, and Mrs. Barnes; (second row) Paul Palow, Catherine Farrell, D. A. Swartz, Mrs. Eisenlord, Albert Champney, Egbert Vickery, Margaret Whalen, Edward M. Halpin, Henry Harrer, and Ira Jackson. (Courtesy of Mary Falk.)

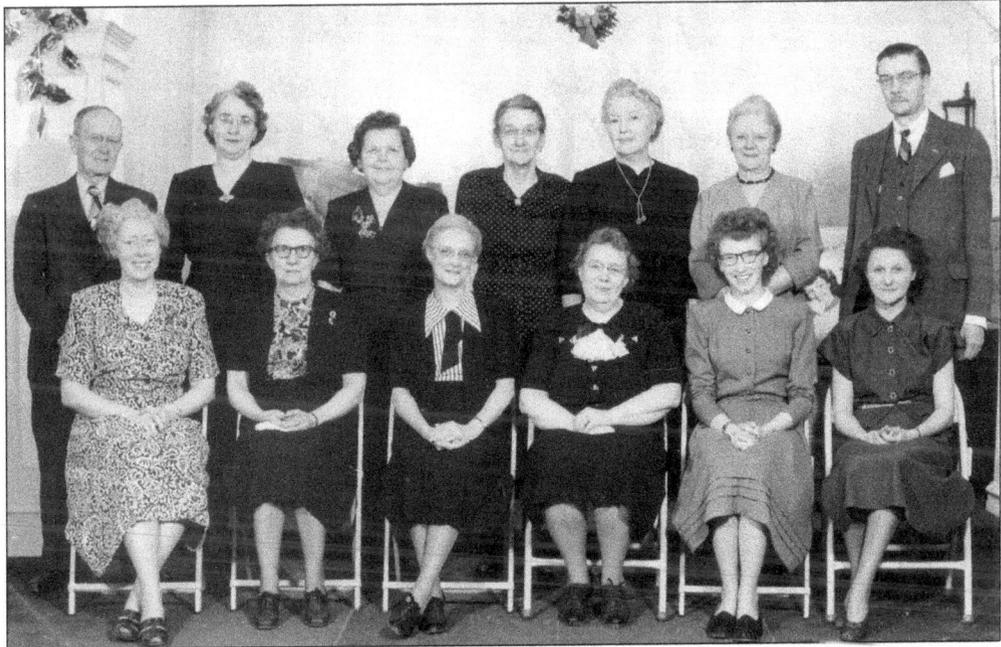

STAFF OF MUNGER'S, 1948. Pictured is the staff of the store in 1948. From left to right are (first row) Martha Babcock, Marjorie Fuller, Flora Morris, Ethel Noyes, Jewell Dreizler, and Alice Root; (second row) Earle Mackenzie, Mrs. Smith, Inez Smith, Sarah Loucks, Edna Wood, Charlotte Cassidy, and Adrian Finlay. (Courtesy of Mary Falk.)

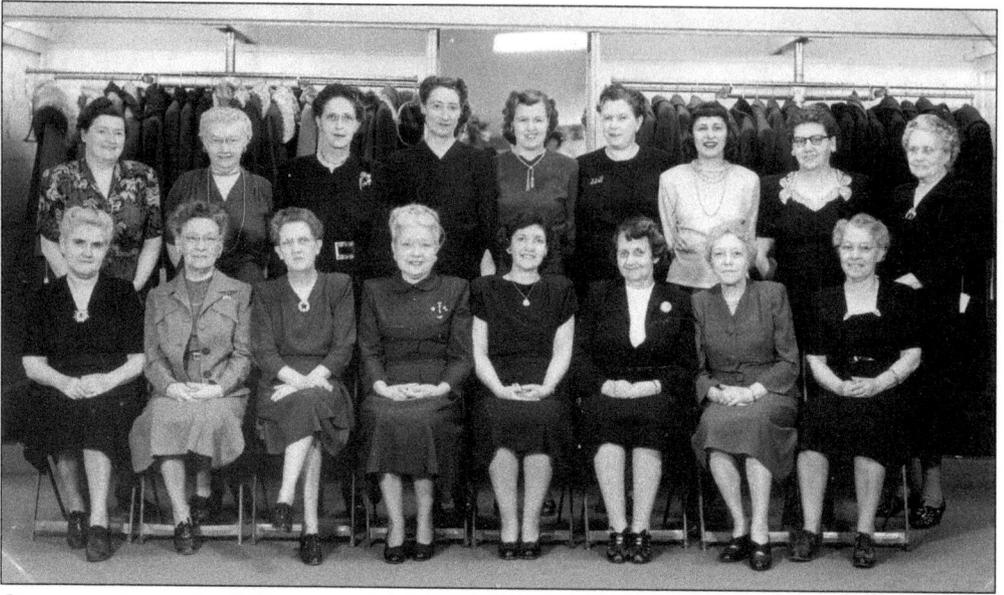

COAT AND SUIT DEPARTMENT OF MUNGER'S, 1948. Pictured is the coat and suit department of the store in 1948. From left to right are (first row) Mildred Riffanacht, Mary Sanders, Ethel Owens, Geraldine Gertenbach, Delilah Allen, Nellie Lever, Eva Hodge, and Olive Laird; (second row) Margaret Shults, Florence McIntyre, Julia Quattlebaum, Marguerite Chelle, Georgette Walstrom, Frances Hartigan, Kathryn Blanco, Florence Partlon, and Gertrude Mang. (Courtesy of Mary Falk.)

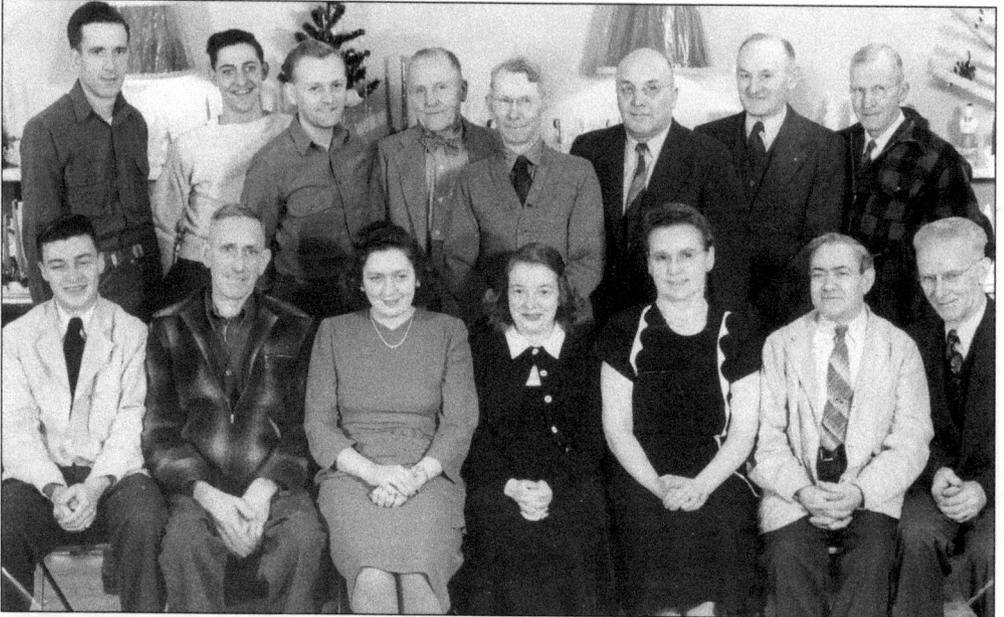

MAINTENANCE DEPARTMENT OF MUNGER'S, 1948. Pictured is the maintenance department of the store in 1948. From left to right are (first row) James Jackson, Hart Seidel, Barbara Miller, Ann Amacher, Christina Zuris, Christenso Teso, and Arthur Miller; (second row) three unidentified men, Charles Payne, Jack O'Brien, Benjamin Pooler, unidentified, and Norman Briggs. (Courtesy of Mary Falk.)

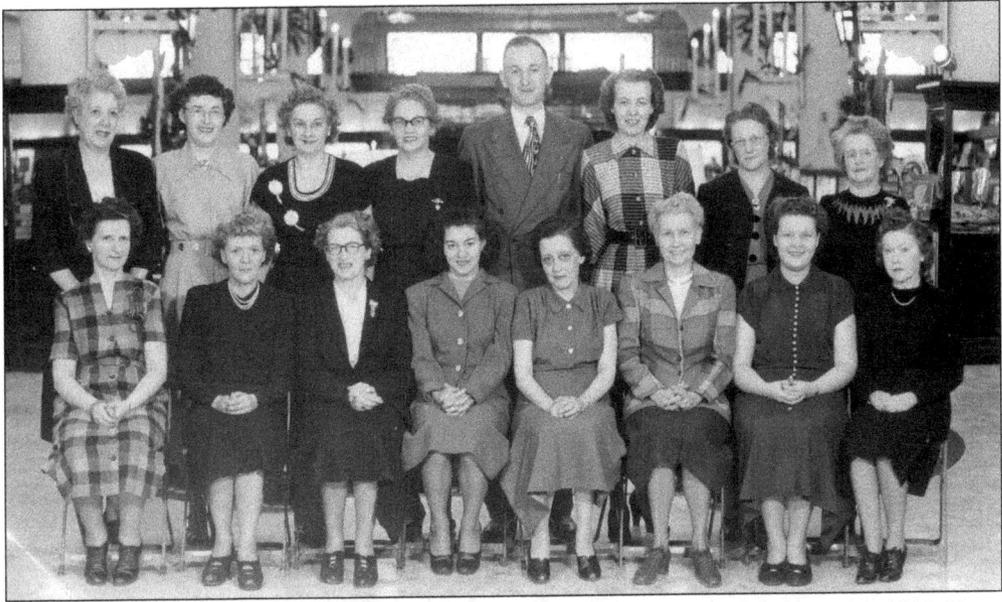

SALES PERSONNEL OF MUNGER'S. Pictured are the sales personnel of the store in 1948. From left to right are (first row) Kathleen Bell, Bess Maguire, Margaret Schwartz, Delores Taffi, Mary Casler, Ethelwyn Murray, ? Nancarrow, and Helen Van Valkenburg; (second row) Mabel Wainman, Frances Bridger, Helen Miller, Beatrice Burney, Robert Dingman, Helen Brownell, Appolonia Nedzynski, and Nora Lally. (Courtesy of Mary Falk.)

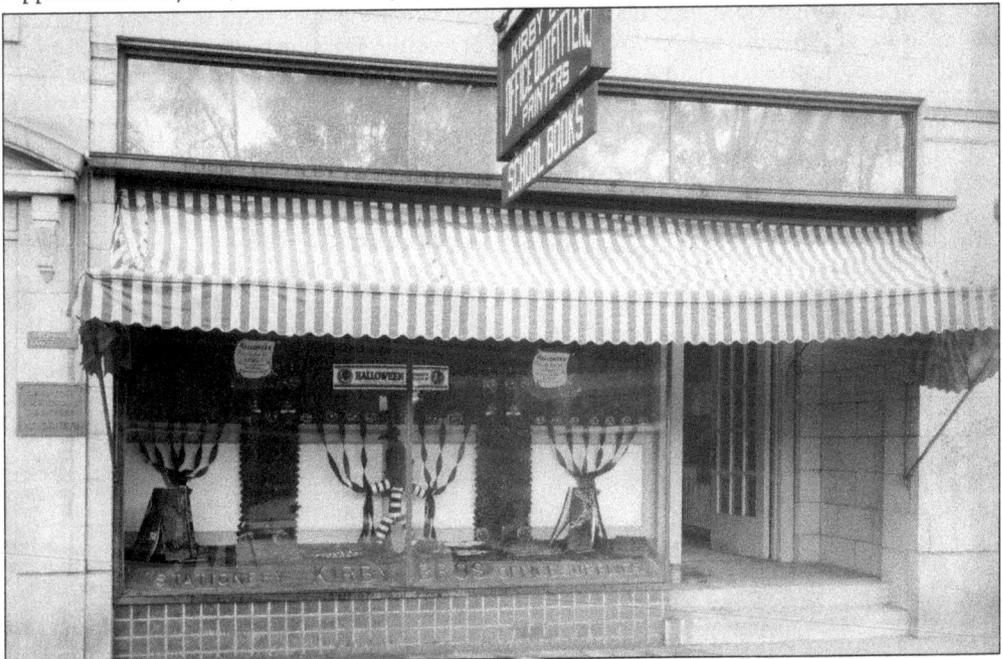

KIRBY OFFICE EQUIPMENT. The Kirby brothers (Earl, Carl, and Paul) opened a stationery and office-outfitters business on North Main Street in the early 1920s. By 1938, Carl was the only brother remaining in the business and had reorganized it as the Kirby Office Equipment Company. The company conducted a large mail-order franchise business that covered 15 states in the northeastern United States.

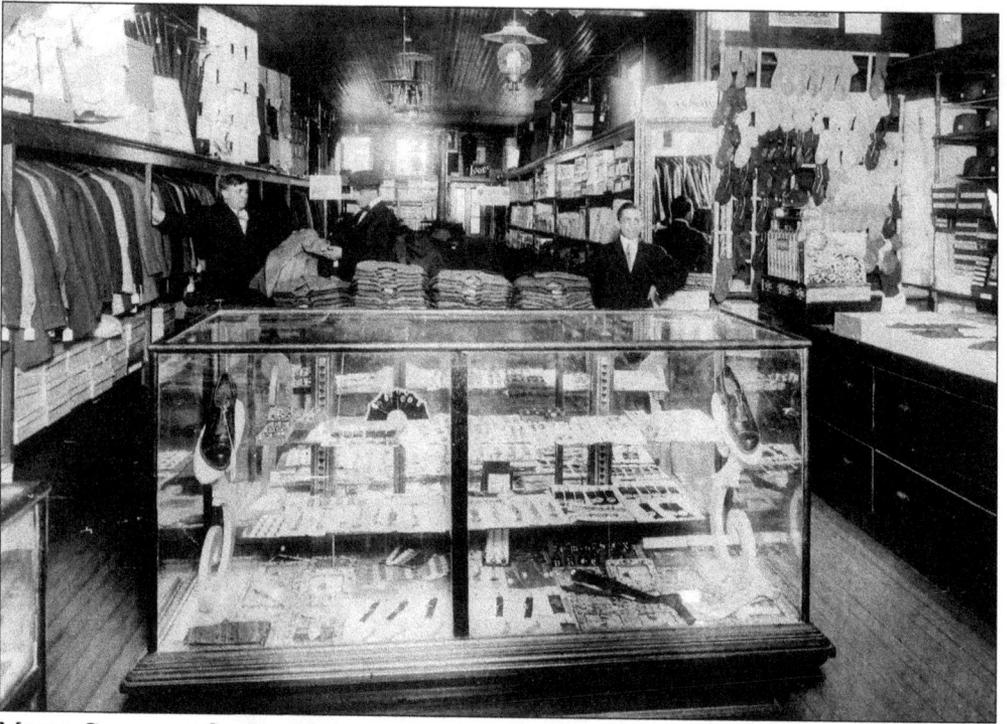

MYERS CLOTHING STORE. Herkimer merchant Nathan Myers came to the United States in 1896 from Lithuania and started his business going door-to-door with his stock of furnishings before he was able to open a shop on South Main Street in 1904, which became Myers Clothing Store. Pictured from left to right are John Pryor, Frank Basloe, and proprietor Nathan Myers.

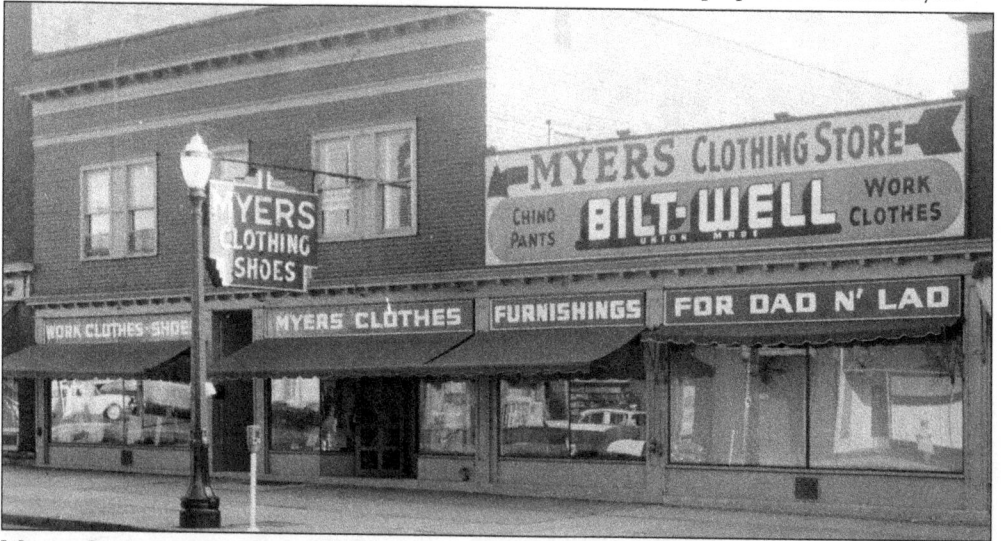

MYERS CLOTHING EXPANDS. The little shop grew to include ownership of three buildings in order to meet expansion needs over the years. Myers's son Saul carried on the family store at 205 South Main Street, which offered clothing "for Dad 'n Lad," and opened up another store on North Main Street for women's clothing. A popular shopping place, a fire on April 8, 1967, destroyed the South Main Street building and its contents. Saul continued the store on North Main Street, offering both women's and men's fashions.

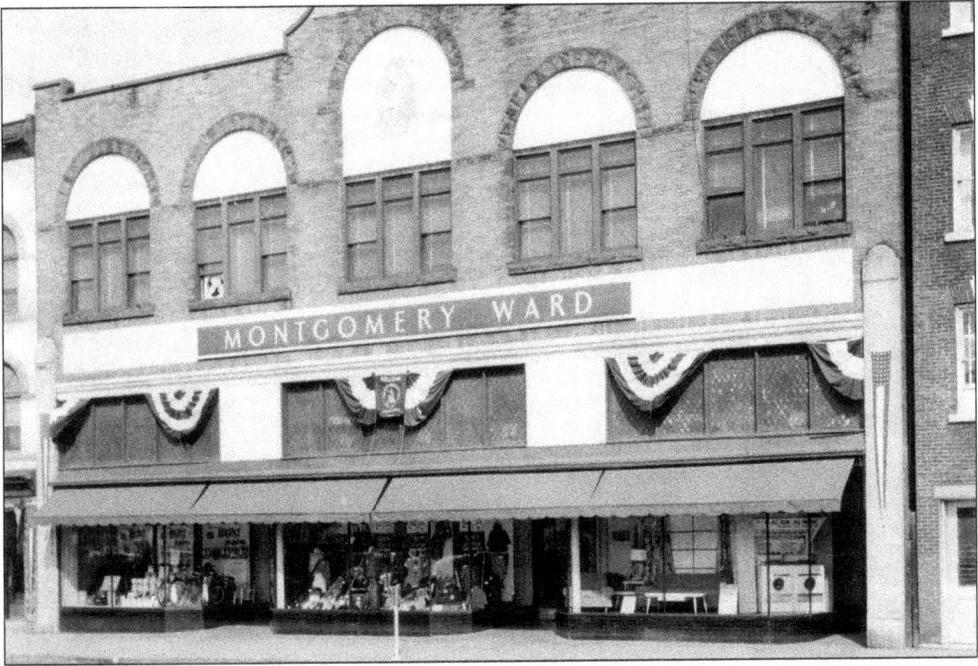

MONTGOMERY WARD. One of the leading national merchandise catalog stores, Montgomery Ward began opening retail stores across the country in the late 1920s, including this one in Herkimer on West Albany Street in 1929 (now the site of Hummel's). It offered affordable, quality merchandise from clothing to appliances. In 1962, the store was moved to 257 North Main Street and stayed until 1986, when it closed its doors and was taken over by Herkimer County for offices.

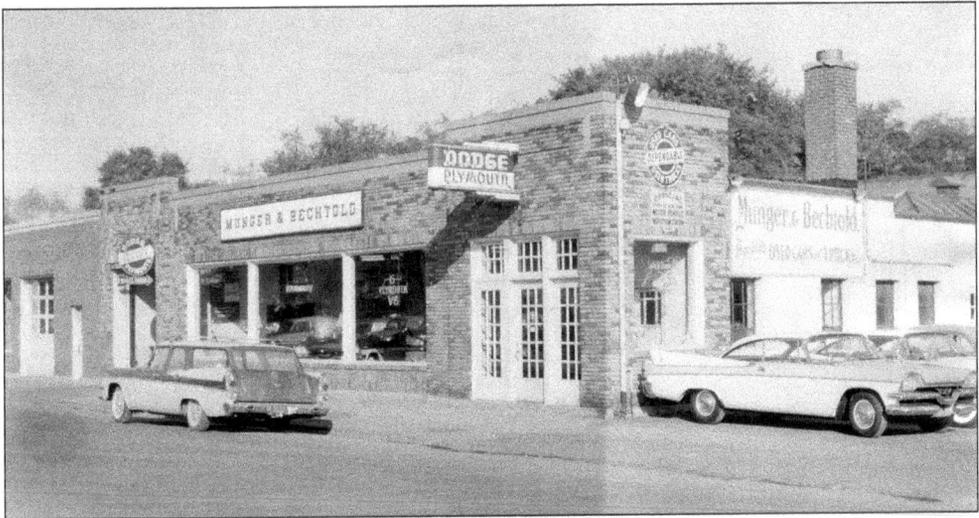

MUNGER AND BECHTOLD AUTOMOTIVE. Charles Munger was a Herkimer newspaperman, directing the Citizen Publishing Company that produced the weekly *Herkimer* and *Ilion Citizens* until his retirement in 1921, when he opened up an automobile business with his son-in-law William Bechtold. The building pictured was erected soon after their partnership on West Albany Street. It is now home to Midtown Autoworld. Bechtold took the business over after Munger's death in 1929 and continued to operate it until his retirement.

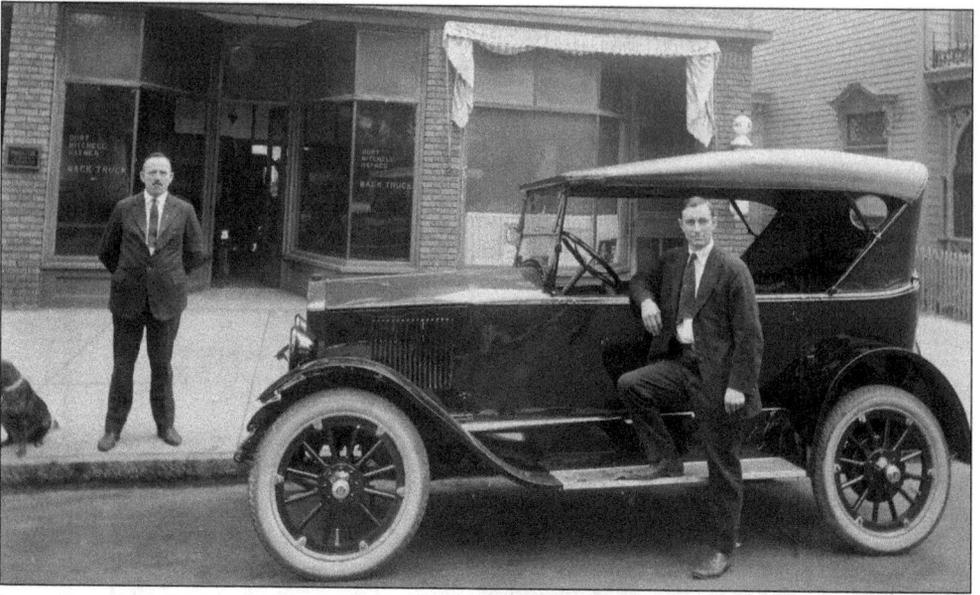

LANNING AND FOLTS GARAGE. Linus Lanning and Frank Folts built a garage at 225 North Main Street next to the library building, selling Plymouth and Desoto cars in 1927. There were offices and a showroom in the front and a service department in the rear. The second floor, reached by a ramp, was used to store cars. Lanning (left) was in charge of sales, and Folts (right) was responsible for the service department. The New York State Department of Environmental Conservation purchased the premises in 1962. (Courtesy of Mary Jo Folts.)

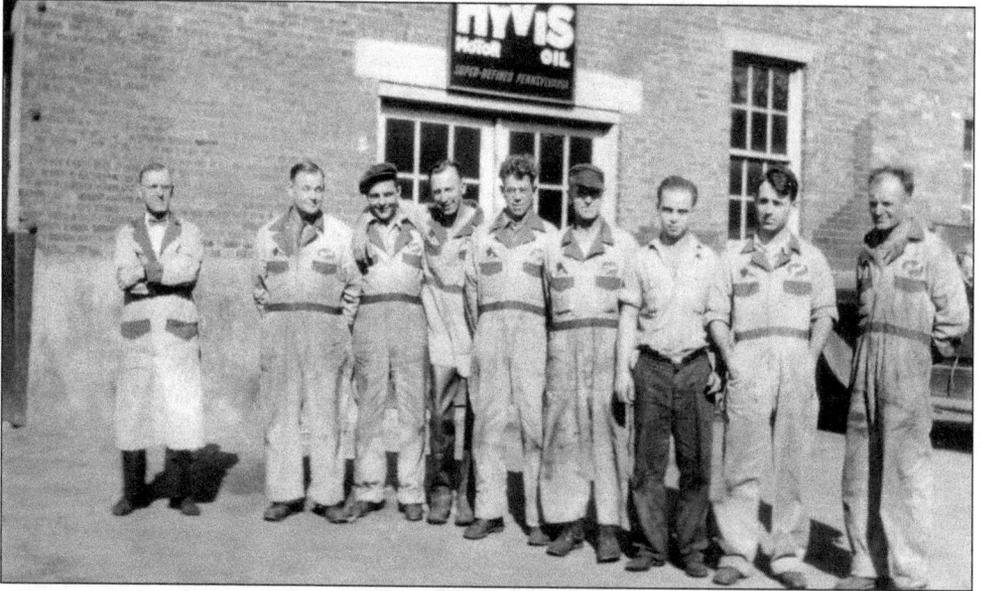

GAFFEY'S BUICK GARAGE. This photograph from about 1935 shows a view from Second Avenue of Henry Gaffey's Buick garage. Gaffey had been in the automobile business since 1913 in Newport and then in Herkimer. By 1925, the business was firmly established at 124 First Avenue. Today it is Gaffey's Car Wash. Shown in the photograph are the garage employees. From left to right are parts manager Leon Tanner, Pete Young, Stan Cherry, Russ Looman, Bill Holliday, unidentified, Terry Looman (?), unidentified, and Harry Eckler. (Courtesy of Marion Morse.)

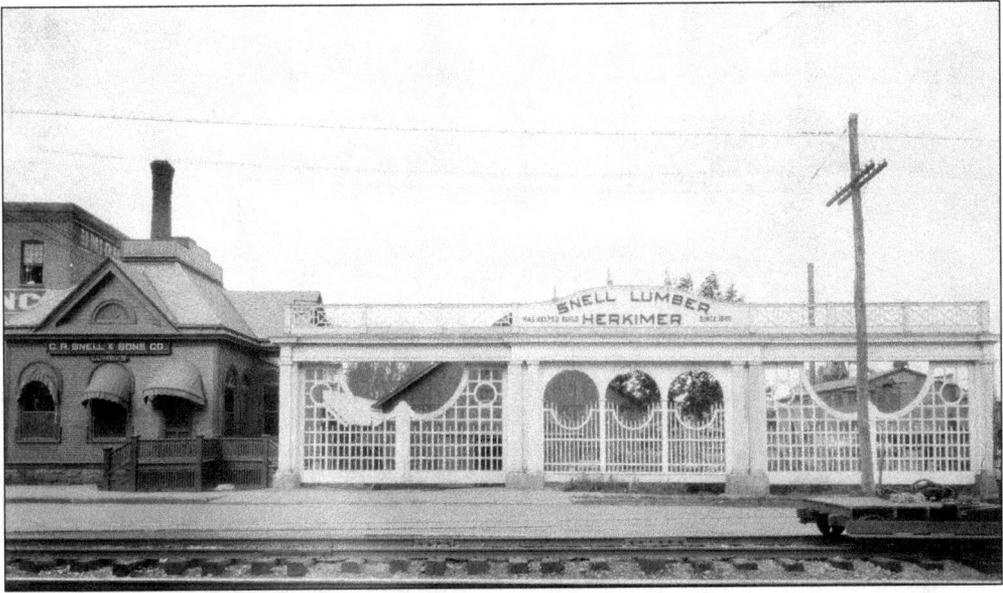

SNELL LUMBER COMPANY. About 1878, Henry Deimel and Cornelius Snell engaged in the lumber business in Herkimer under the firm name of Deimel and Snell on the north side of Albany Street near Mark Manufacturing. When Deimel retired from the firm in 1897, Snell conducted the business as C. R. Snell and Lumber Company. It carried just about everything needed to build a house. The head office was located on East Albany Street and was paneled in oak. The business was sold to Northern Lumber Company around 1945. The lumberyard was eventually razed to make way for an expanded Route 28.

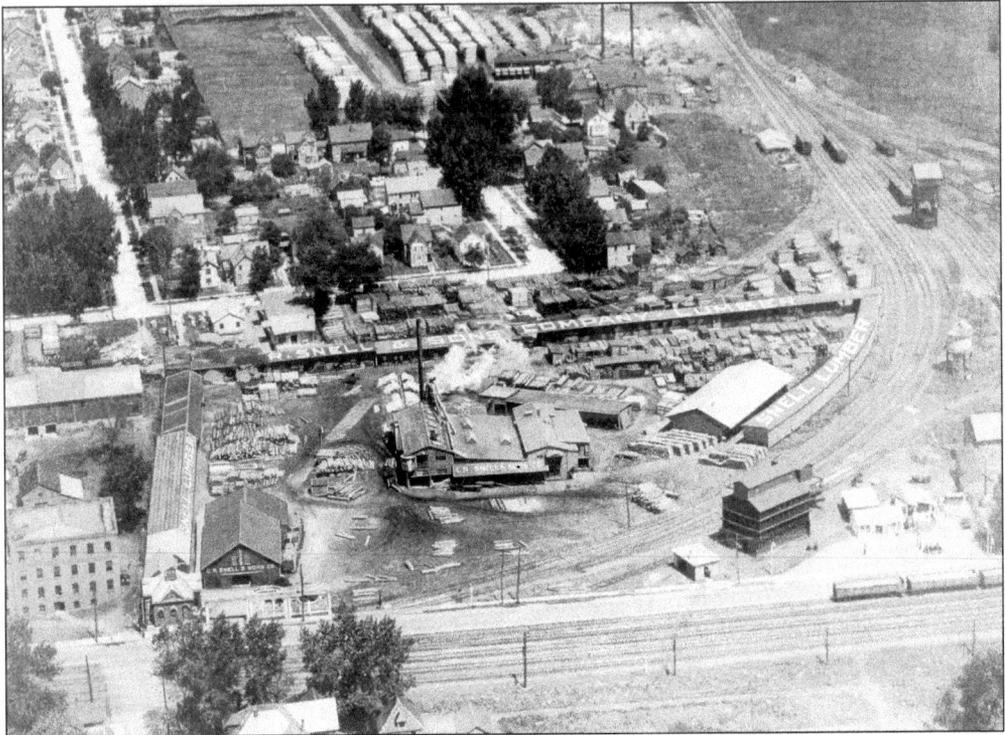

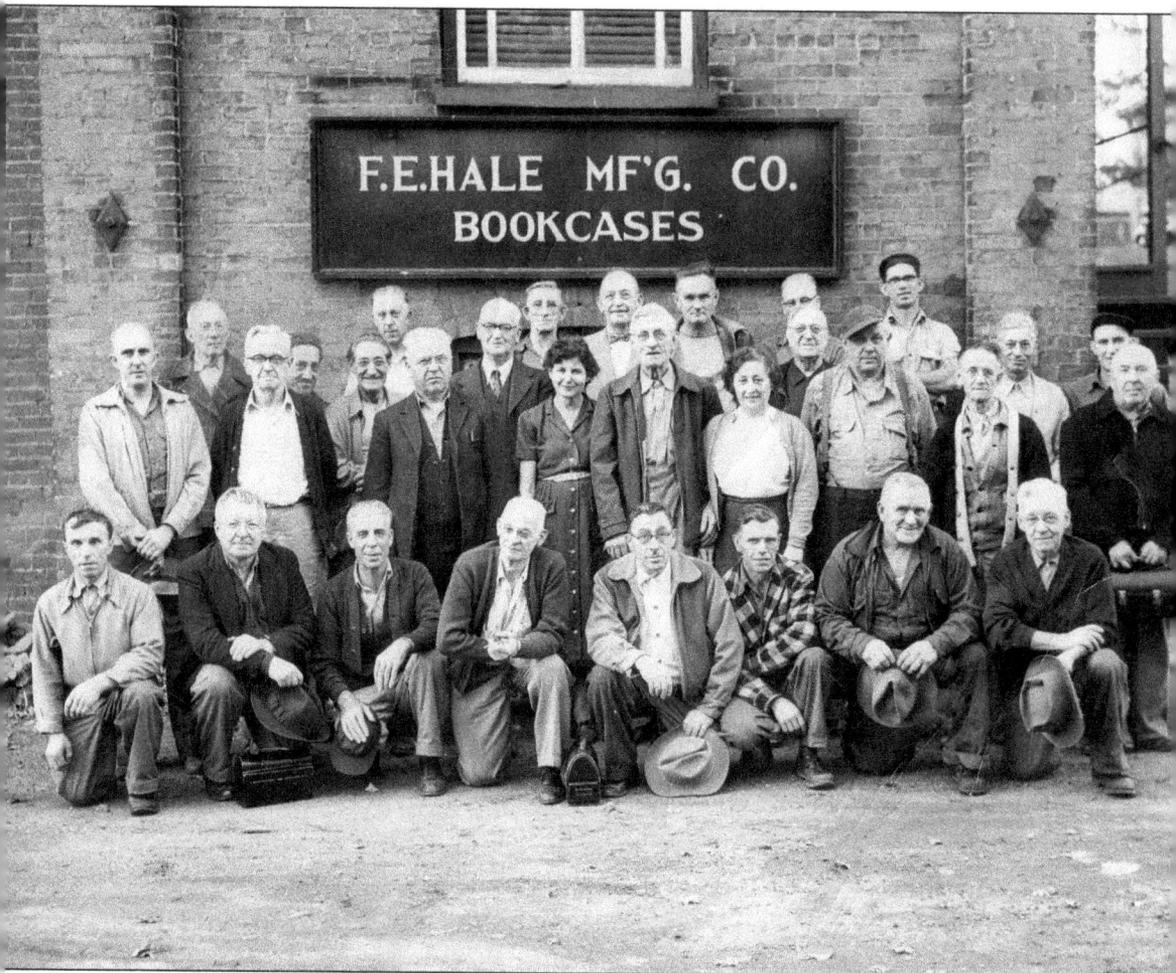

F. E. Hale Manufacturing. The F. E. Hale Manufacturing Company was founded in 1907 by F. E. Hale of Camden and William Horrocks and Henry G. Munger of Herkimer. The company occupied its original building on West German Street until moving to a newly constructed facility in Frankfort in 2002. It continues to manufacture its original product, sectional bookcases, along with an expanded line of wood products. F. E. Hale Manufacturing employees are pictured in 1953. From left to right are (first row) Joe Pellowen, Frank Soiba, John Colonna, Ralph Baum, Rocco Barone, Lloyd Durand, George Whitford, and Owen Dignan; (second row) Wesley Johnson, Harry Anthony, Max Schuyler, Nick Vivacqua, Palmer Cutts, Alvin Schrader, Paul Klys, Clayton Wood, "Stub" Francisco, Lillian Folts, John Benson, Lindley Hubbard, Joe Luczak, Anna Wood, George Steele, Leon Todd, Lee Bouton, Mike Pennucci, Frank Haber, Anthony Casadonte, Charles Grower, and August Kozarewicz.

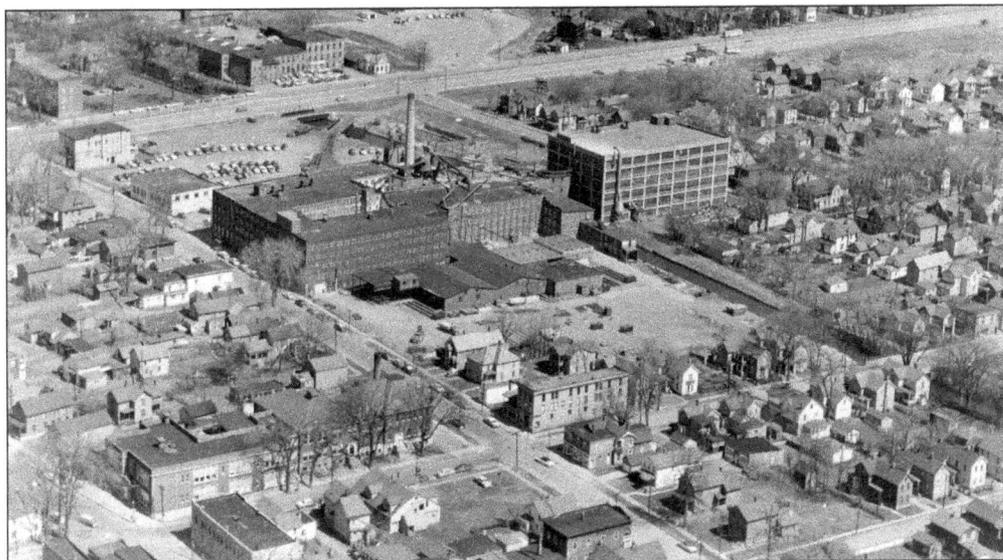

STANDARD FURNITURE COMPANY. Here is an overview of the Standard Furniture Company complex that was located on State Street and King Street. It was the largest manufacturer of wood office desks and furniture in the United States, founded in 1886 by Michael Foley, William Horrocks, and Frank Lathrop. Its market expanded to European subsidiaries formed in London, Paris, and Berlin. In 1916, the company had nearly 800 employees. Representatives from the plant traveled to Ellis Island to hire employees, bringing many people to Herkimer. It closed in 1976.

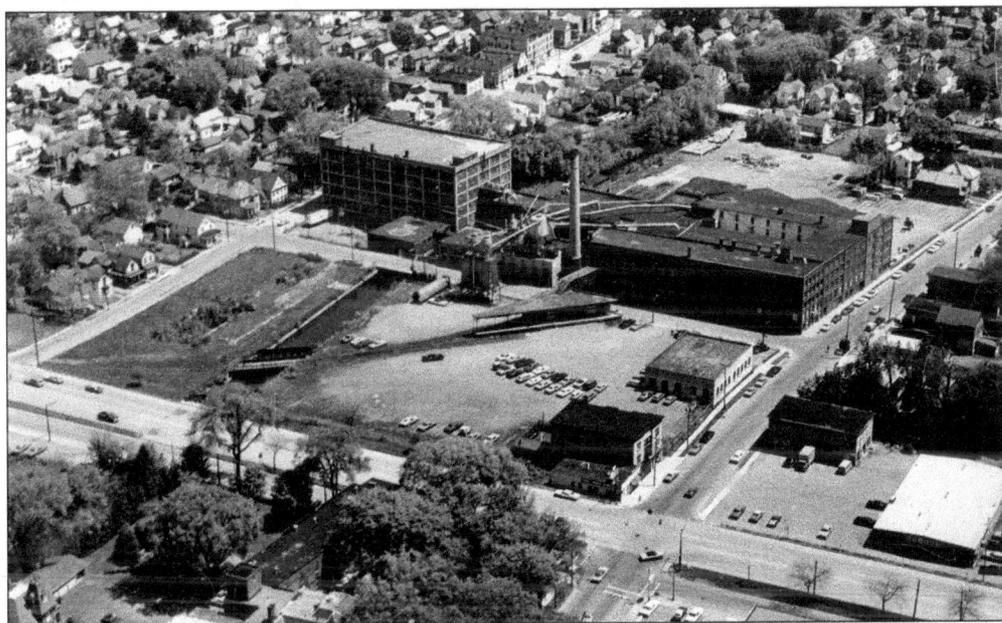

ANOTHER AERIAL VIEW. This bird's-eye view taken in 1971 shows the Standard Furniture Company looking south. Many of the huge, oval wooden desks used at government office buildings in Washington, D.C., were made by Standard. All the buildings pictured, except the six-story building owned by Standard on the left, have long since been demolished. The K-Mart chain store now has its building and parking lot in this area. (Courtesy of William Homyk.)

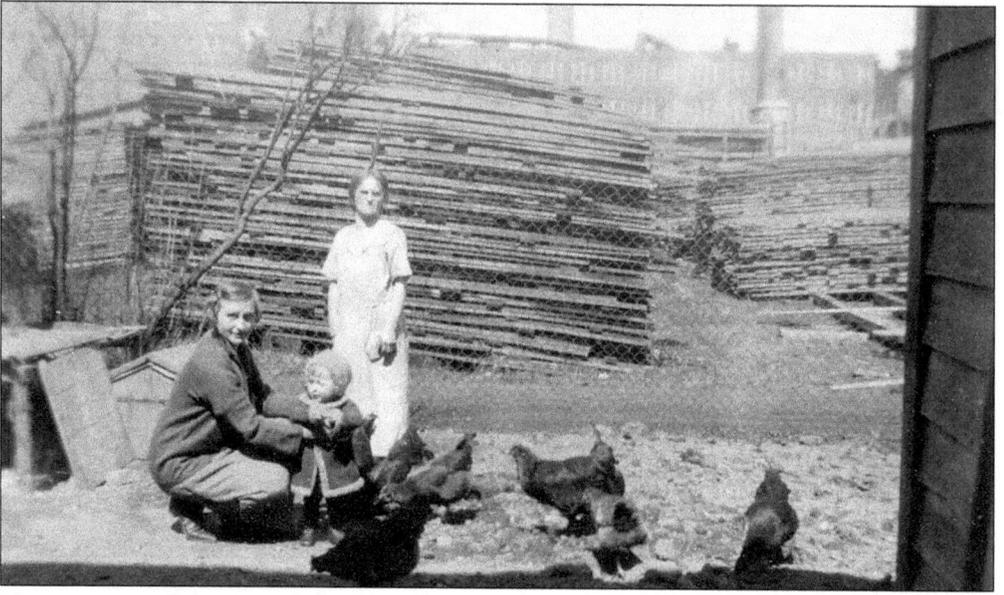

NEIGHBORS OF STANDARD FURNITURE. The lumberyard of Standard Furniture Company was toward the end of East Smith Street. On weekends, the company let its horses out of the barn to graze around the yard. Wire fencing that surrounded the yard kept the horses from wandering into the neighboring families' yards, like the Brown family seen here in 1924, who lived at 217 East Smith Street. Pictured is Caroline Brown with daughter Olive and her mother-in-law, Matilda Polack. (Courtesy of Arthur Brown.)

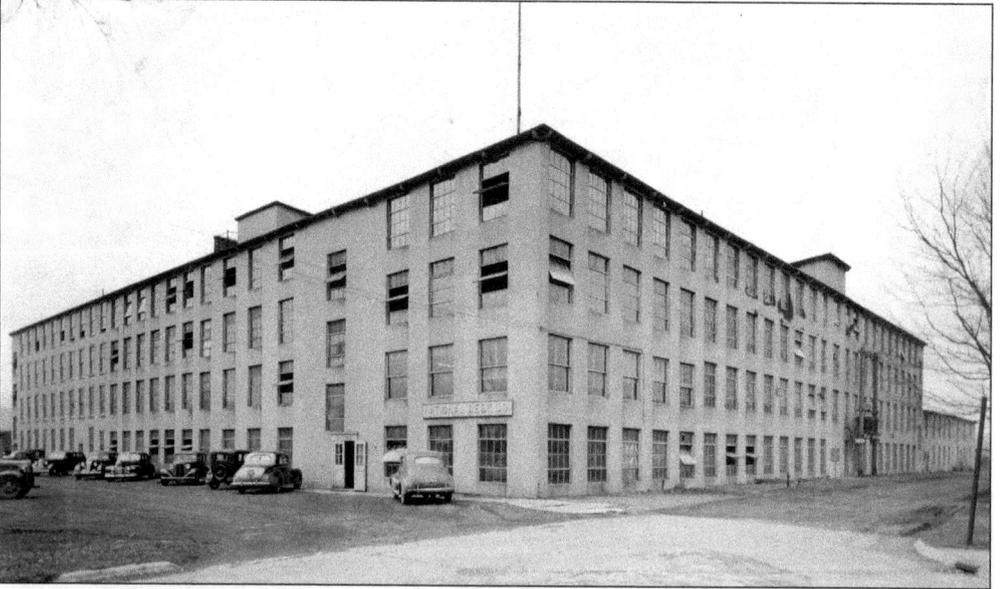

NATIONAL DESK COMPANY. When William Horrocks retired from the Horrocks Desk Company, he and John Metzler formed the Horrocks and Metzler Company in 1905. They constructed a large factory on the north side of the New York Central Railroad tracks on the west end of Park Avenue for the manufacture of wooden desks and tables. Following Metzler's retirement in 1906, the name was eventually changed to the National Desk Company. The plant was sold to Remington Rand, which moved its Library Bureau division there.

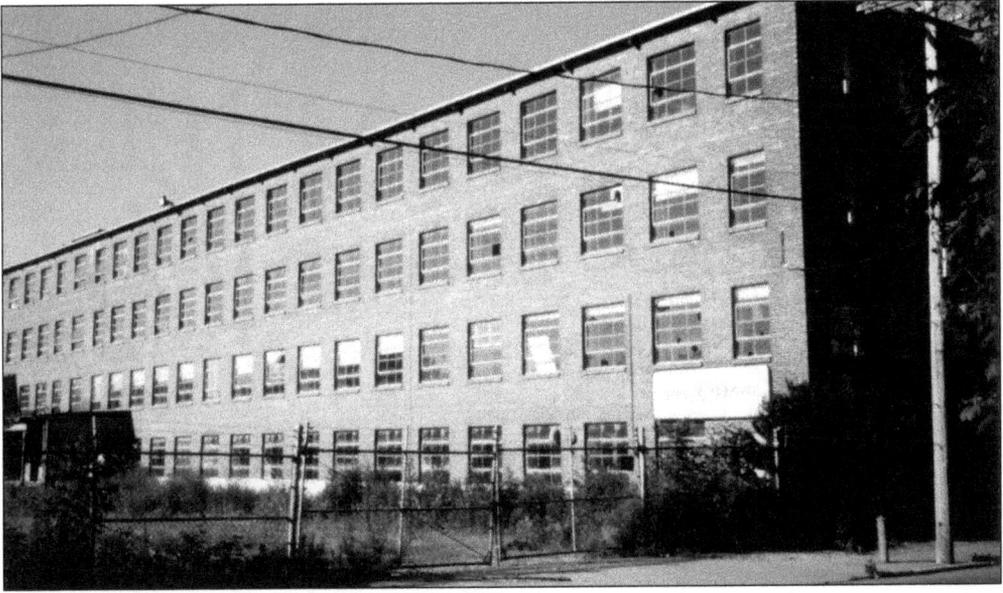

LIBRARY BUREAU. Library Bureau emerged from Remington Rand in Ilion and moved to Herkimer in 1947, where its sawmill was maintained. It was known worldwide for its wood library furniture and office filing equipment. When Sperry Rand phased it out in 1976, the Mohawk Valley Community Corporation bought its assets. After a series of reorganizations, the company filed for Chapter 11 in 1993. The buildings were eventually razed and replaced by the Wal-Mart Supercenter. (Courtesy of Tom O'Connell.)

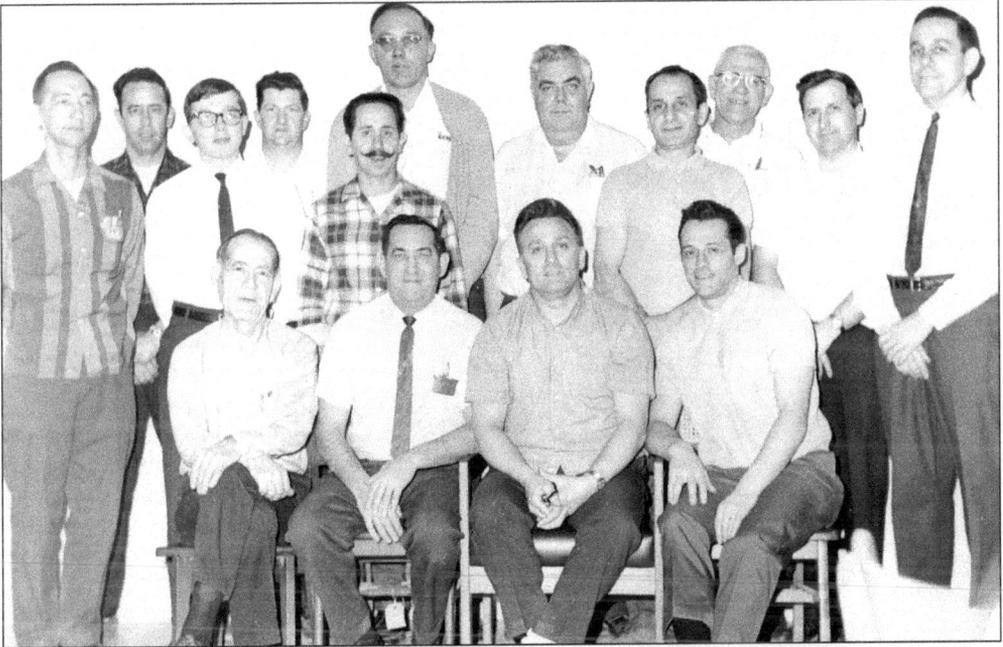

LIBRARY BUREAU EMPLOYEES. Pictured are Library Bureau employees. From left to right are (first row) Lou Averson, Larry Ciano, Rocky Losito, and Richard Risi; (second row) Charlie Schorer, Tim Francisco, unidentified, Dave Riesel, Jim Vivaqua, Erwin Hyer, Bob Burdick, Rocco Morra, Lou DePalma, Allen Kirkey, and Pete Kelly.

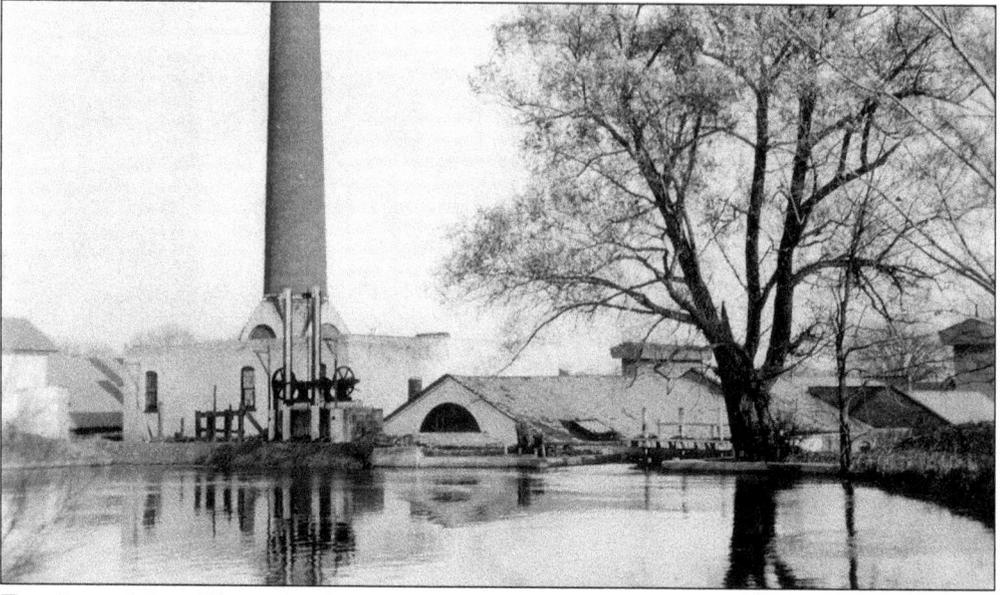

THE PAPER MILL. The original site of this factory on the corner of Willow Avenue and Dorf Street utilized the waterpower of the Hydraulic Canal for paper mills. Sen. Warner Miller started one of the first mills to make paper from wood pulp here, called the Herkimer Paper Company. It was sold to International Paper Company in 1898, and a division of this company was created, called the Herkimer Fibre Company, which made leather board. The smokestack seen here was said to be as high as Niagara Falls.

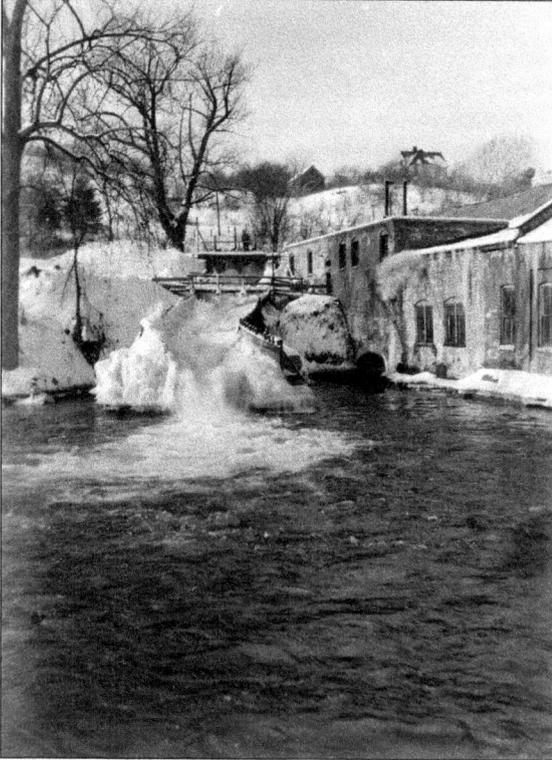

THE CHUTE AT THE PAPER MILL. By the 1950s, the site became the Herkimer Egg Carton Company, producing 700,000 egg cartons a week. In addition to egg cartons, the company installed machinery to make paper pulp from scrap paper. Steve Knight, as a young lad, remembers collecting old newspapers and taking them to the factory where he would get enough money to go down to the local store and buy a soda. The chute, seen here in the winter, had a 22-foot drop on the Hydraulic Canal, which powered the factory. By 1975, it was vacant, and it was razed in 1978.

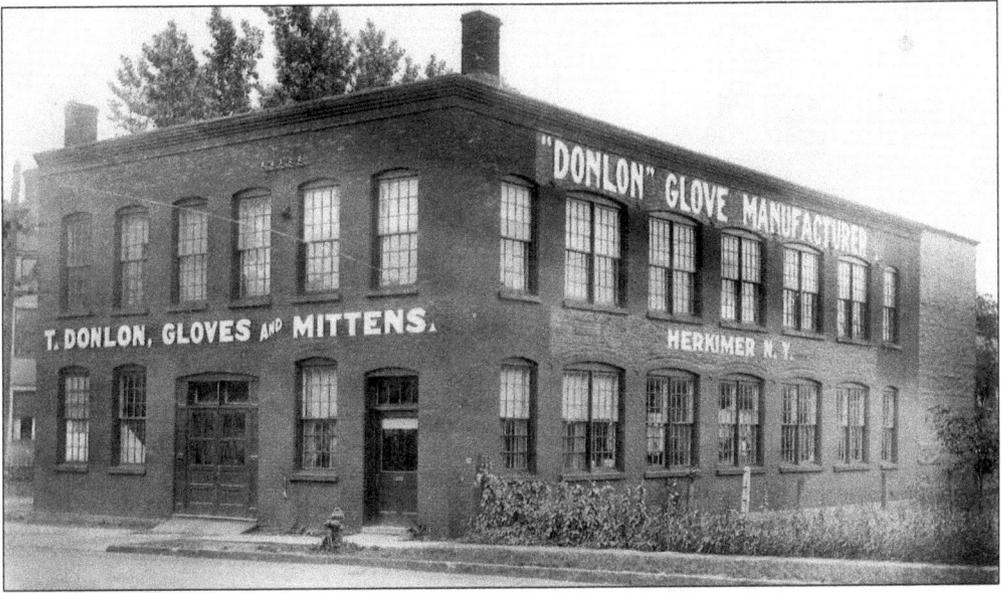

DONLON GLOVE FACTORY. The two-story brick structure located at 108 South Washington Street, originally built by the Standard Furniture Company for use as a machine shop in 1915, was finished by Thomas Donlon in 1921 for a glove-manufacturing plant. Previous to that, the company operated on Prospect Street, making heavy leather gloves for the armed forces during World War I. Following the war, it specialized in children's gloves and expanded its line to include all types of leather gloves.

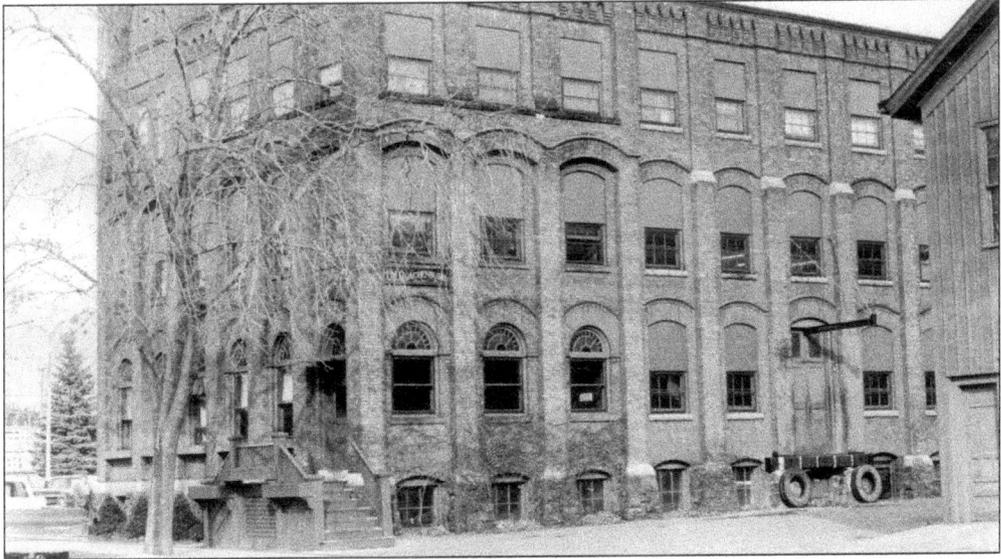

H. M. QUACKENBUSH COMPANY. The H. M. Quackenbush Company was founded by its namesake, Henry Marcus Quackenbush, who started his business in a workshop near his home on North Prospect Street. His first inventions included a velocipede and extension ladder, but it was his toy air pistol that started a manufacturing plant in the 1870s. The company produced firearms, scroll saws, buttonhooks, and other items. By the early 1930s, nutcrackers and subcontract electroplating became the mainstay of the company. Squeezed by foreign competition, the company closed in 2005.

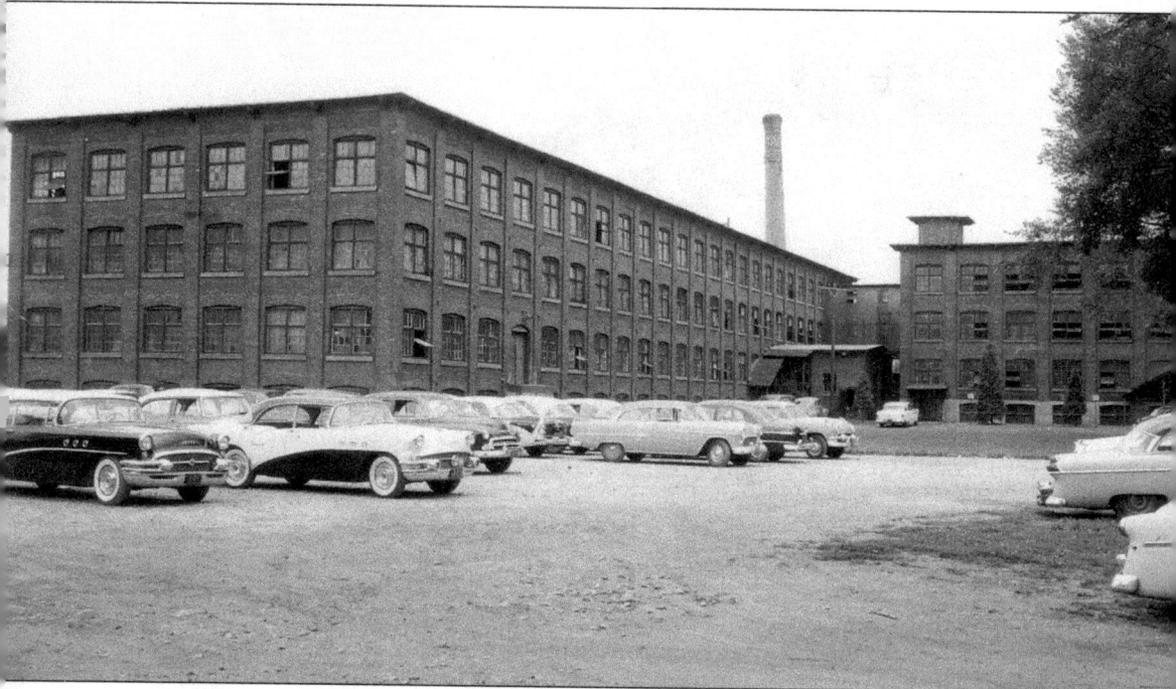

HORROCKS DESK COMPANY. During the boom of desk manufacturing in Herkimer, the Horrocks Desk Company built a new, four-story brick factory in 1904 at 420 East German Street under the leadership of Henry Munger and George Searles. It manufactured desks, tables, and typewriter cabinets that were sold nationwide. The factory was later purchased by Derby Sportswear in 1937 under the management of Bernard Elow, who then founded the Kordeen Manufacturing Company, producing ladies' and children's sportswear and outer garments in 1953.

Six

SCHOOLS

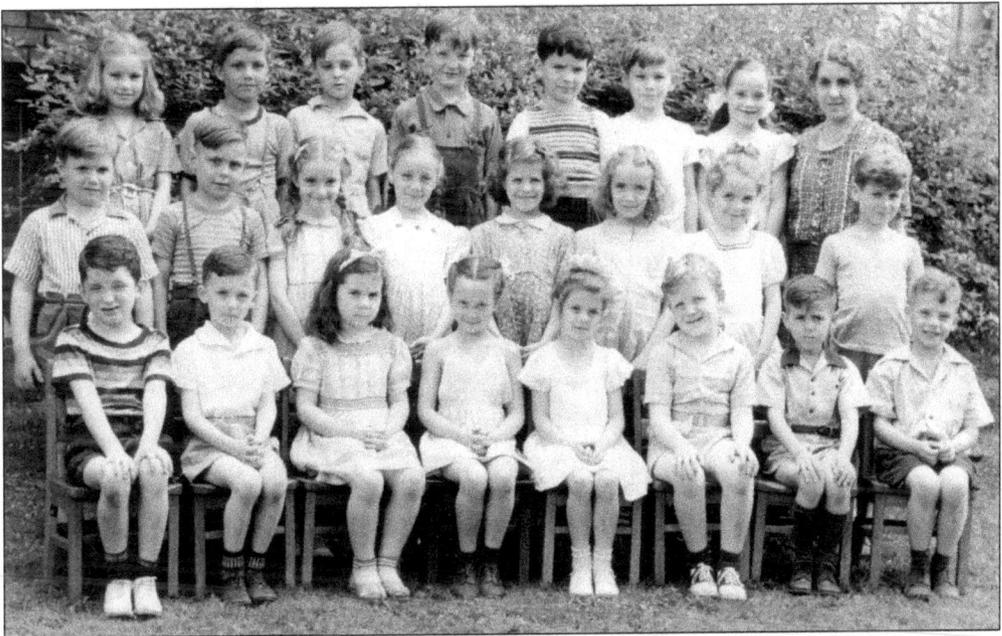

NORTH SCHOOL FIRST GRADE. This first-grade class picture at North School was taken in 1942. Pictured from left to right are (first row) Jack Fagan, Allan Parsons, unidentified, unidentified, Carol Algier, Craig Ruhm, Frank Talarico, and Dick Marks; (second row) Bill Hubbard, Karl Hollerich, Eleanor Miller, Alice Thompson, three unidentified, and Tremper Saltsman; (third row) Charlotte Gage, John Piseck, Dick Quackenbush, Jack Sanderson, unidentified, unidentified, Donna Brown, and teacher Helen Burrill. (Courtesy of John Piseck.)

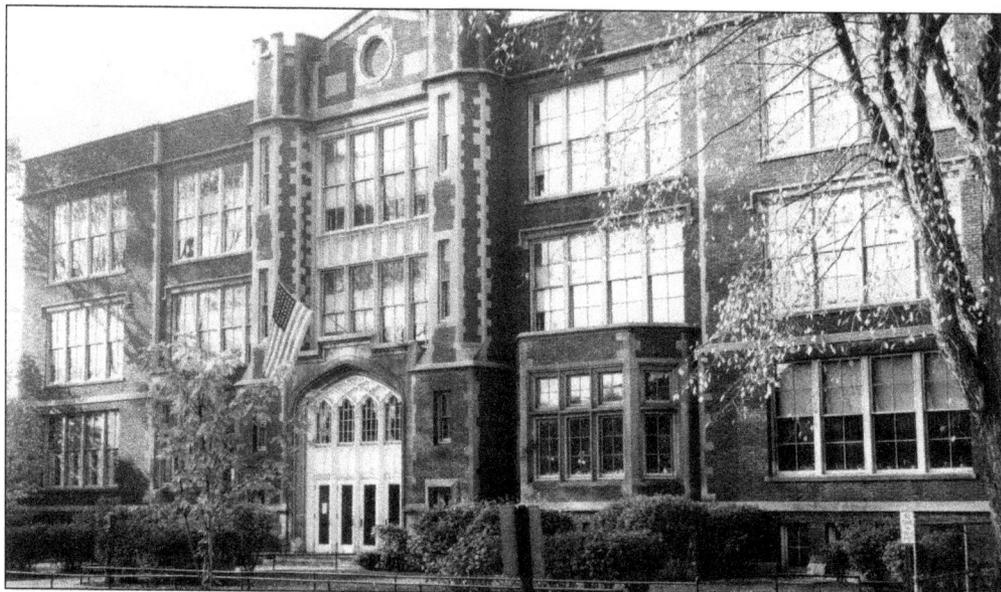

NORTH SCHOOL BECOMES L. W. BILLS SCHOOL. The site of the original North School on North Washington Street served kindergarten through eighth grade. The school building pictured replaced it around 1922. After his death in 1954, it was named for Lorraine W. Bills, who was Herkimer superintendent of schools for 20 years. The last day the L. W. Bills School was open was June 19, 1991. It is now privately owned and used as a storage facility.

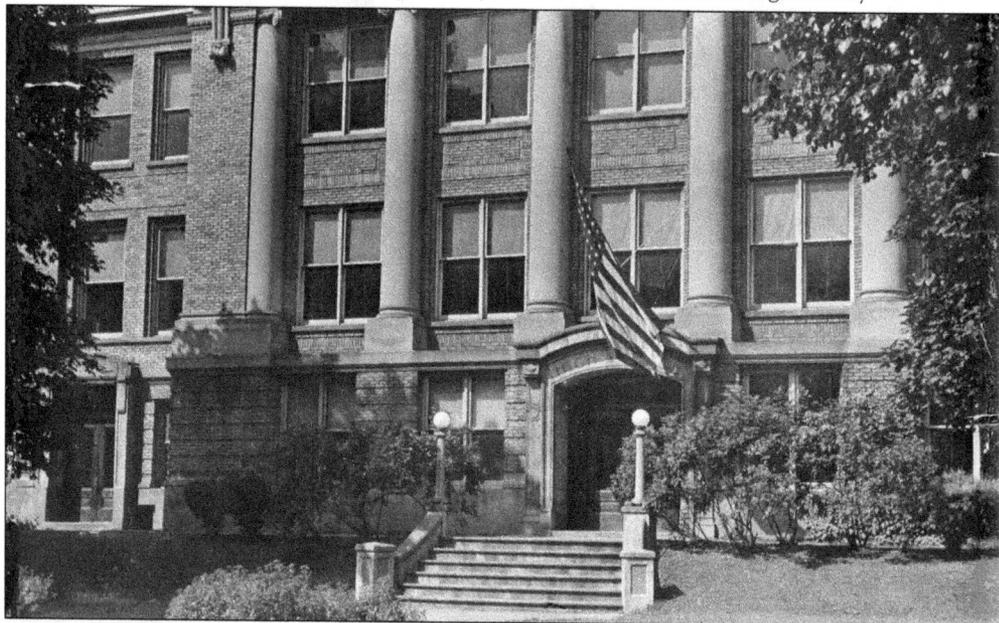

HERKIMER HIGH SCHOOL BECOMES MARCELLA FOLEY SCHOOL. Built in 1913 as the Herkimer High School, this building was located on the corner of Bellinger and West German Streets. It was turned into a junior high school in 1959 when the new Herkimer High School was built. In 1964, it was renamed the Marcella Foley School in honor of its longtime principal Marcella Foley, who served 34 years. The last day it served as a school was June 19, 1991. It is now an apartment building called Majestic Apartments.

98

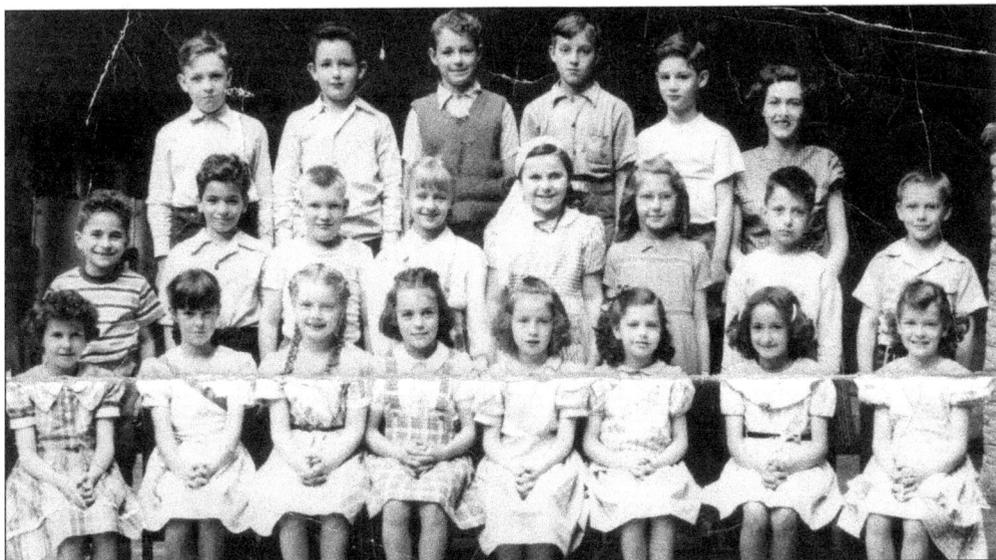

NORTH SCHOOL CLASS, 1948. Here is a third-grade class photograph taken in 1948 at North School on North Washington Street. Pictured from left to right are (first row) Carol Blaise, unidentified, unidentified, Judy Spencer, Donna Nichols, Vicky Cirillo, Cecelia Cool, and Linda Sanderson; (second row) Michael Golden, ? Panarites, Richard Pickens, Elaine Adukiewicz, Judy Goering, Georgianne Sennett, unidentified, and William Pratt; (third row) ? Carpenter, Danny Johnson, Harry Raux, Richard Miller, and Gary Rogers. The teacher was Eva McLeod. (Courtesy of Donna Merryman.)

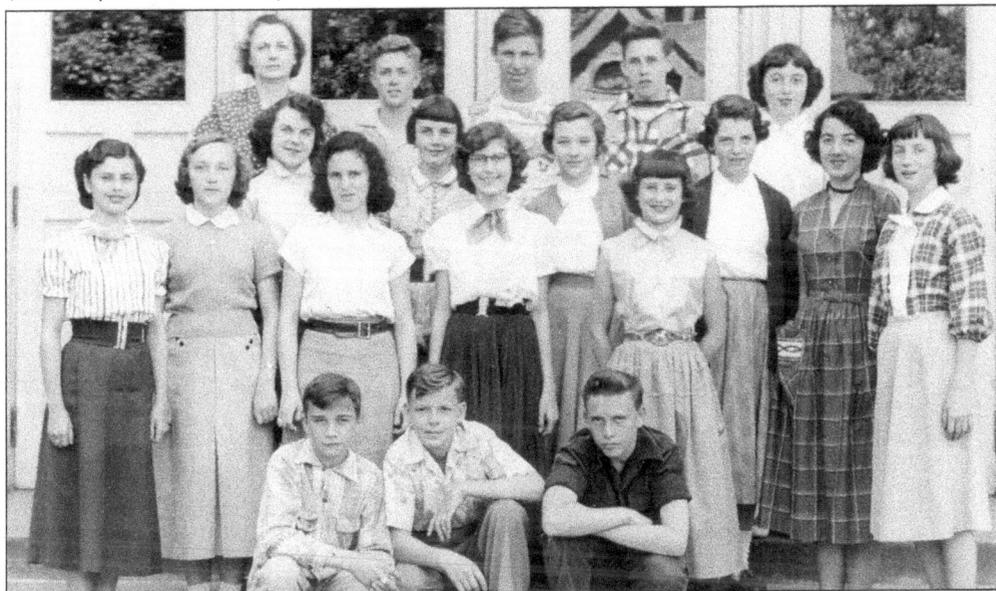

NORTH SCHOOL CLASS, 1953. This is an eighth-grade class photograph taken in 1953 at North School. Pictured from left to right are (first row) Ray Serbanewicz, David Jones, and Pratt; (second row) Cirillo, Hilad Parks, Ruth Bass, Sennett, and Faye Henderson; (third row) Goering, Armeda Schrader, Carol Ritchie, Joan Sweeney, Pat Gross, and Nichols; (fourth row) Carlton Vielhauer, Charles Sullivan, Miller, and Dorothy Gross. The teacher was Lena Briggs, and the principal was Vernon Lee Sr. (Courtesy of Donna Merryman.)

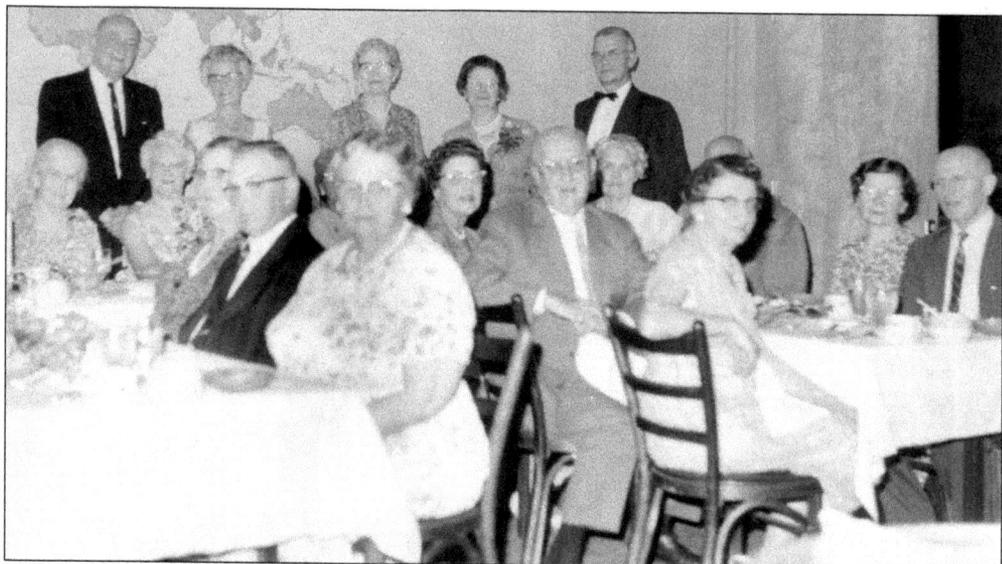

HERKIMER HIGH SCHOOL REUNION. The Herkimer High School class of 1912 held its 50th reunion on June 26, 1962, at the Palmer House. Pictured from left to right are (first row) principal Marcella Foley; Frances Van Alstyne Hoffman; Vera Rasbach Eysaman and her husband, Clarence; Laura Helterline; Izora Brockway; Carlton Morgan and his wife, Marion; Aletha Harvey Boynton and her husband, Wolcott; Naomi Helmer Ray; and Frieda Harter Clark and her husband, Vernon; (second row) Bernard Rasbach; Frances Potter Platt; Ada Jones Dunn; Elizabeth Cox Flynn; and Altee Potter.

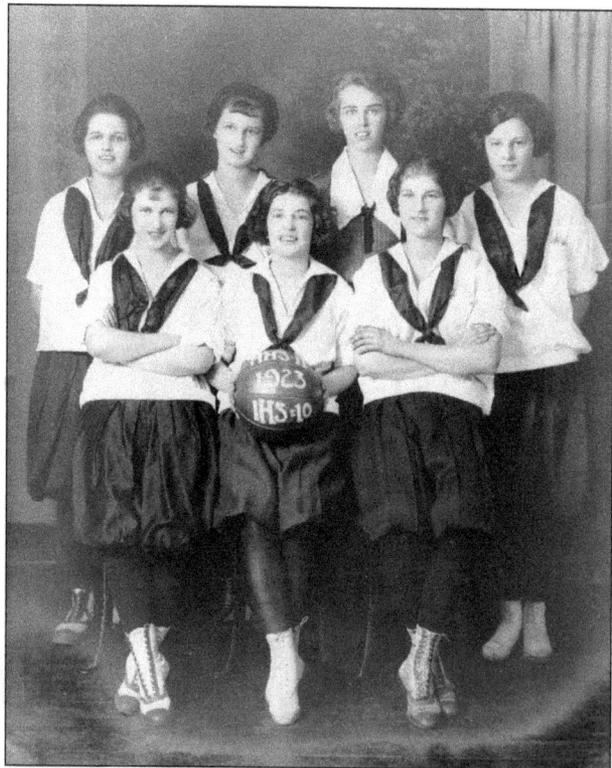

HERKIMER HIGH SCHOOL CHAMPS, 1923. This photograph was taken after the Herkimer High School girls' basketball team defeated Ilion High School 11-10. The girls are shown with their coach, who can be seen in the top row on the right wearing a different uniform. The girls that are identified are Reba Fitch in the upper left and Anna Bostwick in the upper right. The names of the other young women are Violet Boynton, Beatrice O'Connor, Reba Marriott, Alene Ray, and Ethel Swenson. (Courtesy of Pat Meszler.)

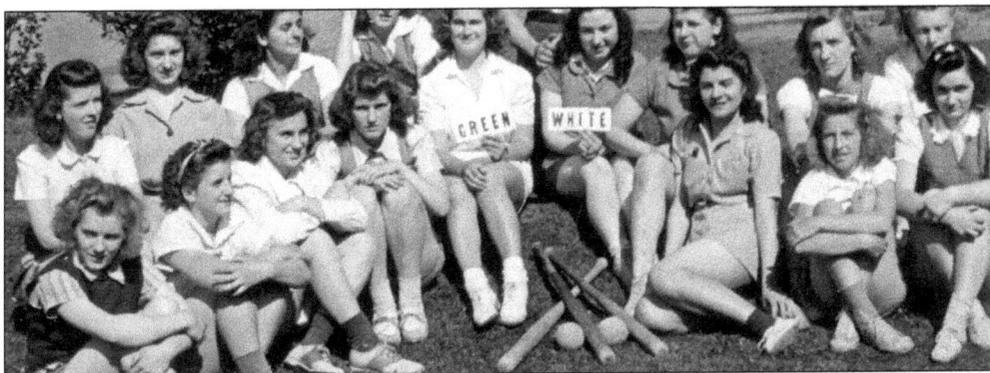

GIRLS' SOFTBALL. The Herkimer High School girls' softball team in 1941 is shown here. Pictured from left to right are (first row) Audrey Salisbury, Geneva Krupp, Beverly Kast, Alda Shaver, Jane McKennan, Evelyn Wicks, Helen Zaleski, Jenny Brandano, Kathryn Backell, Myrtle Hubbard, Margaret Shearer, and Eileen Lynch; (second row) Florence Miller, Hazel Cooley, Ann Burrell, and Betty Lafayette. Dolly Puleo was the coach. (Courtesy of Marion Morse.)

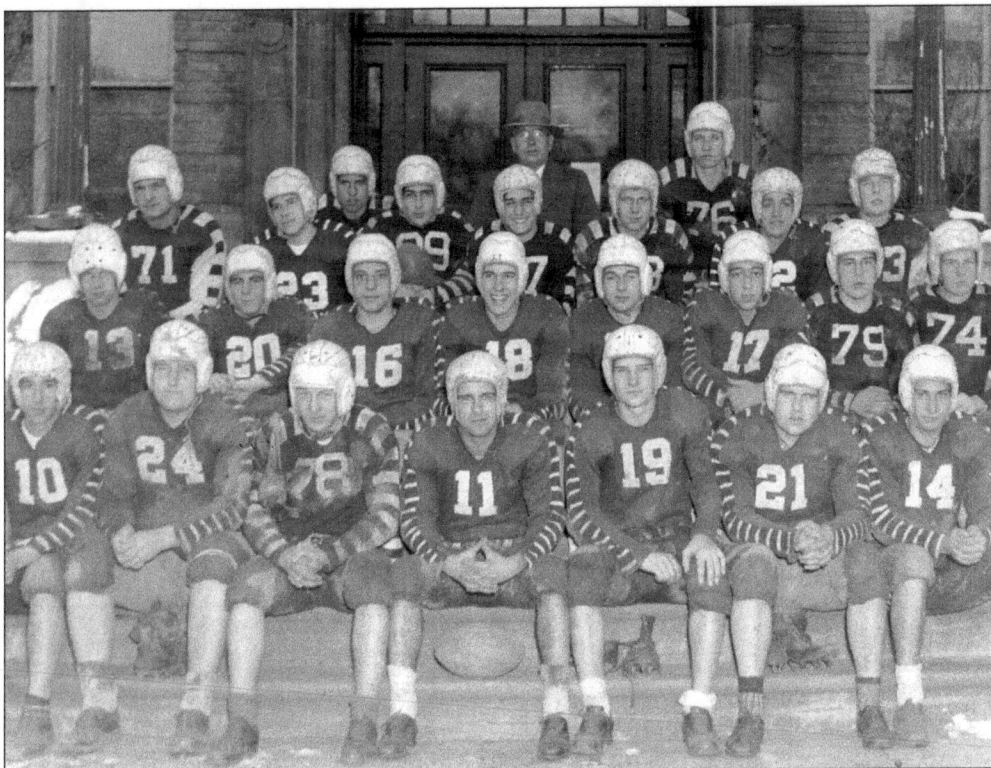

BOYS' FOOTBALL. The Herkimer High School football team was undefeated in 1943 for its sixth year under coach Elmer Morgan. The Little Red Magicians defeated all seven teams opposing them that year. The team is seen here sitting on the steps of the Herkimer High School when it was on the corner of Bellinger Street and West German Street. Elmer is standing at the top of the steps.

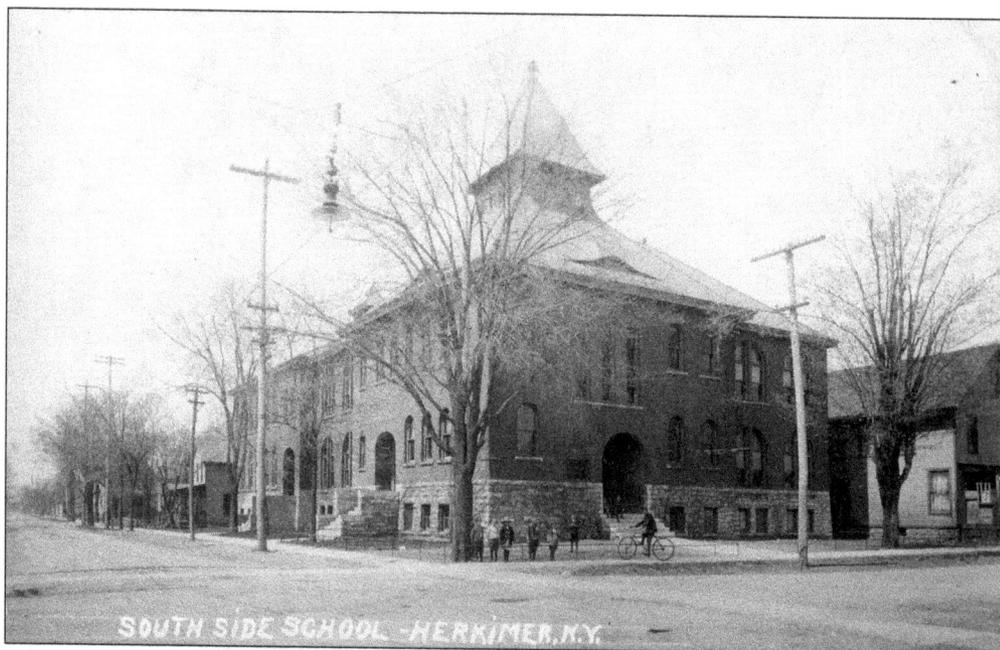

SOUTH SIDE SCHOOL. This brick school was built in 1888 on the corner of South Washington and Smith Streets at an initial cost of $16,000 to serve the hundreds of European immigrant children who came to the school, oftentimes without knowing a word of English. Throughout the years, several additions were made to the school, which extended it the entire block from South Washington west along East Smith Street to South Main Street. (Courtesy of Phyllis Shelton.)

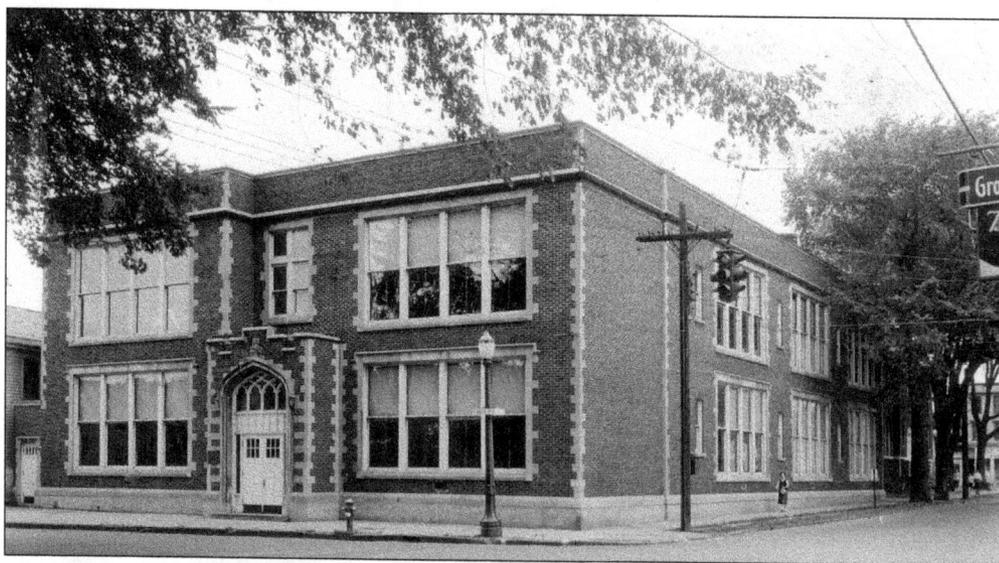

MARGARET TUGER SCHOOL. The South Side School was renamed the Margaret Tuger School in honor of its longtime principal in 1932. In 1959, the Herkimer School Board of Education voted to demolish the old 1888 section of the school, leaving the newer section intact. It was used as a school until about 1981, after which it was purchased by Robert Castle, who named the building for his late father, Nathan Castle, and donated space for a senior center complex, named in honor of Harry Enea, who was instrumental in its establishment.

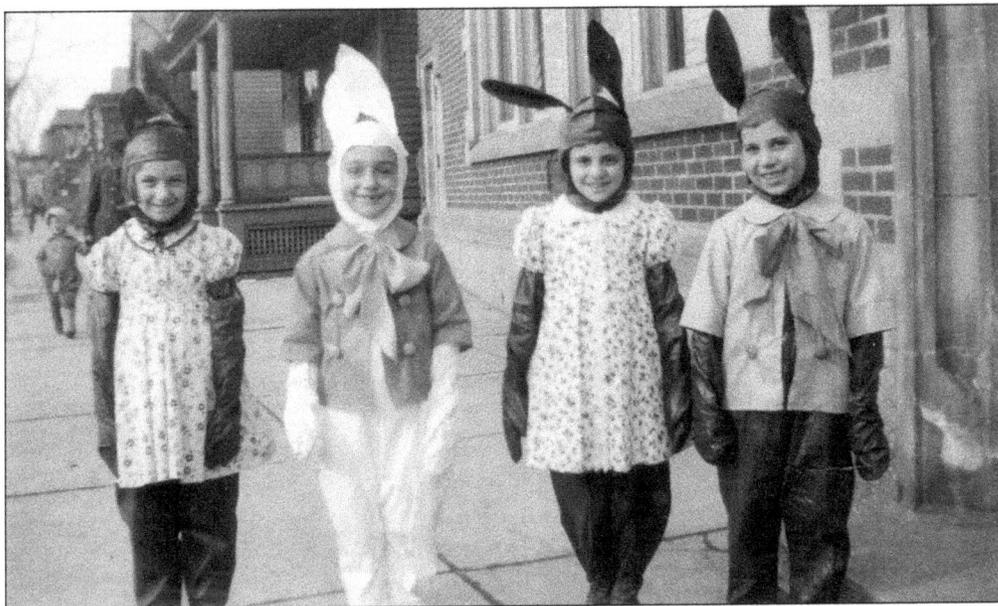

PETER RABBIT OPERETTA. The Margaret Tuger School had an auditorium with a stage where many plays were presented by the schoolchildren. On March 7, 1938, bunnies frolicked among the vegetables in Mr. McGregor's garden in *Peter Rabbit*, directed by Marjorie Gage. The main characters can be seen here standing outside the school. From left to right are Rosina Servidone, who played Flopsy; Douglas Taffi, who played Cottontail; Rosemarie Cassella, who played Mopsy; and Richard Averson, who played Peter.

KINDERGARTEN CLASS. Margaret Tuger, who served as principal of the South Side School from 1891 to 1939, helped shape the minds of many young people on the south side. Pictured is a South Side School kindergarten class, probably in the 1930s. The three children in the picture are Robert Donadio, Vittore Basile, and Filomena Fiorentino.

103

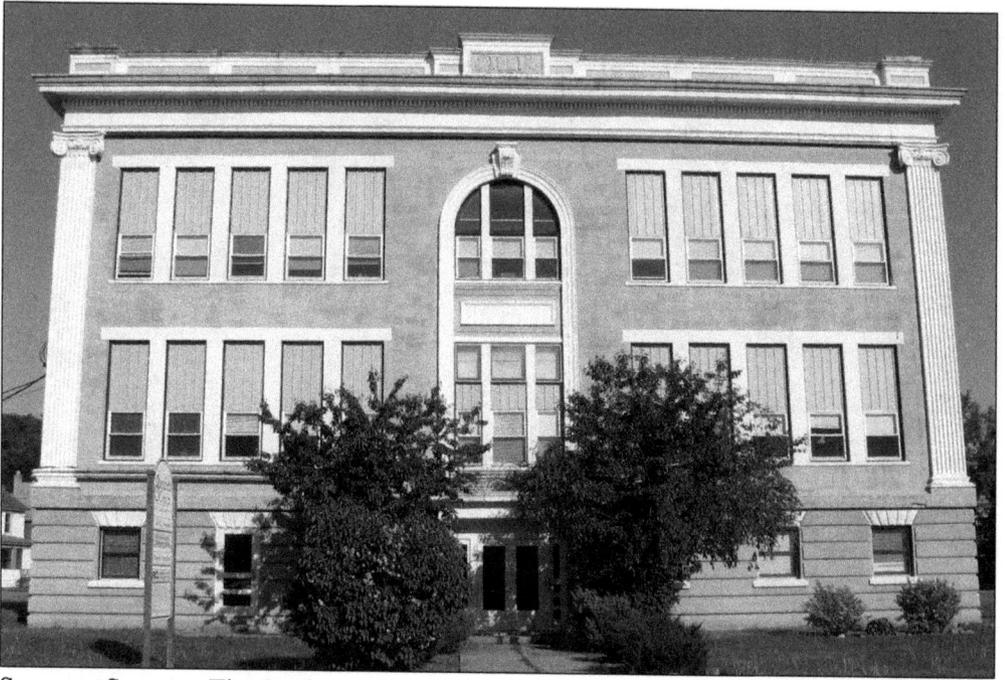

STEUBEN SCHOOL. The Steuben School, located on the corner of East German and Steuben Streets, was built between 1907 and 1908. It housed kindergarten through sixth grade and was named after Revolutionary War general Baron Von Steuben. The school closed in June 1941 due to declining enrollment. It was then used by the high school as a shop-training school and later as a war-training center during World War II. Today it is called the Steuben Center and houses several offices.

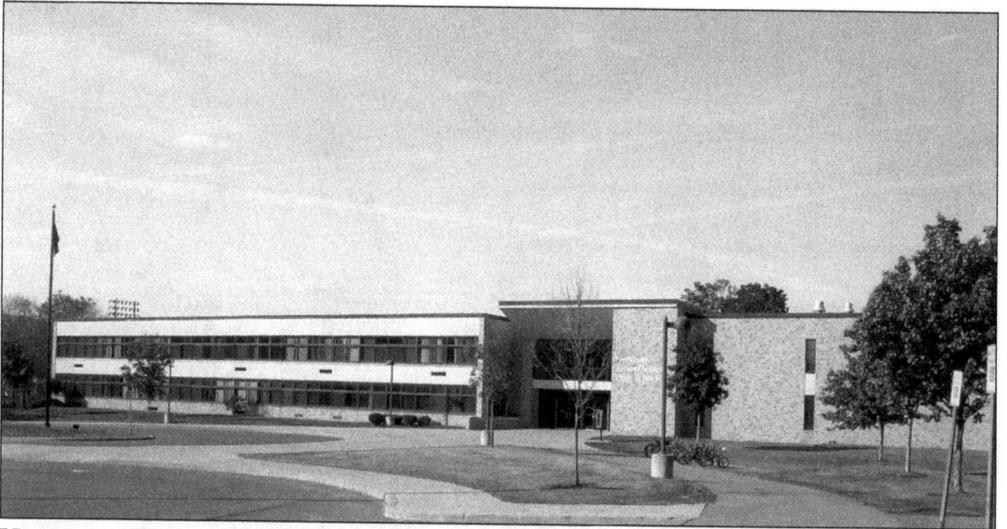

HERKIMER CENTRAL HIGH SCHOOL. When the previous high school on Bellinger Street became too small to meet the needs of a growing student population, plans began in 1956 to build a new school on the slope of Oak Hill south of West German Street adjacent to Harmon Field. The architects of the new school complex were Ketcham, Miller and Arnold of Syracuse and included a large classroom wing, a gymnasium, an auditorium, and a swimming pool. It officially opened for classes on September 8, 1959.

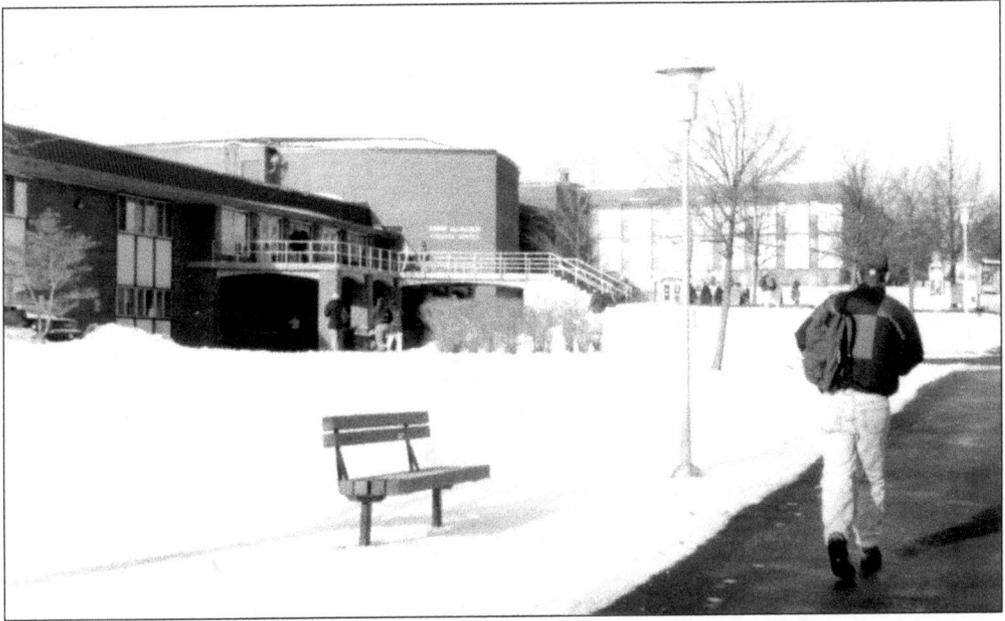

HERKIMER COUNTY COMMUNITY COLLEGE. The state university approved the establishment of a community college in Herkimer on January 13, 1966, after a referendum was approved by county voters and a long preparatory effort on the part of the Herkimer County Board of Supervisors. Its first classes were held in the old Univac plant in Ilion with an enrollment of 490 and a staff and faculty of 32. Robert McLaughlin was appointed its first president. Construction of a permanent campus on a site overlooking the village began in 1969 and was completed with a dedication on October 17, 1971. Many improvements have been made to the campus over the years, and enrollment today numbers 3,000, including international students. The picture above is a view of the campus prior to the Hummel's Corporate and Professional Education Center expansion of the Robert McLaughlin College Center, completed in June 1999. The library expansion named in honor of its longtime president, Ronald Williams, was completed in May 2008 and is seen in the picture below. (Courtesy of Herkimer County Community College.)

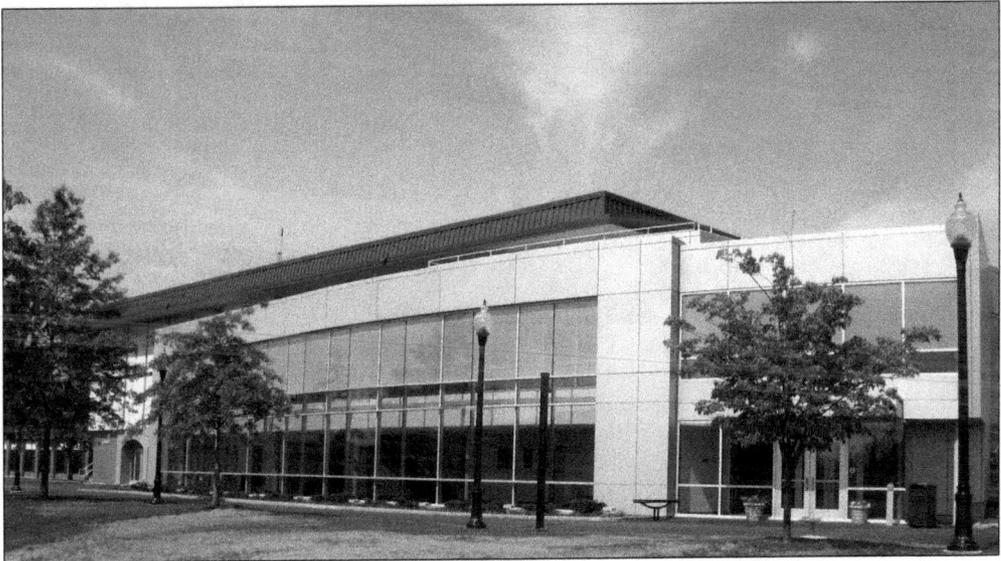

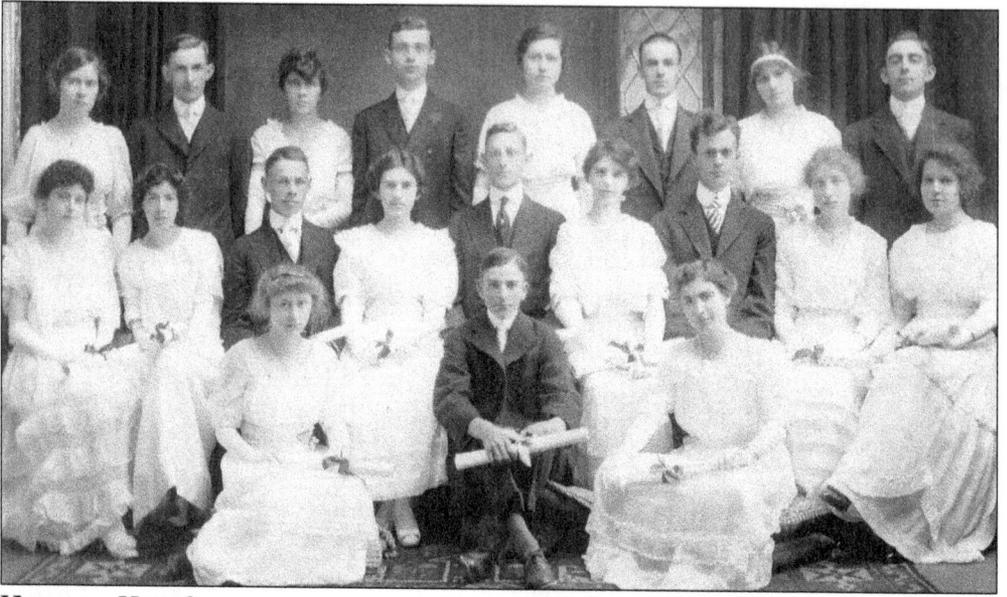

HERKIMER HIGH SCHOOL CLASS OF 1915. Pictured is Herkimer High School's class of 1915. From left to right are (first row) Ruth Hall, "Pop" Harold Nichols, and Isodene Crego; (second row) Dorothy Terry, Mary Western, James Delaney, Delilah Folts, Harold Wheeler, Katherine Earl, Victor Edmunds, Ethel Munro, and Helen Rich; (third row) Valeria Frosch, Reuel Smith, Agnes Barry, Maynard Morris, Ann Klossner, Russel Ertman, Ethelwyn Murray, and James Gallo.

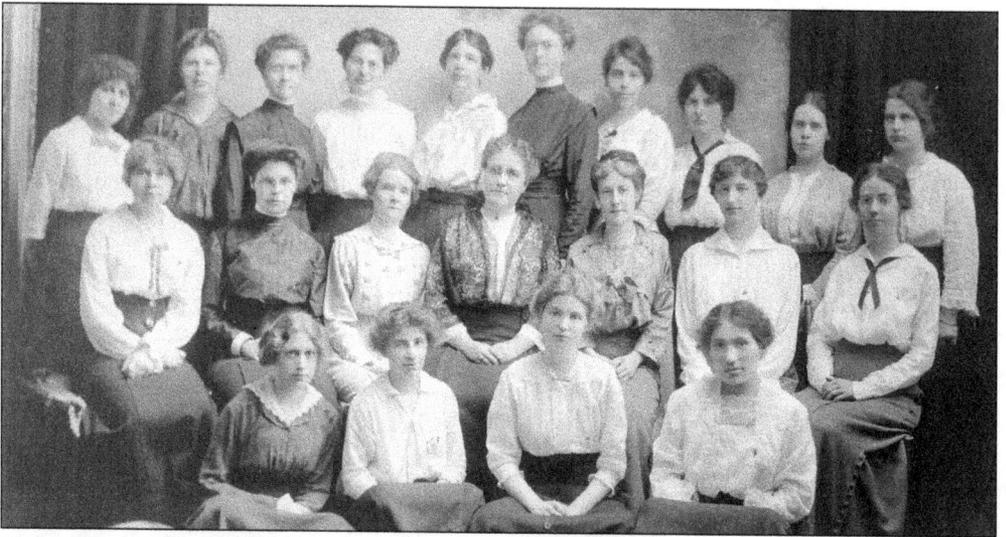

FOLTS MISSION INSTITUTE CLASS OF 1915–1916. The Folts Mission Institute was founded in 1893 as a special kind of religious school or college under the auspices of the Methodist Church. Pictured is the Folts Mission Institute class of 1915–1916. From left to right are (first row) Marjorie Williams, Marguerite Harrison, D. Blanche Lemonte, and Sarah Osorio Murillo; (second row) Lora Ackerman Ricer, Alice Fry, Mrs. Decoster, Miss Fowler, Miss Carter, Miss Perkins, and Miss Quackenbush (teachers); (third row) Teresa Villa (?), unidentified, Bertha Wood, D. Mary Wilcox, D. Florence Johnson, Edna Baxter, Helen Jenne (?), Josephine Mackenzie Anderson, Laura Armstrong Athearn, and Irene Kilburn.

Seven

TRANSPORTATION

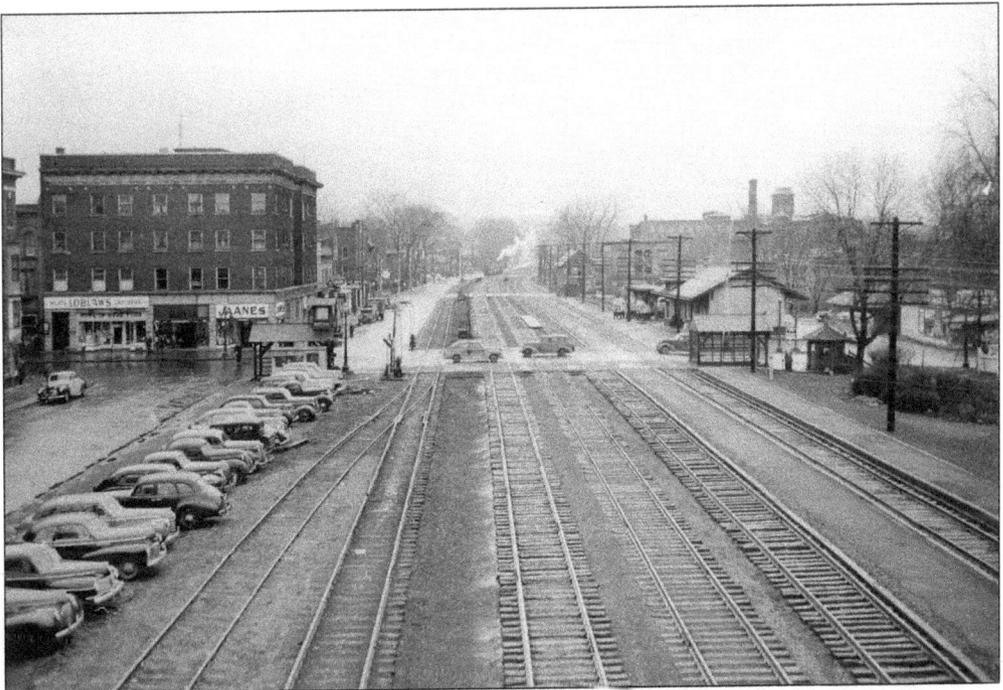

NEW YORK CENTRAL RAILROAD. The railroad came to Herkimer in 1836 with the Schenectady and Utica Railroad. In the 1850s, the New York Central Railroad formed as the main line for the state, and the train depot was located at Main and Albany Streets. The two tracks on the right were passenger train tracks, the two tracks in the center were for freight, and the tracks on the left were switching tracks used by yard engines.

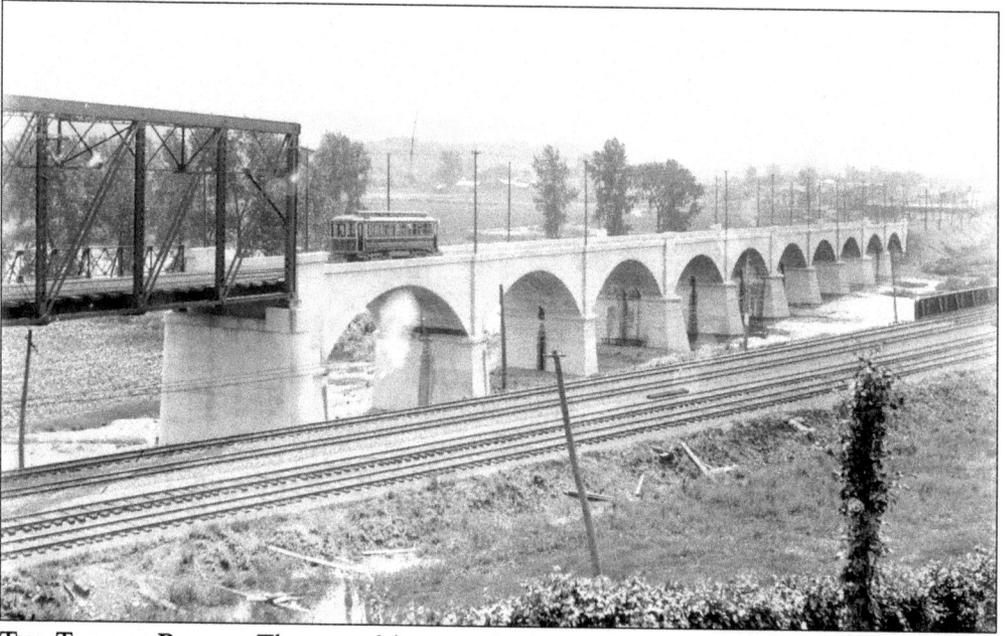

THE TROLLEY BRIDGE. This graceful cement bridge, spanning the West Canada Creek, was built by John V. Quackenbush (1833–1903) of Mohawk and Col. Clinton Beckwith (1848–1926) of Herkimer. It was completed in 1903 and made travel by trolley from Little Falls to Rome possible. It has not been in use since buses replaced the trolley in 1933 and still stands as a remembrance of the days gone by when trolleys came through Herkimer.

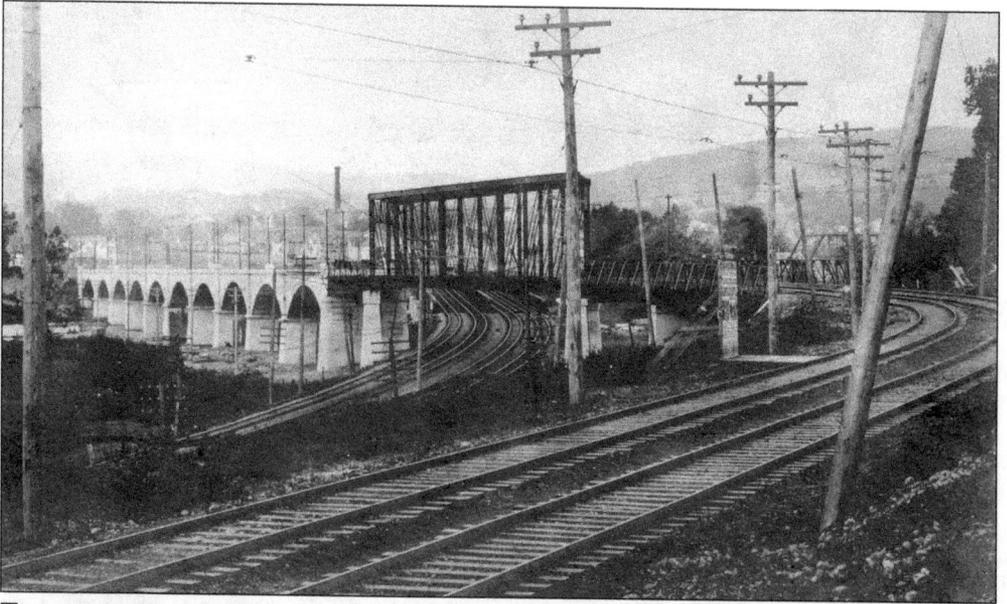

TRANSPORTATION LINES INTO HERKIMER. This picture, looking west toward Herkimer, shows the massive cement trolley bridge that connected with a metal bridge on the upper tracks and the New York Central Railroad tracks just below. Trolleys relied on overhead wires for the streetcars to travel on the rails and were used mainly by local people for transportation to work and for short pleasure excursions. The trolley bridge is the only structure still standing from this picture.

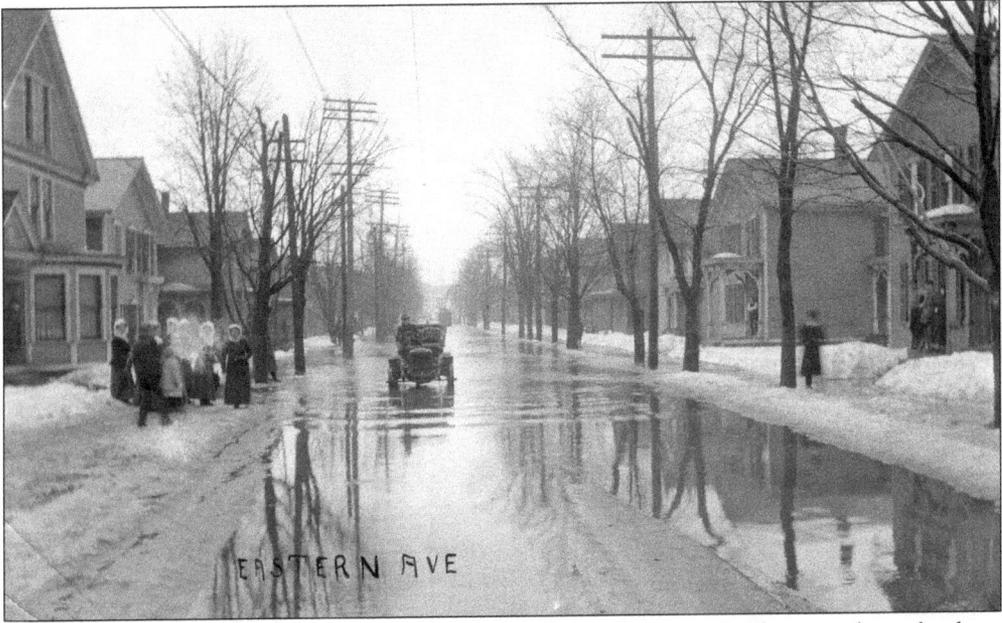

Trolleys on Eastern Avenue. These ladies need a gentleman to lay his coat down for them on Eastern Avenue in this undated photograph. Note the trolley at the far end of the street. Trolleys traveled along Eastern Avenue, which extended from South Washington Street to Protection Avenue, on their way to Little Falls. The tracks must be covered with water because they cannot be seen. (Courtesy of Bob and Julie Lasowski.)

Albany Street Bridge. This concrete arch bridge was built in 1913 over the West Canada Creek as an extension of Albany Street to East Herkimer. When the railroad tracks were moved and Route 5 was redirected to the center of the village, a new bridge was built up from the former New York Central Railroad bridge in 1949. No longer the main route, the bridge was condemned in the late 1960s, and on July 19, 1999, it was demolished with explosives by the army's 41st Engineer Battalion from Fort Drum.

ALBANY STREET. Car traffic went alongside the railroad tracks on Albany Street. The bridge crossing the Hydraulic Canal can be seen with the Union Mills building (formerly the Mark Mill) just out of the picture. On the right are the living quarters for professors at the Folts Mission Institute, and the Herkimer train station can be seen on the left. In the distance is the John Campbell furniture store building, and farther down is the Nelson Block on North Main Street.

RAILROAD FREIGHT HOUSE. The New York Central Railroad freight house was relocated from a site near North Prospect Street to North Caroline Street in 1911 to run parallel to the main line tracks of the railroad. After the main line tracks were moved in 1943, the freight house was taken over by the Library Bureau. The Library Bureau used it as a staging area for customer orders, inventory of unfinished wood, storage of finished and unfinished products, and to manufacture items such as museum cases.

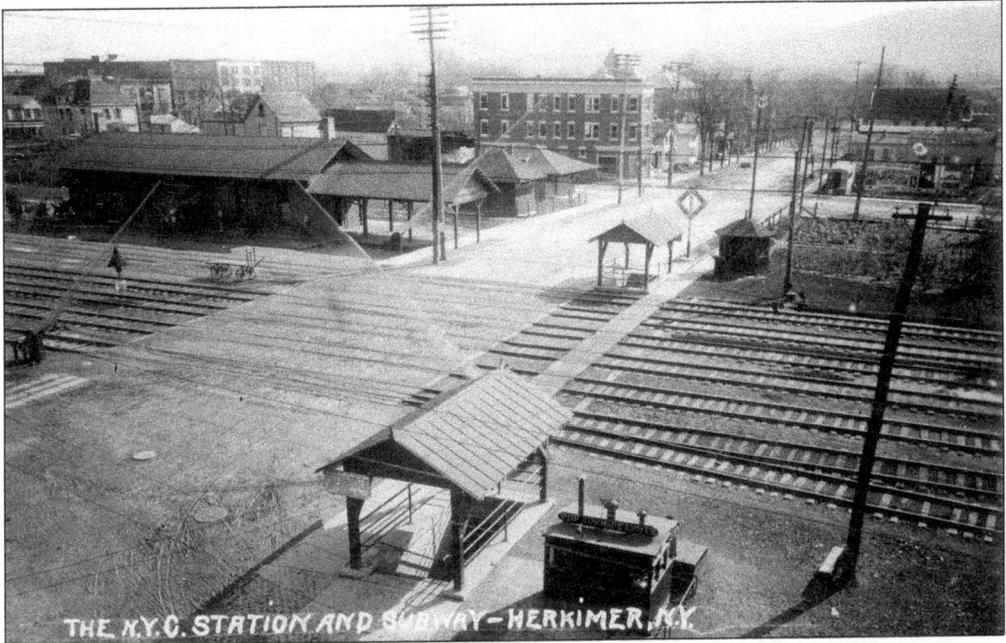

DEPOTS AT HERKIMER. The main route through Herkimer today used to be the main thoroughfare for the New York Central Railroad. To serve as a safe way for pedestrians to access North and South Main Street, an underground tunnel called the subway was completed in 1905. The entrance can be seen in the foreground. It was illuminated by an electric bulb at each end near the stairways. The train depot is on the left, and beyond it is the trolley depot, which served the line that ran east and west through Mohawk Street.

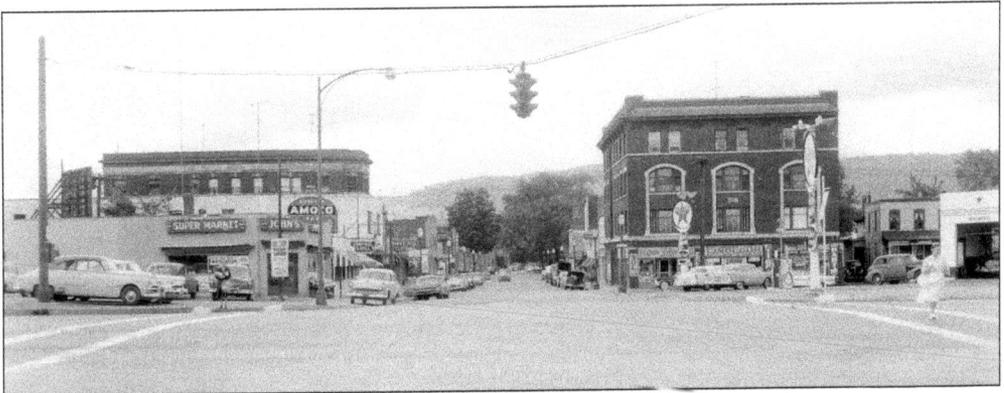

ROUTE 5 REPLACES TRAIN TRACKS. This picture, taken in the 1950s, is looking south on Main Street after Route 5 replaced the train tracks. The train station was replaced by the parking area of the building that is seen here as John's Super Market. The parking area is now the site of Cole Muffler. Myers Clothing Store can be seen on the left farther down the street, and on the right stands the Alvaro building, constructed in 1915. (Courtesy of Jim Greiner.)

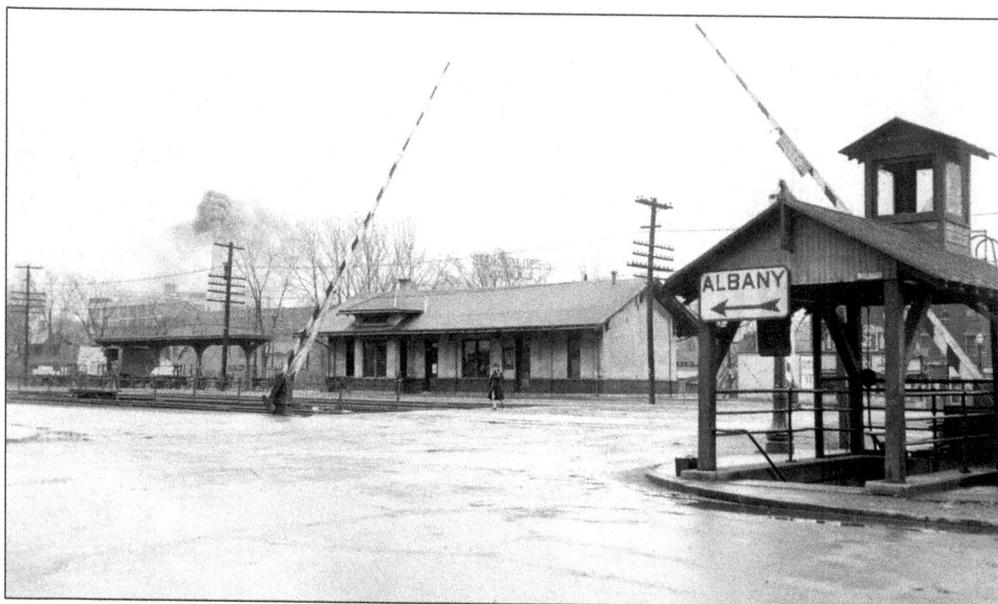

HERKIMER TRAIN STATION. This is the New York Central Railroad station and subway entrance as they appeared in 1943 before the tracks were moved south of Herkimer. The Albany sign directs motorists to Route 5 east and reminds one of how Route 5 used to come into Herkimer. Coming from Little Falls in the east, Route 5 went through East Herkimer, across the bridge over the West Canada Creek, and on to East Albany Street. It turned left on Prospect Street and then right on Mohawk Street, connecting with Route 28 at Caroline Street.

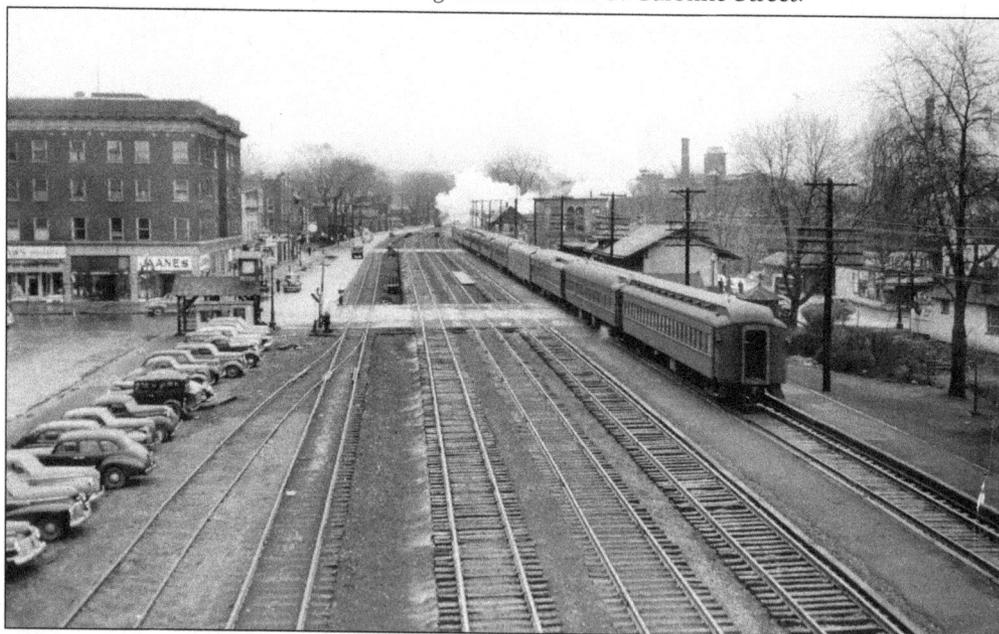

THE LAST TRAIN. On April 5, 1943, an eastbound passenger train was the last to use the New York Central Railroad tracks through Herkimer. The village had been divided by railroad tracks since 1836 when the Utica and Schenectady Railroad began regular runs. The main line of four tracks now runs to the south, eliminating grade crossings that separated the village and were considered hazardous for local traffic.

112

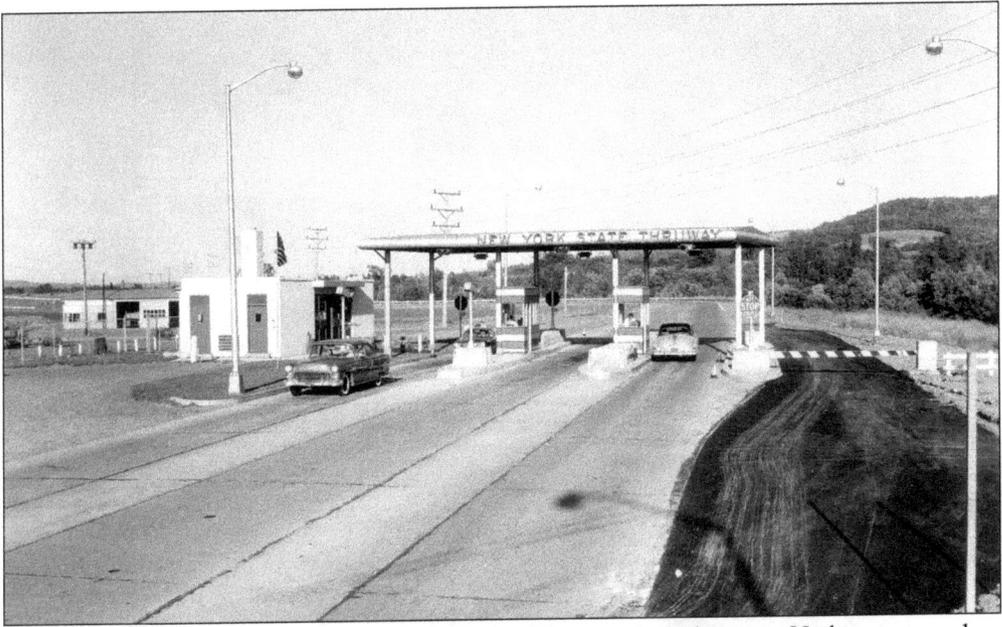

NEW YORK STATE THRUWAY. The New York State Thruway interchange in Herkimer opened on October 26, 1954. Locally, the thruway cut across the old Herkimer fairgrounds. The opening of the interchange was celebrated by a cavalcade of state and local officials, led by Gov. Thomas E. Dewey. Joseph Nicolette of Frankfort and Nancy Sosin of Little Falls were crowned thruway king and queen by assemblyman Leo Lawrence.

HYDRAULIC CANAL. Ground was broken for the Hydraulic Canal on July 4, 1833, and was completed in 1836 at a cost of $35,000. It traveled through the village of Herkimer with mills and factories along its route, providing power from the mill wheels turned by the force of the water. This picture, taken around 1910, is looking north from Green Street with the Folts Street bridge in the background. Many young children were warned to stay away from the canal because there were no protective fences along its length until the 1940s.

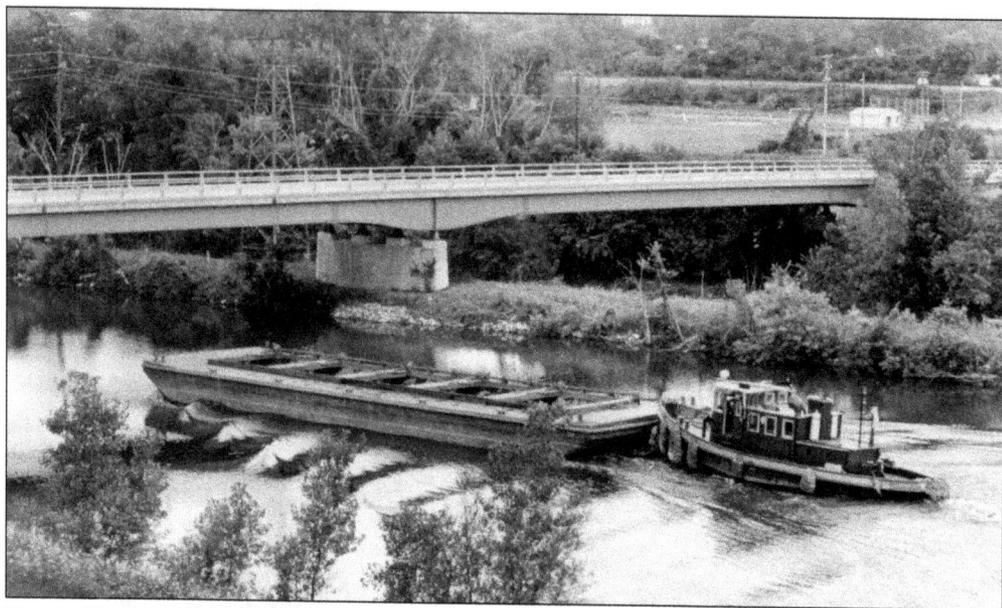

BARGE CANAL. The New York State Barge Canal opened to traffic between the Hudson River and the Great Lakes on May 15, 1918. The main line of the canal, which follows, in part, the route of the old Erie Canal from Watervliet to Buffalo, was 352 miles in length. Shown is a picture taken by Steve Tooney of a tugboat pushing an empty barge near the South Washington Street bridge. Today the canal is used primarily for recreational purposes, and bike paths are being constructed along its route.

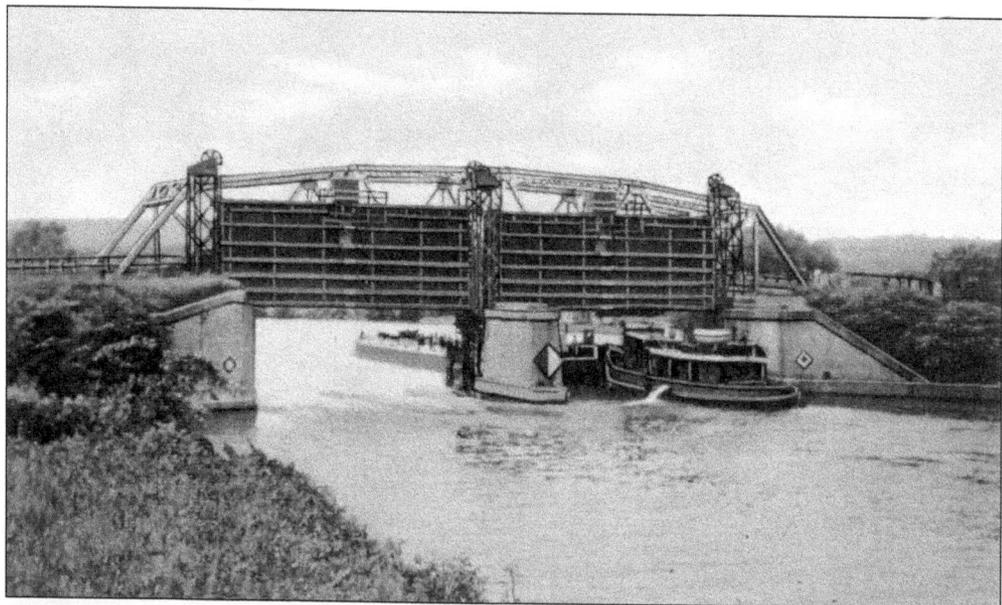

BARGE CANAL GATES. This postcard shows the steel guard gates that help regulate the flow and level of the water on the barge canal near the Mohawk Street bridge in Herkimer. It was part of a $1 million federal government water-improvement project that began in 1939 and was not completed until the early 1950s. The project also reduced the size of an island, eliminating a troublesome current for boaters, and widened the canal by at least 10 feet. (Courtesy of Thelma Miles.)

114

Eight

MAIN STREET SHOTS

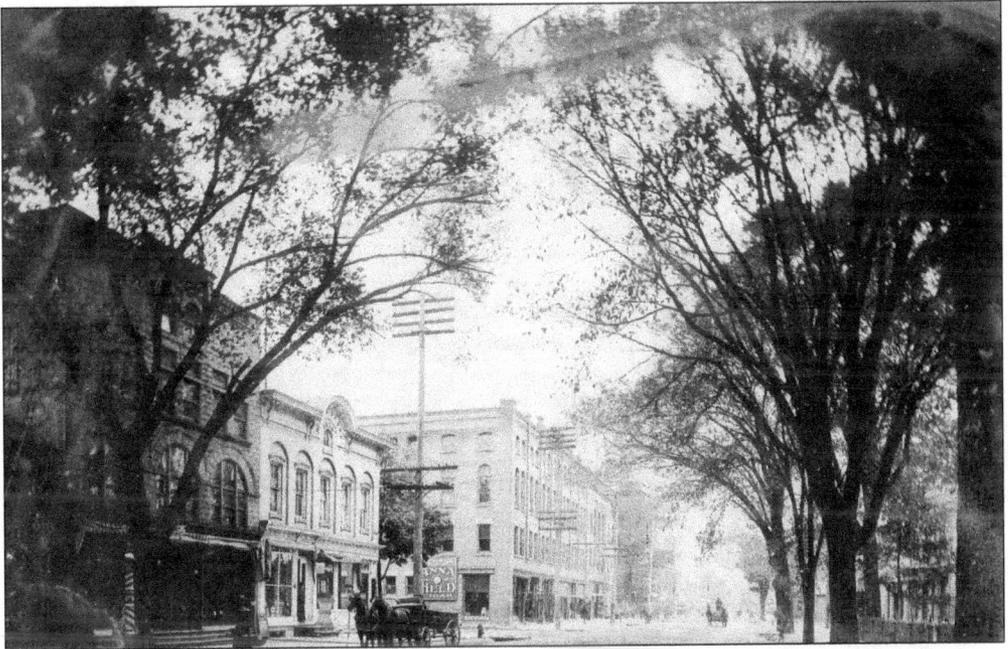

NORTH MAIN STREET, 1907. Horse-drawn wagons were still the preferred mode of transportation in this 1907 view of the northeast side of North Main Street. The first building on the left shows George Speice's barbershop and W. S. Howell's furniture store and undertaking business. Nearby is the Metzger Block, built in 1878, that housed druggist Le Grand Hollan and the First National Bank. On the next corner with the Anna Held Cigar sign is the Earl Block that housed the Whitehead Drug Store and Model Clothing store.

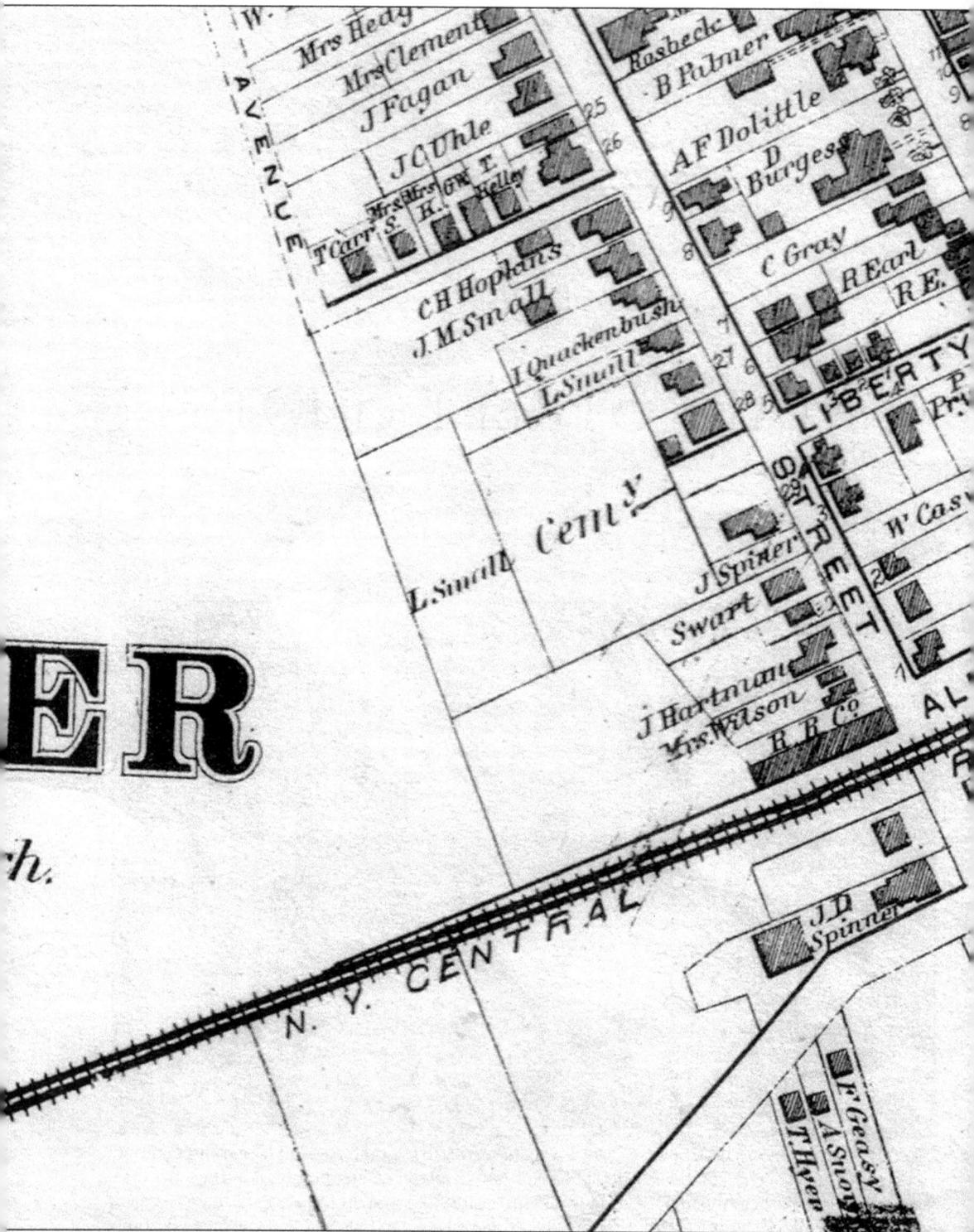

VILLAGE OF HERKIMER MAP, 1868. This map is from the 1868 Herkimer County Atlas showing a close-up view of the village of Herkimer. The streets crossing Albany Street (from left to right)

are Prospect, Main, and Washington Streets.

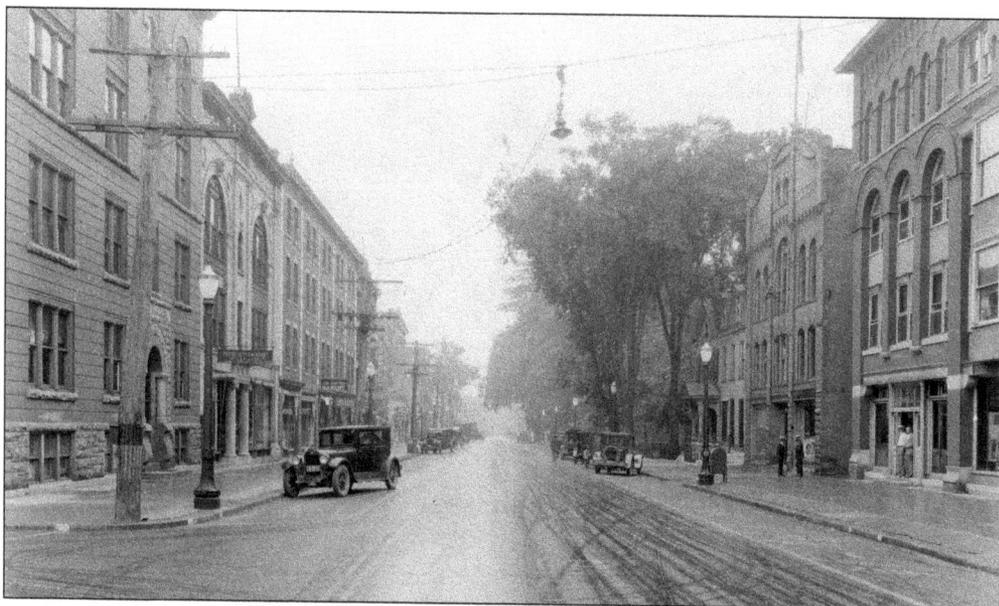

NORTH MAIN NEAR MARY STREET. This picture on North Main Street looking south was taken in 1926 by General Electric to show its ornamental lampposts. On the east side, the Van Kirk apartments are just visible. Next is the Metzler Block with its large, rounded windows that housed Roy Devendorf's tailor shop and then Hemstreet Apartments with the Haynes Bakery and the five-and-ten store are seen. The Waverly Hotel can just be seen in the distance. On the west side is the Palmer house, the Herkimer Post Office, and Dr. Cyrus Kay's house and office.

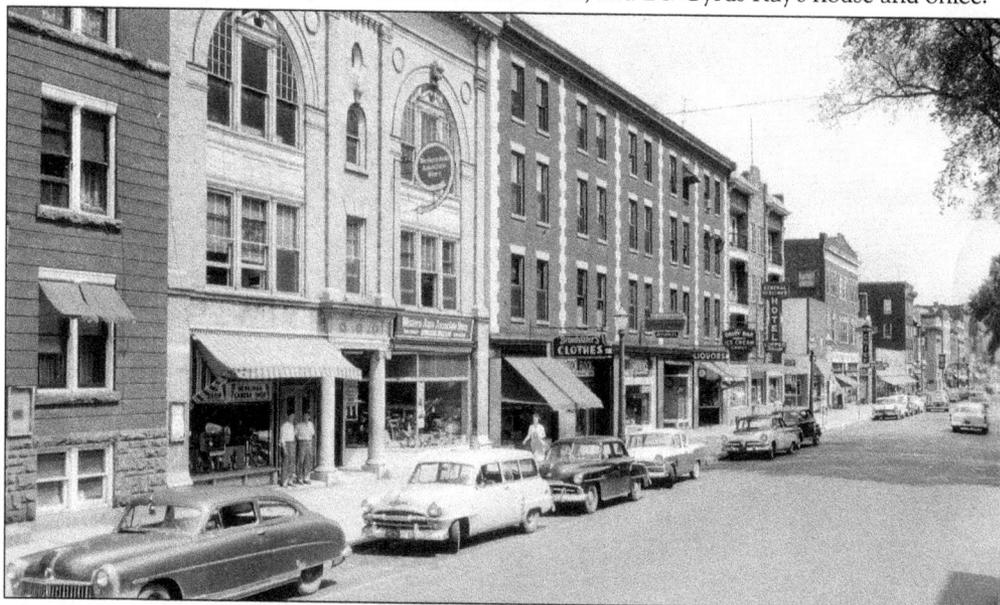

HERKIMER, 1957. This same view of North Main near Mary Street in 1957 shows the bustle of an active business district. The Metzler building housed professional offices, while the Western Auto store occupied the ground floor. Brondstater's Clothing Store, Community Pharmacy, the Herkimer Liquor Store, and Harry's Dairy Bar filled the ground floor of the Hemstreet Apartments building. The General Herkimer Hotel (formerly the Waverly) is next farther down the street.

118

ZINTSMASTER PHOTOGRAPHY STUDIO. Many events and places were chronicled by Albert Zintsmaster, who owned a photography studio at 122 North Main Street in the early 1900s. The most famous photograph he took was of murderer Chester Gillette in 1906. In 1926, Zintsmaster's son Max joined the business, taking it over in 1927 when his father moved to Utica. Max ran the business until 1945, when Donald Robertson and Lloyd Elston opened Robel Studio.

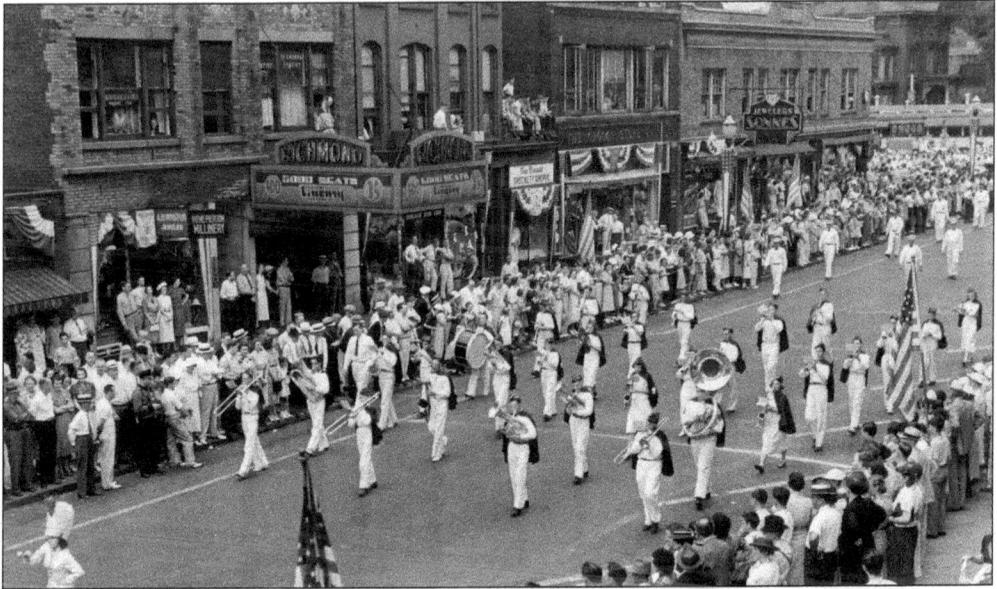

EVERYONE LOVES A PARADE. Crowds lined the street as this marching band walks down North Main Street. This photograph gives a good view of the Richmond Theater, which was opened in 1914 by William Douque at 131 North Main Street. It was best known as playing second-run movies and Westerns that entertained the children that packed its seats on Saturday afternoons. A bowling alley was in the basement, and pins could be heard crashing while watching the movie. The Richmond closed in 1961. (Courtesy of the Herkimer Fire Department.)

119

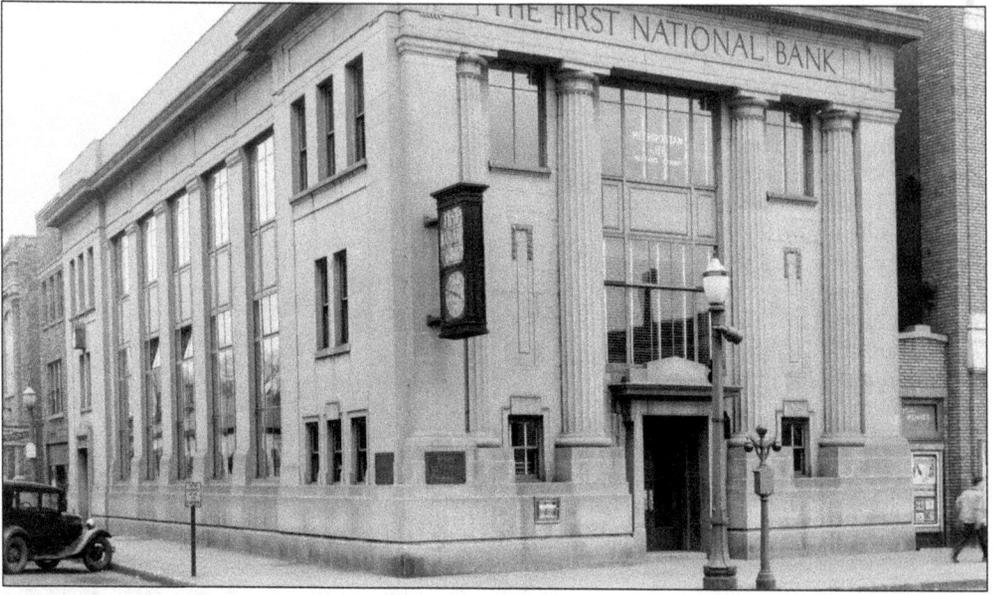

FIRST NATIONAL BANK. The First National Bank was chartered on May 12, 1884, and was first housed at 230 North Main Street until it moved several doors down the street in 1891. When it merged with the Herkimer National Bank in 1931, it moved into the building, shown here, located on the corner of Green and North Main Streets, with Henry Munger as its president. Note the police call box with three globes on top at the curbside, and the fire-escape door for the Liberty Theatre can be seen on the right.

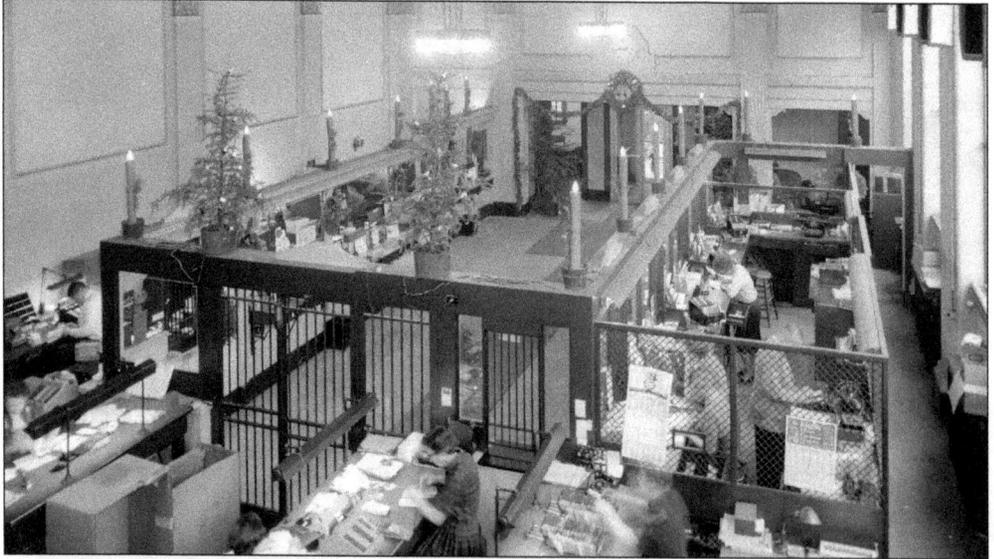

INTERIOR OF FIRST NATIONAL BANK. This picture shows the interior of the bank during the Christmas season around 1932. It boasted the latest advances in modern banking technology. The building was constructed in 1921, and its architect was A. Ross Sluyter. First National Bank merged with Marine Midland Trust Company in 1958 and was later bought out by HSBC (Hong Kong and Shanghai Banking Corporation) in 1999. In 2004, it was purchased by Adirondack Bank, which closed its doors when operations were moved to the current location on Prospect Street.

HISTORIC FOUR CORNERS. An aerial view of North Main Street shows the Historic Four Corners, the center of the original Palatine settlement, and the site of the Revolutionary War Fort Dayton. The Herkimer Reformed Church still stands on the site where it has been since its founding in 1723. The 1834 Herkimer County Jail sits across Church Street with its enclosed yard in the back. It was the site of the execution of Roxalana Druse and where Chester Gillette was held while awaiting trial for the murder of Grace Brown. The courthouse, built in 1873 across Main Street, was the site of Gillette's trial, which was chronicled in Theodore Dreiser's book *An American Tragedy*. The Queen Ann–style house of Dr. Walter Suiter, built in 1884, occupies the fourth corner and is the home of the Herkimer County Historical Society.

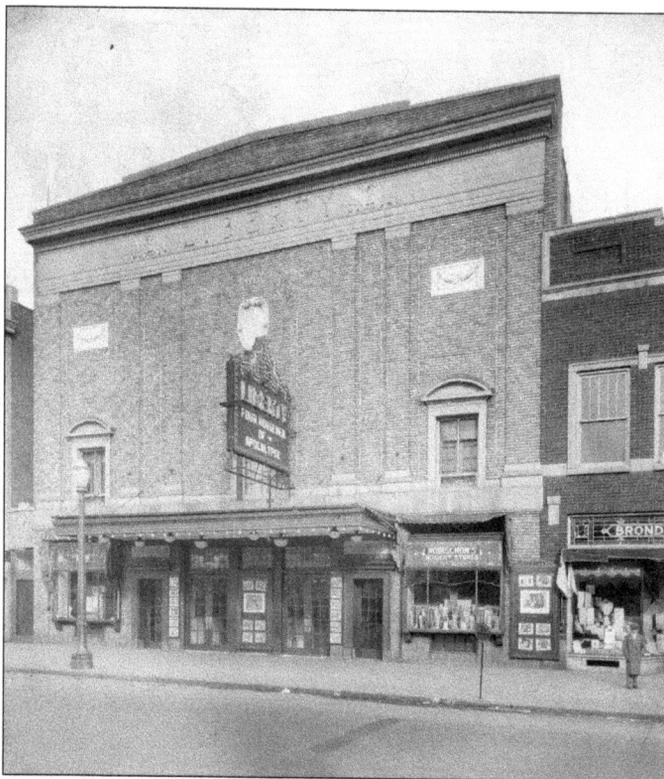

THE LIBERTY THEATRE. The Liberty Theatre was a popular gathering place after its opening in 1920 on North Main Street. The first movies to be shown were silent, featuring popular stars such as cowboy Tom Mix. It cost a dime in the afternoon and 15¢ at night for kids and 20¢ for adults. There was a balcony that overlooked the stage, and there was a gallery above that. This picture shows the early marquee featuring the 1921 war drama *Four Horsemen of the Apocalypse*, starring Rudolph Valentino.

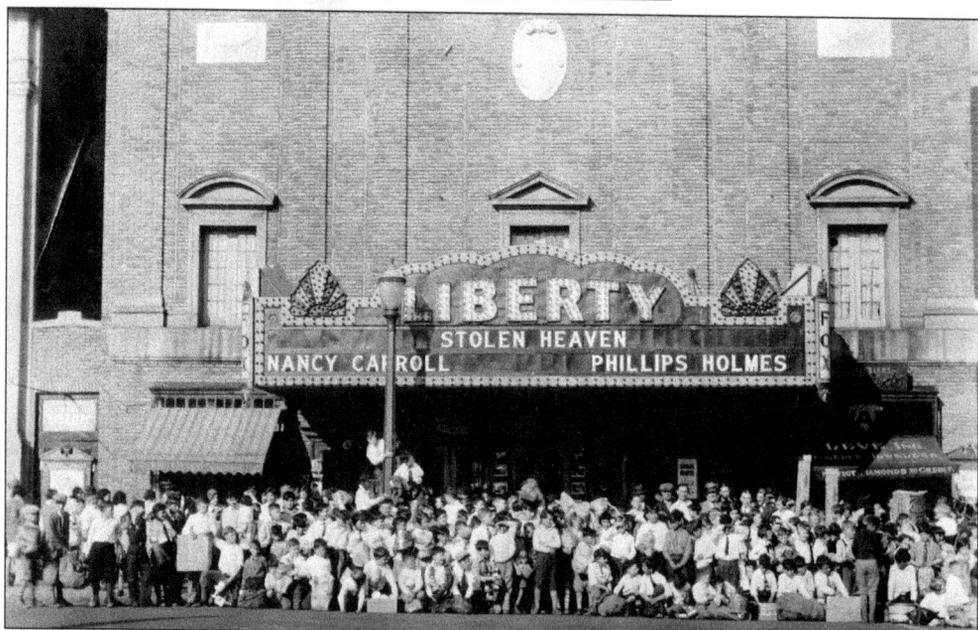

CROWD AT THE LIBERTY. This picture may not show a special occasion, as this was the amount of children that came to the Liberty Theatre every Saturday. It opened at 11:00 a.m., and some stayed all day until it closed at 11:00 p.m. The theater officially closed its doors in 1969, when it was purchased by the Marine Midland Trust Company and razed to make room for a drive-in teller facility at the bank. *Gone With The Wind* was the final movie shown at the theater.

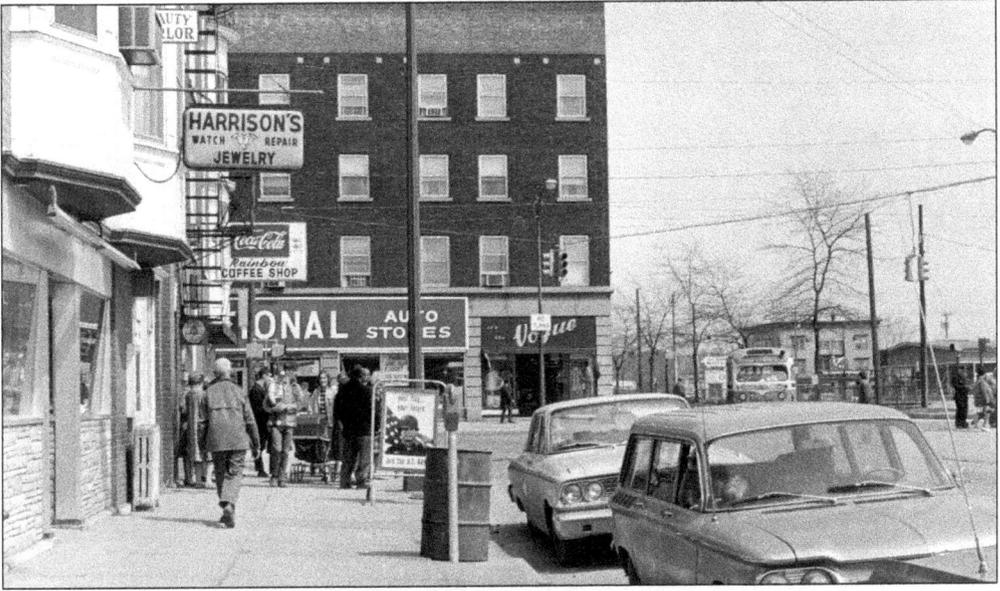

MANION BLOCK AND NELSON BLOCK BUSINESSES. This photograph from 1969 or 1970 of North Main Street shows the old Manion Block, featuring the Rainbow Coffee Shop, where the Empire Diner is located today, and the Nelson Block, with National Auto Sales and the Vogue ladies store, now Collis Hardware. The Manion Block burned in February 1975 and was razed a week later. Note the Corvair in the picture, which were only manufactured from 1960 to 1969. It had an engine in back and a gas tank in front.

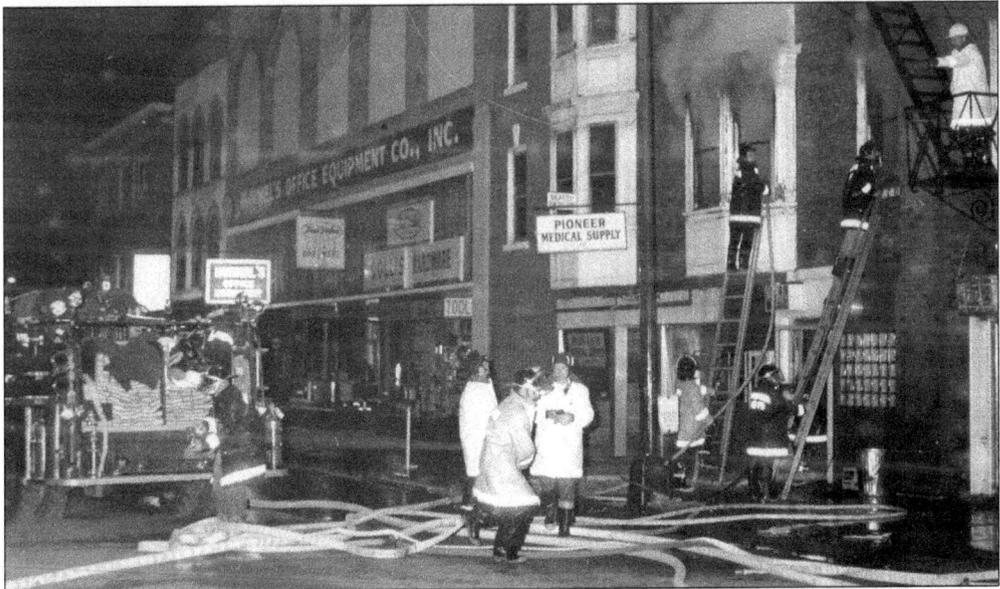

MANION BLOCK FIRE. The Manion Block, located on the corner of North Main and Albany Streets, had a major fire on February 21, 1975. Firemen from Herkimer, East Herkimer, Ilion, and Little Falls battled the fire most of the night. The block's first floor was occupied by Pioneer Medical Supply, the Rainbow Coffee Shop, and the Variety News Shop. The second, third, and fourth floors were dentist offices, Michele's Beauty Salon, Herkimer Karate Club, and apartments. (Courtesy of the Herkimer Fire Department.)

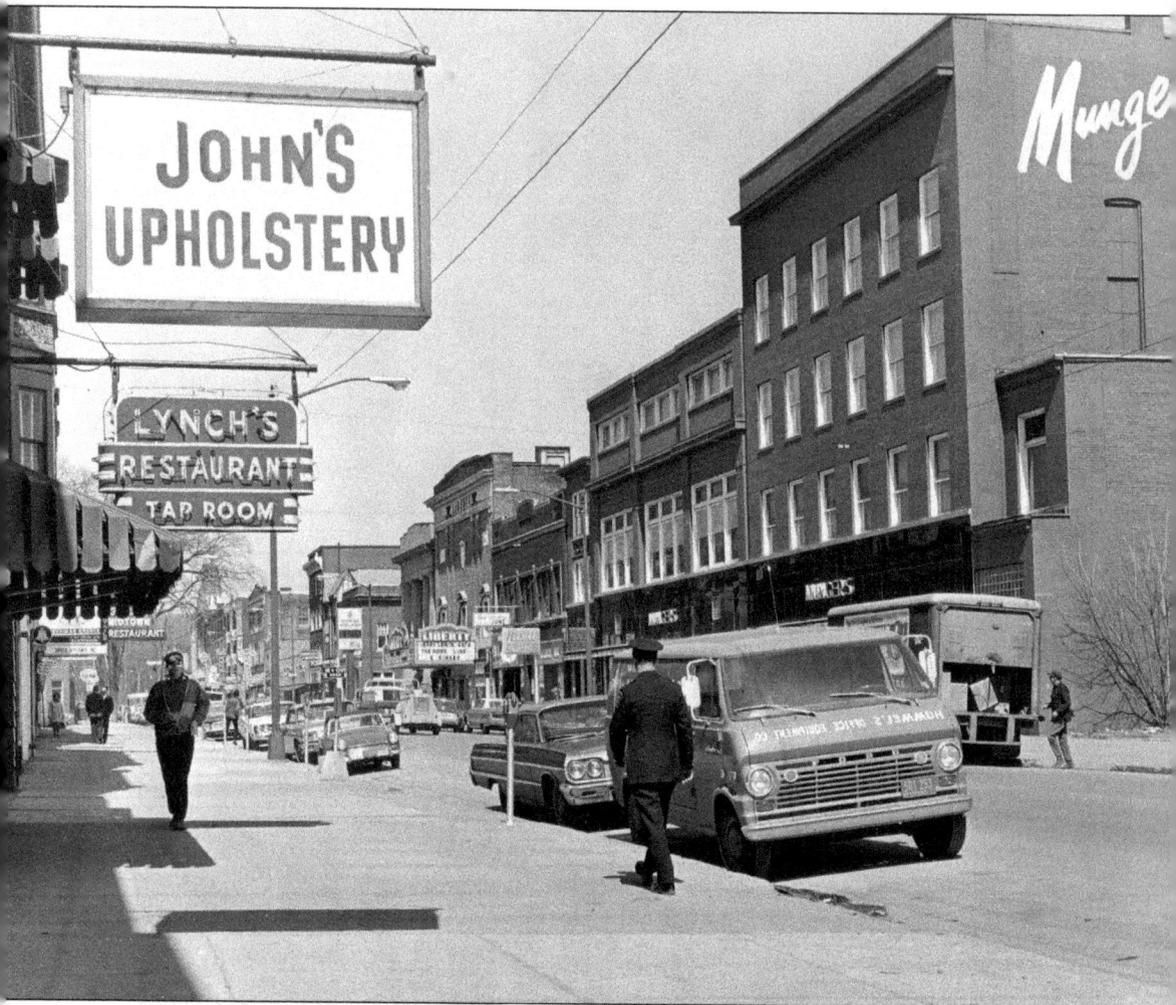

SHOPPING ON MAIN STREET. This 1969 Main Street shot looking north shows the number of businesses that lined the street, including John's Upholstery, Lynch's Restaurant, H. G. Munger's, and the Liberty Theatre, with the marquee advertising "Jerry Lewis gets the Hook, Line and Sinker." H. G. Munger's was a first-class department store selling such fine goods as china and silver.

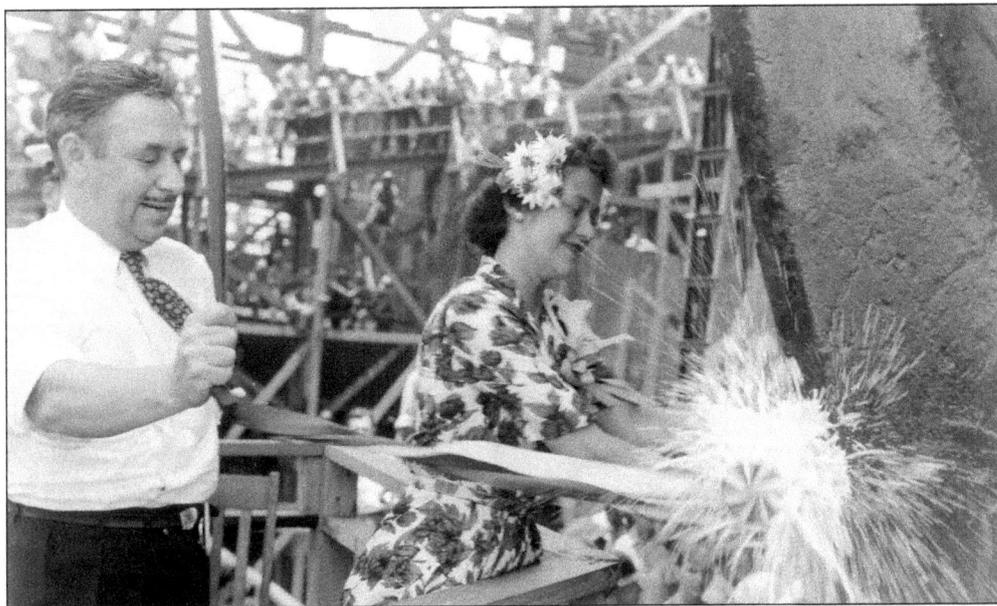

THE S. S. NICHOLAS HERKIMER. Liberty ships were built in the United States between 1941 and 1945 during World War II. They were used as cargo ships by the military to carry supplies to the American forces. The Southeastern Shipbuilding Corporation, based in Savannah, Georgia, launched its 14th vessel, named the S. S. *Nicholas Herkimer*, on June 8, 1943. The 10,500-ton transport was named after Gen. Nicholas Herkimer, Revolutionary hero and namesake of the village of Herkimer. The ship was christened with a champagne bottle by Anne Stevenson, daughter of John D. Hollister, a former Ohio congressman and one of Southeastern's legal advisers. Pictured with Stevenson is Harry Fair, purchasing agent. The S. S. *Nicholas Herkimer* served its country well and was eventually scrapped in 1967 at Green Cove Springs, Florida.

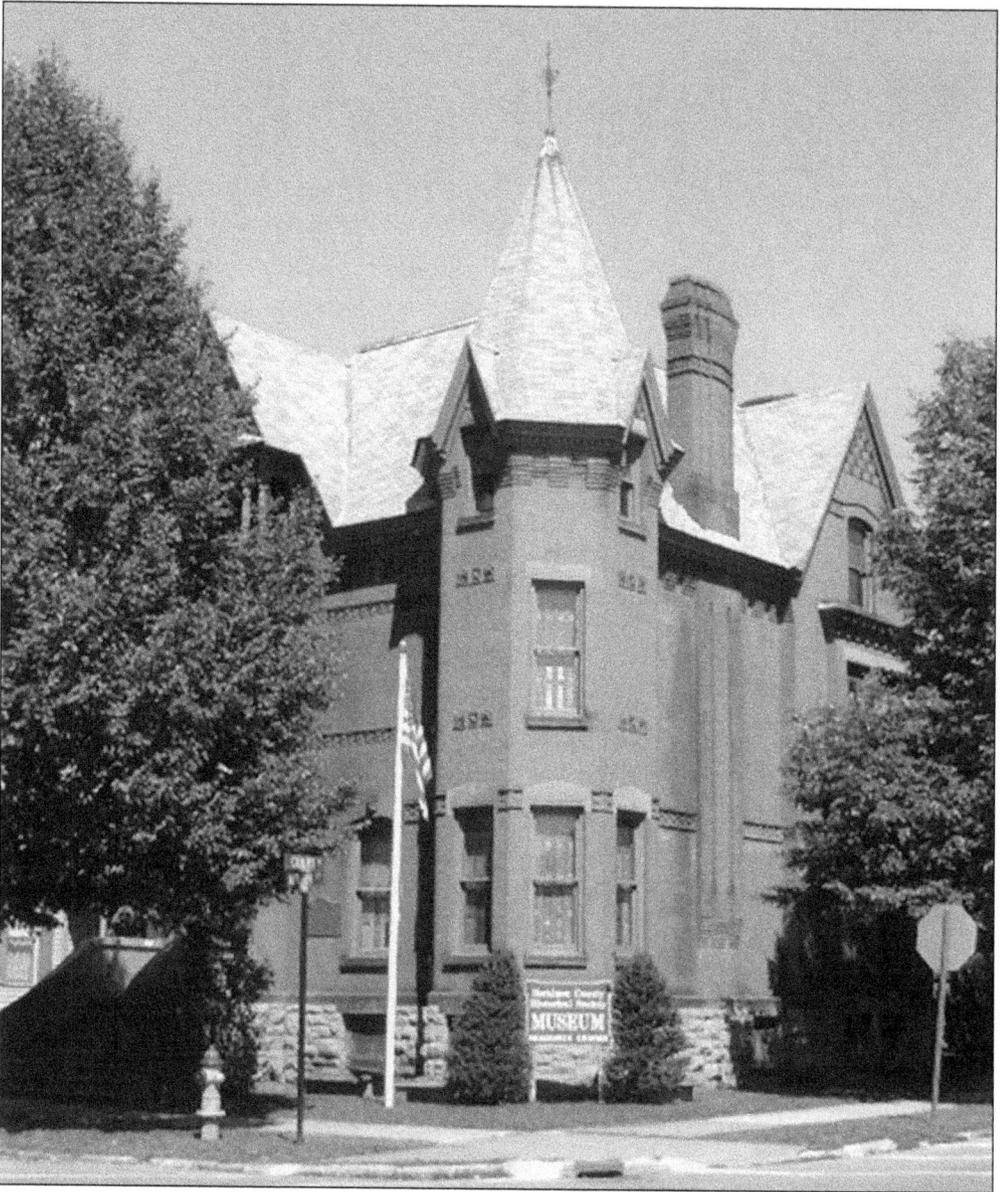

HERKIMER COUNTY HISTORICAL SOCIETY. This Queen Anne–style building, constructed by Dr. A. Walter Suiter in 1884, houses the Herkimer County Historical Society's museum and collections. It is located on the corner of North Main and Court Streets at the Historic Four Corners in Herkimer.

ABOUT THE HISTORICAL SOCIETY

Since 1896, the Herkimer County Historical Society has been a not-for-profit organization, discovering, collecting, preserving, and publishing information pertinent to the county's history. With the donation of the Suiter Memorial Building in 1925, the society has had a permanent headquarters, where exhibits could be displayed, and a library, where people could research their genealogy and local history.

In 2000, the society moved its library, gift shop, and offices into the renovated Eckler building, which neighbors the Suiter building on Main Street. The Suiter building still contains a museum with displays open to the public, the society's vast collection, and a DAR room with genealogical material.

Both buildings are handicapped accessible with an adjoining link.

The society is located at 400–406 North Main Street and can be reached by telephone at (315) 866-6413 or through its Web site at www.rootsweb.com/~nyhchs. It is open Monday through Friday, 10:00 a.m. to 4:00 p.m., and on Saturdays during July and August, 10:00 a.m. to 3:00 p.m.

The 2008 board of directors includes Jeffrey Steele, president; John Stock, vice president; Timothy Daly, treasurer; M. Scott Vaughan, secretary; Carolyn Canary; Steve Canipe; Kathy Crowe; Carol Dippolito; Alicia Helmer; Steve Knight; Jan McGraw; Garry Outtrim; Sylvia Rowan; Donna Rubin; and Frank Spatto. The society's executive director is Susan R. Perkins, and the administrative assistant is Caryl A. Hopson.

Visit us at
arcadiapublishing.com

www.ingramcontent.com/pod-product-compliance
Lightning Source LLC
Chambersburg PA
CBHW050632110426
42813CB00007B/1787